craftivism

the ART of CRAFT and ACTIVISM

CRAFTIVISM

edited by **BETSY GREER**

Arsenal Pulp Press Vancouver

CANCEL

ARSENAL PULP PRESS
Suite 202–211 East Georgia St.
Vancouver, BC V6A 1Z6
Canada
arsenalpulp.com

Efforts have been made to contact copyright holders
wherever possible. The publisher and author welcome
correspondence from any copyright holders of material
used in this book who have not been contacted.

Design by Gerilee McBride
Editing by Susan Safyan

Printed and bound in Korea

Library and Archives Canada Cataloguing in Publication:

 Craftivism : the art of craft and activism / edited
by Betsy Greer.

Includes index.
Issued in print and electronic formats.
ISBN 978-1-55152-534-1 (pbk.).—
ISBN 978-1-55152-535-8 (epub)

 1. Handicraft—Social aspects. 2. Handicraft—
Political aspects. 3. Social movements. 4. Social action.
5. Art, Modern—21st century.
I. Greer, Betsy, editor of compilation

TT149.C73 2014 745.5 C2014-900268-8
 aC2014-900269-6

Efforts have been made to locate copyright holders of
source material wherever possible.
 The publisher welcomes correspondence from any
copyright holders of material used in this book who have
not been contacted.

CONTENTS

ACTIVATING COMMUNITIES 155

Knitting Craftivism: From My Sofa to Yours

BETSY GREER

In the fall of 2000, I was living in New York City in my aunt's amazing Greenwich Village apartment. It was pre-9/11, post-turn-of-the-century, during a hotly contested presidential race between Al Gore and George W. Bush—a good time to be living in New York. On Halloween night, I walked to the annual Greenwich Village Halloween Parade to watch the bright and colorful costumes of the heavily made-up drag queens and enjoy the general merriment. However, I was most impressed by the literally larger-than-life puppets of both Bush and Gore that deftly paraded down the street, thanks to the help of a puppeteer each. Suddenly, the atmosphere went from boisterous and cheerful to solemn; the election was in just a few days, and everyone (no matter which side they were on) was worried.

After the puppets went past, the parade once again became a loud, happy, celebratory whirl of colors and sparkles and sequins. But there was something in that schism between the loud and the quiet that spoke to me. I didn't put it together until one night later that fall while knitting on my aunt's comfy sofa. I began to think about how I could donate the items that I was making to worthy causes and knit things for people in need. And then I remembered the silent but powerful presence of those puppets in the parade. I had always thought that activism had to be loud and in-your-face. Maybe the

quietness of the puppets resonated with the quietness of the knitting, but it made me think about *quiet* activism and wonder how craft could be a part of it. This idea tumbled around in my brain for a while like a load of clothes in the dryer.

Many months later, I mentioned this connection between craft and activism to my knitting circle. One woman, nicknamed Buzz, spoke up and said, "You could call it craftivism." I posted this on my online journal, but didn't begin to explore the concept in depth until 2002 when, in a research proposal, I explained that, "the creation of things by hand leads to a better understanding of democracy, because it reminds us that we have power." I felt that artists needed a term for crafting that was motivated by social or political activism, and "craftivism" fit the bill. In March 2003, I bought the domain name *craftivism.com,* which allowed me to talk about craftivism to others; suddenly it was no longer just a crazy idea in my head. People I didn't know started to write to me about how craft and activism were related in their own lives. "Craftivism" gave people a quick way to explain what they were doing and a platform from which to create.

The very essence of craftivism lies in creating something that gets people to ask questions; we invite others to join a conversation about the social and political intent of our creations. Unlike more traditional forms of activism, which can be polarizing, there is a back-and-forth in craftivism. As craftivists, we foment dialogue and thus help the world become a better place, albeit on a smaller scale than activists who organize mass demonstrations. To some, our work may seem unimportant, but to me, the small scale of craftivism is vital. It turns us, as well as our work, into vessels of change. As craftivists, we are also permission-givers, helping to breathe life into artistic practices that some people may think are obsolete by showing their relevancy and poignancy. We also demonstrate that the act of "making" is important; we give other craftivists permission to make boldly, make with the greater good in mind, and make in order to nourish ourselves.

I've organized this anthology so that it moves from the personal to the political to the level of broader community involvement, in much the same way craftivism came to me. It began inside and, over time, began to grow into something much larger. In the first section, "Personal Threads," you'll read about the concept of guerrilla kindness and other creative personal approaches to craft. Next, in the "Refashioning Craft" section, authors and interviewees show how adornment can help us locate our own unique style. The focus is on how we adorn ourselves and our surroundings with what we make and why this is important. With "Craft as Political Mouthpiece," the focus shifts away from the self to politics, as we learn how a very tiny knitted mouse turns the tide and how the very act of making can be life-saving under oppressive regimes. In the final section, "Activating Communities," we see how craftivism can aid communities and foster both strength and empowerment through creations such as knitted basketball hoops and fabric water droplets. In showing you all these facets of craftivism, it is my hope that you find a way to incorporate craftivism into your own life.

Over the past ten years, I have collaborated with many of the contributors to this book, and I am glad to call them my friends, peers, and colleagues. It is my hope that this anthology will give you an idea of the breadth of craftivism, and show you how you can use your creativity to improve your own life as well as the lives of others.

Personal Threads

When you first start to craft, you may find that the most rewarding aspects are personal. It's just you and your materials, intertwined in a silent conversation. It's a tale as old as time, part conjuring—as you try to create something you can see only in your mind's eye—and part gift, as you begin to see it unfold in the outside world, there before you.

In the following essays, the writers explore the personal journeys that we each take to create. I have placed this section first to show that craftivism is about change from within as much as it is about creating work that makes the world a better place. In order to inspire the best, most lasting change, we need to create from a place of determination and love inside ourselves. So these essays aim to gently nudge you toward looking into your own ways of making and to provide examples of how different personal journeys take shape from similar threads. From leaving gifts for passersby to quilting for people we've never met, we see how creating for those we don't know can fuel our hearts. By bringing positive intention to the making of things and creating to soothe our own as well as others' emotions, we can discover what it's like to create for the greater good. By making intentionally ugly things, we question conformity to media beauty standards, and we can see how difficult (and important) it is to create without pure aesthetics in mind. Finally, by following our roots and connection to the DIY ethos, we see how our own work can unfold and allow us to find our best selves. Like the dance of the thread as it winds itself up, around, and through the cloth, these essays show what it means to be makers.

GUERRILLA KINDNESS

Sayraphim Lothian

I'm a joyful optimist. I want the world I live in to be a wonderful place, a place where neighbors chat to each other over fences and people new to the building are welcomed with a plate of home-baked treats. A place where, if you walked along a footpath in the city, you might find a random piece of art hanging from a tree or a poem inscribed on a wall. I want the world to be a place where magical or surreal moments are commonplace, where you never know what's going to be around the next corner.

As the well-known maxim says, we must be the change we wish to see in the world. I have taken this to heart and am trying to do exactly that. I think the importance of having lovely things happen to us cannot be overstated. That is why I make small handcrafted artworks to leave on the streets of cities around the world for people to find and take; I practice random acts of guerrilla kindness to lift people's moods and make them happy. The world needs more moments of joy, more unexpectedly wonderful things to happen, more enveloping moments of beauty that catch the eye and the heart, even if only for a second. If acts of road rage can create a ripple effect that sparks more road rage, then surely acts of loveliness can ripple outward too?

I've walked down alleys and found stenciled artwork left on fence palings for people to take, discovered tiny sculptural works half hidden on windowsills, and seen hundreds of bells hanging from a tree on pale ribbons in the middle of Melbourne's Central Business District. I've found magic in the strangest places and always loved the thrill of the find and the chance to own an amazing work of art, an item created with care and love by a (sometimes anonymous) artist. I get the same kind of thrill from finding beautiful street art—intriguing stickers on the backs of signs and strange but wonderful figures nailed to light posts and fences. Walking through the city is an adventure; some days, I feel like I'm on an art safari. When I was younger, I always wanted to contribute to the evolving gallery on the streets, but I've never been very good at painting or drawing. My skills lay in the vast and endless possibility that is craft.

Musing on that fact some years ago, I decided to make a start in streetcraft, something you don't see a lot of, aside from mad amounts of yarn bombing. At the same time, I wanted to do something nice for strangers as a way of making the world a better place. I wanted to make something that I could leave out on the streets for people to find and take. My friend Bianca Brownlow founded the (Secret) Toy Society, a worldwide collective of people who make toys and leave them to be found by strangers. It's a beautiful, simple idea: take the time to make a toy, then leave it in a ziplock bag in a park or at a library with a note that reads, "Take me, I'm yours."

When I first found out about the (Secret) Toy Society, I reveled in its grassroots rebellion. This transaction takes all the corporations and government officials and media employees who usually get a say in how we interact with each other and the world out of the picture, and reduces it down to a transaction between just a couple of people. My rebellious, DIY heart rejoices at the thought of this. A Toy Society "drop" (which is how they refer to the act of leaving the toy—how spy-cool is that?) is a deeply personal exchange between two strangers. One spends time at home hand-making a toy, devoting hours

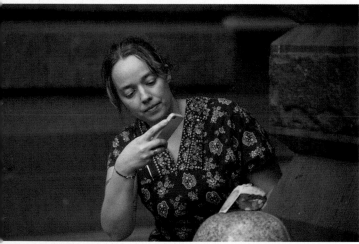

and materials to creating it specifically to bring joy to someone else. They leave it somewhere where another finds it, takes it home, and gives it to their child to play with. Not only does it end up in the geographical heart of someone's life and home, it also lives in the imagination, mind, and heart of their child.

With this example in mind, I wanted to emulate the idea of "dropping" something handmade that a stranger would be thrilled to find. My project was aimed more at adults than children because, as adults, we so often lose our joyous sense of discovery, and I wanted to help coax that feeling back. As I considered what the actual item might be, a prop-maker friend absentmindedly chatted to me about a fake cake he'd made for a display and how easy it had been to create with expanding foam, spackle (that thick white stuff used to fill holes in walls), and a bit of acrylic paint. In that moment, I decided to make fake cupcakes to leave on the street with a little tag that read, "For you, stranger." Nice, simple, and clear.

The cakes were simple to make and fun to paint and decorate. My friend Holly McGuire makes hand-carved stamps under the name Two Cheese Please, so I asked her to make one that read, "For you, stranger" with my name (which is also my Twitter handle) on it, "@sayraphim." The @ symbol is in the shape of a heart, so the tag reads like a little card.

I put my name on it in case people wanted to look up the project and see what it was all about, but I'm just as happy if they don't. It's not about taking credit or being contacted; the main aim is to simply create a moment of happiness and magic when someone finds the work. Putting my name on it just makes it a little more personal; a gift from me to the finder.

Once created, I then go on a daylight mission into the city to drop the work. It's a challenging task to find drop

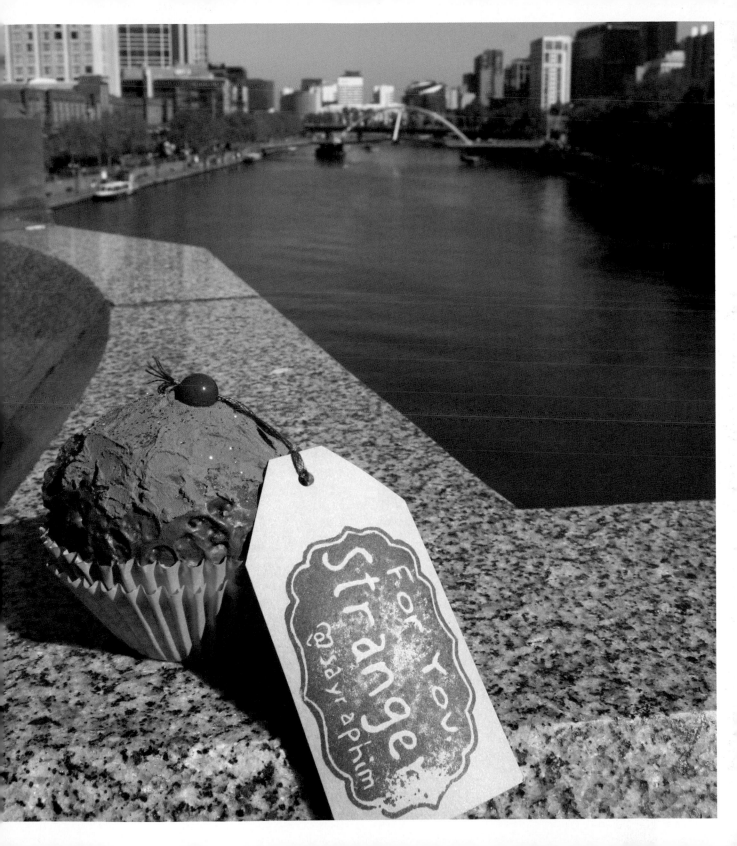

spots in the city. Put them too high or too low and people won't see them; hide them too well and they may never be found. Once I've spotted a good place to leave one, I put the work down, photograph it, and then walk away. The temptation is to stay and watch to see who picks it up, but I've learned that this changes the act itself. Deciding that you'll stay and watch what people do with the cupcake makes the act of dropping an exchange; it becomes a matter of, "Sure, you can have this thing I made, but I want to watch what you do with it." It makes the finder an unknowing participant in a voyeuristic kind of performance that's sort of creepy. I set my guerrilla kindnesses down and walk away from them.

There is also the thrill of the unknown. If I put out twenty cupcakes, I might get two enthusiastic responses, usually via Twitter, and I may never know what happens to the other eighteen. They might be lost, thrown out, swept up, or otherwise discarded. After all of that work, they might never be found. But then again, eighteen other people might have had that moment of discovery when they saw a piece and figured out that it's not a real cupcake, then taken it home.

At first, I thought that my acts of guerrilla kindness created the same kind of private moments that the (Secret) Toy Society drops do, flowing purely from my hand to someone else's. But after a while, I realized that these works reached out to more than just the person who finds the cupcake. In 2012, I was tweeting photos while dropping "guerrilla kindness" works around a park—tiny, hand-sewn felt houses with *Mi casa es su casa* (My house is your house) handwritten on the green paper lawns. It was a gift of gratitude for a town in which we had experienced so much warmth and hospitality from strangers that we felt at home during every moment of our visit there. I wanted to pay that generosity forward and make a sincere offering of returned hospitality when

I got home. One day someone will need to stay at my house, and my promise to myself was that I would find them room to crash, somewhere between the crazy boxes of craft supplies and teetering towers of books.

As I uploaded a photo of the final drop via my phone, a friend in Melbourne tweeted to me, "I've decided that my new goal in life is to find something that you've made." This made me realize that the loveliness that comes from each guerrilla kindness work ripples out not only to the person who finds it and takes it home, but also to everyone who sees the photos online, either on my website, Facebook page, or Twitter feed. These works also touch people who spot a work while walking past it, take a photo, and upload it to their various social media sites, even though they may not take the piece home with them. In this way, bits of these works ripple past friends of friends who see them in their online social media stream and beyond. It was a pivotal moment for me when I realized that though my guerrilla kindness work is based on personal interactions, it has implications that reach further than I'd ever imagined.

Ultimately, guerrilla kindness is about discovering that people care about one another, and that someone out there cares about you. Therefore, guerrilla kindness work is about extending your community. It's about reaching out your hand to a stranger and using your skills to make someone's day brighter. It's a handcrafted, joyous experience for the maker and the finder. My work is aimed at creating tiny bubbles of joy in the lives of passersby, tiny surreal moments that might make people do a double take. It's the artwork equivalent of finding fairies at the bottom of your garden.

~~~~~~~~~~~~~~~~

**SAYRAPHIM LOTHIAN** *is a public artist who aims to facilitate meaningful connections between people through craft. Her work is in the Museum of Modern Art in New York, the archives of the National Gallery of Victoria (Australia), the State Library of Victoria, the MonashHeart Art Collection (Australia), as well as in private collections and on the streets in cities around the world. Lothian and her work appear in a number of books including Garth Johnson's* 1000 Ideas for Creative Reuse, *Vickie Howell's* Craft Corps, *and* Heads On and We Shoot: The Making of Where The Wild Things Are *by the editors of McSweeney's. She is a cofounder and constructive communities manager of the playful company Pop Up Playground and is currently taking her Masters in Art in a Public Space at RMIT University, Melbourne.*

~~~~~~~~~~~~~~~~

PHOTOS:

Page 10: Sayraphim Lothian, *For You, Stranger*, 2013, dropped at a tram stop in Melbourne, Australia. Photo: Sarah Walker

Page 12 (top): Sayraphim Lothian, *For You, Stranger*, 2013, dropped at a bike share in Melbourne, Australia. Photo: Sarah Walker

Page 12 (middle): Sayraphim Lothian photographs a *For You, Stranger* drop at the Melbourne Town Hall in Melbourne, Australia, 2013. Photo: Sarah Walker

Page 12 (bottom): Sayraphim Lothian, *For You, Stranger*, 2013, dropped in an alley in Melbourne, Australia. Photo: Sarah Walker

Page 13: Sayraphim Lothian, *For You, Stranger*, 2011, dropped on Princes Bridge, Melbourne, Australia. Photo: Sayraphim Lothian

Page 14: Sayraphim Lothian, *Mi Casa Es Su Casa*, 2012, dropped in Castle Park, Bristol, UK. Photo: Sayraphim Lothian

Holly Levell, 22,
Textile Artist,
Neston

The Blood Bag Project

Leigh Bowser

My three-year-old niece Chloe suffers from a rare blood condition called Diamond Blackfan Anemia (DBA). This means that her bone marrow does not create new red blood cells, causing her to become severely anemic very quickly. There are thought to be around 125 people with DBA in the UK and only 700 worldwide.

Chloe has blood transfusions every three to four weeks; she received her first two while still in the womb. When she reaches the age of ten, Chloe will be strong enough to undergo chemotherapy and receive a bone-marrow transplant. Until then, she will need more than thirty-five pints of blood and will have had around 120 transfusions to keep her alive.

I set up the Blood Bag Project to educate people about DBA and encourage them to donate blood.

Participants are asked to visit the project website (see below) and download the free PDF template. They can then make their own textile "blood bag" and create their own piece of art to help raise awareness of this rare condition. Over 250 bags have been made so far, by young and old, novice and experienced crafters from all over the world. Any fabrics and designs can be used—it doesn't even have to be red! We ask people to send their bags to the address provided in the template so they can be shared online with the world.

Website: *thebloodbagproject.com*
Facebook: *facebook.com/TheBloodBagProject*
Blog: *thebloodbagproject.tumblr.com*

PHOTO:
Submissions to the *Blood Bag Project*, 2012. Photo: Leigh Bowser

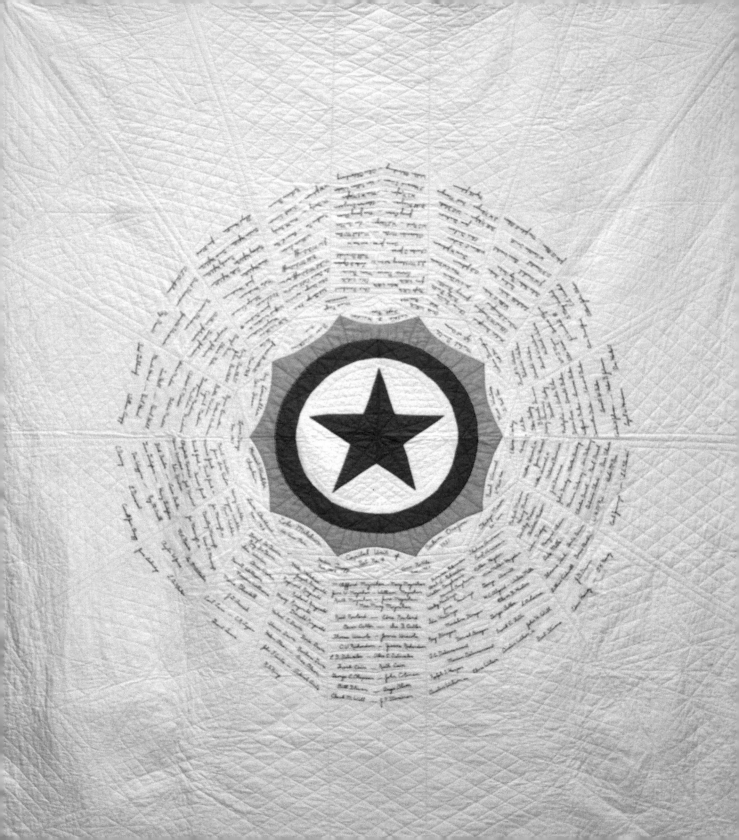

CHARITY QUILTING

Susan Beal

The urge to offer support, warmth, and kindness to someone else in need is a very powerful human trait, and individuals and communities alike have always rallied around those affected by natural disasters, loss, or tragedy. Channeling that generosity and energy into the gift of a quilt—meaningful, beautiful, tangible, and comforting all at once—is a special facet of craft activism. As Katherine Bell, author of the wonderful book *Quilting For Peace*, says in the book's introduction, "Making quilts is an exceptionally good way to comfort those who need solace, provoke positive change, and provide hope."

Historical Charity Quilting

Early charity quilting likely centered around supporting families in a small community, when women gathered for a sewing bee to create quilts that would be given collectively. Girls as young as three years old were taught to sew their own doll quilts, and most assuredly watched their mothers, grandmothers, aunts, and family friends stitch quilts for their friends in need. In an era of high childhood mortality, dangerous farm work, few doctors or hospitals, and unpredictable natural disasters, a family's sudden loss could always be answered by friends' generosity and love.

The inscribed medallion quilt that the women of the American Legion Auxiliary (Capitol Unit of Post #9, Salem, Oregon) made in the early 1930s is a happy exception to the many vintage and antique charity quilts that have survived without their makers' names or circumstances recorded. This quilt included the Legion's own distinctive star logo surrounded by the 300 names of the members of the Auxiliary and supporters;

embroidered in blue, two names are specially marked with memorial gold stars. One of the gold-star names was the beloved brother of Post #9's president, Mae Urshel Waters, J. S. Urschel, who was killed in World War I.

As quilt collector and historian Bill Volckening has suggested in a thoughtful essay entitled "Why Quilts Matter," in an era when women had only recently won the right to vote and had limited opportunities to earn their own money, the women of the Auxiliary found another way to support the causes they valued most. This stunning, intricate quilt (now in Volckening's own collection) was made in support of the Legion's musical trio and quartet and their many fundraising performances. Each person whose name was inscribed donated ten cents to the fund for the musicians, who were so successful in their own fundraising efforts that they helped build both a new Salvation Army and the Salem, Oregon, airport. As Volckening writes, "The quilt's importance doesn't end there. Mae Waters memorialized her brother, keeping his story alive, and the group commemorated its officers. Most importantly, the women of Post #9 created a legacy by reinvesting in their community. In doing so, they left behind an enduring historical document with a truly remarkable story."

Modern Charity Quilting

Charity quilting has taken on new energy and life in the Internet era because quilters—individually or in groups—can share information, organize charity drives, and move quickly to give quilts or raise funds when local or global tragedy strikes. They can offer meaningful,

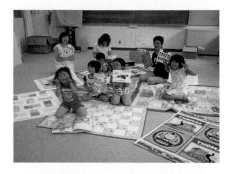

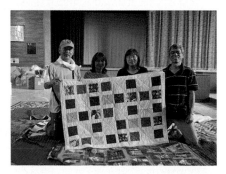

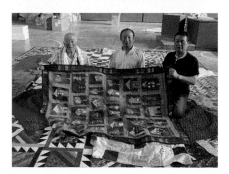

ongoing support through organizations that honor deserving recipients.

Craft Hope

Craft Hope was founded in the kitchen of mother and teacher Jade Laswell in 2009 with a simple call to followers of her blog for pillowcase dresses for orphans in Mexico. The group has grown exponentially in size with each project. The twenty-two (and counting) charity crafting projects—several centering on quilts—that Laswell has hosted to date have gathered over 100,000 handmade items to donate worldwide. Project 3 partnered with the Miracle Foundation to collect quilts and other handmade items for orphans in India—a total of over 2,300 items. For Project 5, Craft Hope partnered with the organization Margaret's Hope Chest to collect 436 handmade quilts for inner-city children in the Grand Rapids, Michigan, school system.

As Laswell explains on her blog, "The time and love it takes to make a quilt takes a lot of patience and passion. I truly believe that time is one of the greatest gifts you can give someone, and making a quilt is one of the greatest examples of this ... Each and every stitch is a labor of love. To know that someone will be consoled and loved because of this act of stitching is beautiful. Craft Hope aims to give a little bit of hope to people who have might otherwise [have] lost it."

Quilts for Japan

After a devastating earthquake and tsunami struck northeastern Japan in March 2011, a truly remarkable international partnership made it possible for quilters in Europe and North America to send their love and support—in the form of comfort quilts—directly to people living in shelters after their homes were lost. Naomi Ichikawa, editor of the Japanese magazine *Patchwork*

Quilt Tsushin, partnered with Colorado-based *Quilter's Newsletter* to put out a global call for quilts. Fabric importer Seven Islands then also generously offered to cover all shipping costs to Japan. While there were many opportunities to support the important relief efforts financially, the chance to also donate quilts handmade with love—but without the expenses and questions of international shipping and distribution—clearly resonated with many quilters around the world.

 Quilter's Newsletter gathered a remarkable 4,000 quilts for those in need over the course of the year, enough to fill several of their offices from floor to ceiling—as well as the nearly 5,000 quilts that *Patchwork Quilt Tsushin* received from other worldwide donors (Seven Islands alone sent nearly 700 quilts, and reported that 388 were given by quilters in North America and 295 from quilters in Europe). Ichikawa said, "We worked hard to pass all of the quilts on; they were really needed and loved."

Quilts of Valor

The Quilts of Valor (QoV) Foundation is a national organization whose mission is to "cover all combat service members and veterans touched by war with comforting and healing Quilts of Valor," to award handmade quilts to returning soldiers in a solemn ceremony of thanks. Nikki Johnston McDonald of Kansas says that her passion for supporting military service members and her love of quilting inspired her to begin working with the Blue Valley Quilters' Guild to make QoV quilts. McDonald now works with the expanded QoV Kansas City area organization to connect quilt top-makers with longarm quilters and award finished quilts to their recipients in the military. She says, "We typically just award a few at a time. If it's possible, I really prefer to have custom embroidered labels on each quilt with the recipient's name."

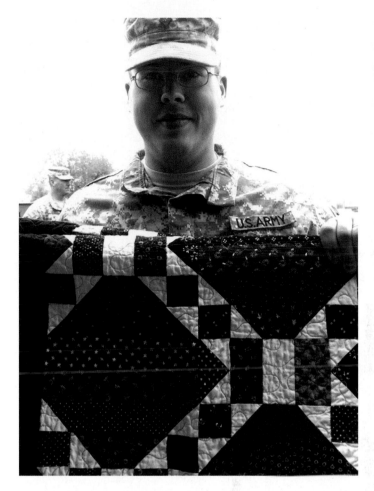

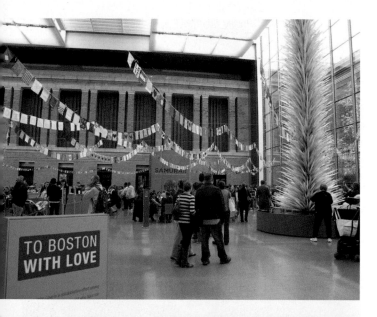

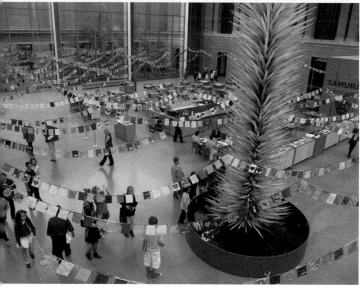

But McDonald says the most special day of her QoV work was in April 2012, when she and her friends awarded nearly 600 handmade quilts to soldiers at Fort Riley, Kansas. Five hundred and forty-eight quilts went to returning members of the 4-4 Cavalry Division, which had suffered heavy casualties in Afghanistan. Special quilts were also given to family members of the fallen soldiers from that division. She says, "It truly warmed my heart. I will never forget it."

To Boston with Love

After the senseless bombings at the Boston Marathon in April 2013, quilter Berene Campbell of Happy Sew Lucky (a sewing pattern and kit line in British Columbia) was inspired to do something very special from 3,000 miles away. "After watching the footage on the news on the night of the bombings," she writes, "I dreamed that I had made peace and love flags and hung them in a park in Boston. And in my dream, Bostonians felt uplifted and peaceful. When I woke in the morning, I just had it in my head that that was what I had to do." She reached out to Amy Friend, a renowned quilter and blogger who lives in Massachusetts, and *To Boston with Love*—a global outpouring of small, colorful patchwork flags representing peace and hope in the aftermath of tragedy—was born. Campbell writes:

Then I contacted the executive members of my guild, Vancouver Modern Quilt Guild (VMQG), and everyone was quite excited. I made up some sample flags, wrote a step-by-step tutorial for the VMQG blog, and created some free downloadable patterns for those who needed them. Amy Dame, from the VMQG, compiled a list of links to patterns and inspiration. We did everything we could to make it exciting and easy for people to participate

and shared it all through social media and blogs—it caught on pretty much immediately. We decided that Amy Friend needed a post office box to receive the flags, so she set that up. Good thing she did, because within a few weeks, she had packages with flags in them arriving from all over the world.

Amy Friend writes:

Meanwhile, I needed to find a location to hang the flags. I saw this as a critical part of the project. I wanted them to hang somewhere that represented Boston and all of its history, and I also wanted the general public to be able to see them without cost. I really felt like the Museum of Fine Arts in Boston (MFA) was the right location. I hesitated to contact them initially because the timing didn't feel right; the suspects were still on the loose, and the week closed with the city of Boston in lockdown. I waited till the following week to make contact with the MFA. Fortunately, they had been looking for a way to address the Boston Marathon bombings and suggested hanging the flags in their courtyard. This was the ideal location. The MFA also generously opened the museum to the public for free for a period of three days so that tens of thousands of visitors could see the exhibit without cost.

Campbell says:

It was all coming together perfectly. We knew then that this was going to be way bigger than we had ever imagined. The MFA kindly flew me to Boston to be there for the installation and opening. It was great to meet Amy after all our conversations over the preceding month. I will always be incredibly

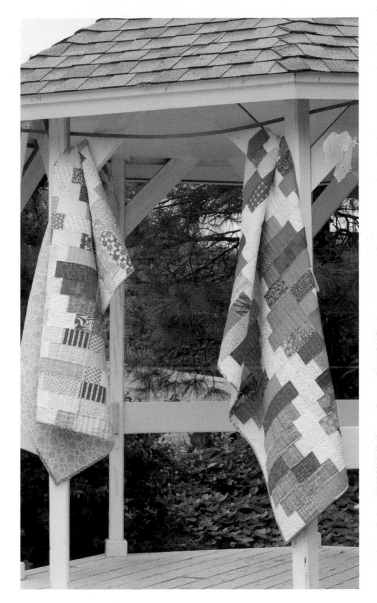

grateful to the MFA for taking us on and for letting us be a part of the installation.

Most of the flags were mailed at the last moment to arrive on the deadline—which was the day before the installation. So we had just a rough estimate of how many flags we would be working with. The museum designer had a plan laid out, but we had twice as many flags as he'd planned for, so we had to improvise. But being up on the lift in that exquisite space while hanging the flags was an incredible feeling. Just as we tied the flags together, it really felt like we were bringing people together. It was beautiful and uplifting—just like in my dream. I cherish that day.

I arrived early on the morning of the opening weekend. The museum wasn't open yet, and there was already a line-up of people standing in the rain. That line-up stretched around the block within a couple of hours. I was in the Shapiro Courtyard when the museum opened. The first visitors I saw walked in, came around the corner, looked up at all the flags, put their hands to their chests, and gasped. Then they quietly walked around, going from one flag to the next, visibly moved by the emotion stitched into each flag. And this reaction was repeated by those who followed. It was quite something to witness. That's when I knew that this was the right thing to have done.

Friend says:

It was an outpouring of love for the people of Boston from people all over the world—heartwarming and healing in its own right. It helped quilters by directing their energy to something good, and it helped those who saw the results of hundreds of hours of work done by good people who cared. We had collected 1,756 flags by the opening of the exhibit. Some were received after the deadline and will be included in the re-installation next year. We received flags from ten Canadian guilds, sixty-one guilds/groups from the US, five international guilds, and more than 294 individuals.

Campbell adds, "There are 565 images in the Flickr group, and 435 posts on Instagram tagged with #tobostonwithlove. More than 30,000 people attended the MFA over the Memorial Day weekend event." The *To Boston With Love* flags were re-installed at the museum for the first anniversary of the Boston Marathon bombing in spring 2014.

Moore Love

The Oklahoma City Modern Quilt Guild (OKCMQG) and their supporters were quick to act after terrible tornadoes struck Moore, Oklahoma, in 2013. OKCMQG president Jemellia Hilfiger says:

Our guild had an emergency meeting the day after the tornadoes and discussed making two quilts. We would sell virtual raffle tickets and draw two winners from those who had donated to one of two charities we had chosen. Volunteers from our guild each made a block or two, using our guild colors—blue, orange, and green. One quilter pieced the completed blocks, and two others quilted and bound them. I found a quilt pattern called "Tulsa Town" by Villa Rosa Designs, and the company owner let us use the pattern for free. We asked our members to donate completed quilts.

We announced this plan on our website the following morning, and emails immediately poured in.

To say we were overwhelmed is an understatement; we were so excited about the love and concern our fellow quilters expressed. We received more than 400 quilts to be given to those in need, and the raffle quilts raised over $1,300 for tornado relief efforts.

Charity Quilting Resources:

Quilting For Peace: Make the World a Better Place One Stitch at a Time by Katherine Bell (Stewart, Tabori, and Chang, 2009)

Why Quilts Matter: *whyquiltsmatter.org*
Craft Hope: *crafthope.com*
Quilts of Valor: *qovf.org*

SUSAN BEAL *is a craft writer and charity quilter in Portland, Oregon. She's the author of six books, including* Sewing For All Seasons *and* Modern Log Cabin Quilting, *and like Betsy Greer, wrote an essay for* Handmade Nation. *She's also a contributing editor at* Stitch *magazine, and her own craft blog is at westcoastcrafty.com.*

PHOTOS:

Page 18: This inscribed medallion quilt was made by members of the American Legion Auxiliary (Capitol Unit of Post #9, Salem, Oregon) to honor members and raise funds for civic projects, 2011. Photo: Bill Volckening

Page 20: Comfort quilts and their recipients in emergency shelters in Japan, 2011. Photo: Naomi Ichikawa

Page 21: A soldier with his *Quilt of Valor*, awarded in April 2012 at Fort Riley, Kansas. This quilt was made by the "Stilwell Bee Girls," Oneta Auer, Janie McDonald, Kaye White, and Donna Drew. Photo: Nikki Johnston McDonald

Page 22: *To Boston With Love*, Boston, Museum of Fine Arts, 2013. Photo: Berene Campbell

Page 22: *To Boston With Love*, Boston, Museum of Fine Arts, 2013. Photo: Berene Campbell

Page 23: Two collective *Tulsa Town* quilts made by the OKCMQG in 2013. Photo: Amanda Lipscomb and Mandy Suellentrop

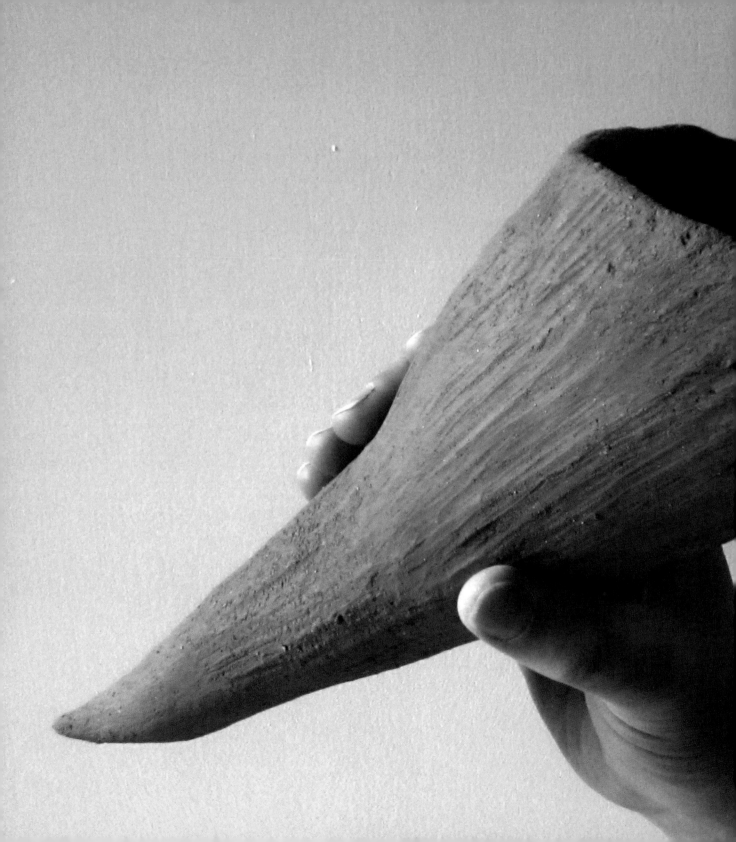

DAILY NARRATIVES AND ENDURING IMAGES: THE LOVE ENCASED BY CRAFT

Inga Hamilton

I inhabit the world where art and craft cross over. It's a place where art often seems to focus on the discordant and conceptual elements of the human condition, and craft seems to come from a place of humanity and love, even when used as an activist's tool. These are generalizations, but it's true that the sensibilities of art and craft often seem to meet uneasily.

All over the world, activists take a stand against moral injustice and social inadequacies. The very nature of fighting for justice can lead to aggression and tense situations, and artwork can bring powerful, positive messages to the community, but when craft gets involved, it seems to soften the blow so the message is both more heartfelt and quick-witted. For example, in 2013 in Detroit, Michigan, student Charles Molnar and friends were appalled by the lack of seating at bus stops throughout the city. They could have petitioned the transit authority, printed leaflets, and tried to bludgeon someone into providing benches, but, as makers, they built the benches themselves, put them out on the street, and provided welcome rest stops for tired commuters while humorously shaming the local authority for their lack of compassion.

It doesn't matter whether you're bringing the community together to cover a gas station in crochet to highlight the world's dependence on oil, create garden sculptures in a disillusioned neighborhood to convince large corporations to clean up a local lake, or leave cushions on buses in random acts of kindness to ease someone's day—the gentle, nurturing act of craft reaches people in a non-threatening manner. It's harder to "remove" a

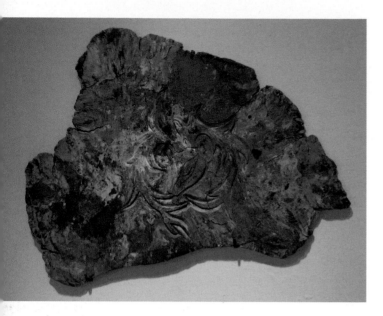

political statement that makes the viewer smile, such as a World War II tank covered in pink knitting, than it is to take down an anti-war poster. That tank is an enduring image that will reside in many people's consciousness for decades to come—until they are ready to challenge their own apathy. That's even more powerful than a street demonstration.

Sadly, craft generally doesn't command the price tag that accurately reflects the hours that have gone into honing the skills, choosing the materials, and shaping these pieces lovingly, yet we like to surround ourselves with crafted things; they carry their own narratives, which are rarely as closely analyzed as those of artworks. Traditionally, craft pieces weren't about clever concepts, but made to serve a purpose. Have consumer trends and vanity led us to reject these handmade objects, or is it that the production of many crafts has now been industrialized and thus devalued? We use decorative craft objects to adorn our environment, so why is "decorative craft" so often seen as a derogatory term? Why can't something instantly engaging and pleasurable have the same value as a high-concept art piece? I see this tension between craft and art because I use the craft pieces I make to build art installations. The individual pieces have no purpose except to capture your heart with the beauty that I hope they convey. These pieces are anything but functional, but I still need to craft them lovingly, with *craftsmanship*. And this is where the wonderful weirdness of craft lies—in the process.

I take raw fleece and mud and turn them into yarns, fabrics, clays, and sculptures. My large installations take at least three months to make. It is my own obsessive-compulsive madness. No one will know if I've used pieces of commercially dyed yarn or factory-processed clay—no one except me, that is. If I just wanted the "look" for my final installation, I could produce the

results a lot quicker by buying all my fibers ready-pro-
cessed, but it wouldn't have the same heart; it would feel
kit-made rather than bespoke. There is nothing wrong
with using commercially produced raw materials, but
it's not for me. And I know of other craftspeople who
are on their knees late at night, smashing earth into just
the right type of crumbliness, picking up tiny stitches
in a pattern till their eyes are sore, slicing and burning
their fingers on hot metal and glass with ever-patient
exactness in their alchemy. None of it makes sense in
a time-and-motion study. And no one would have been
able to spot where the knitter ripped back hours of work
to correct an incorrect stitch at the back of the sweater.
But the obsession for craftsmanship and respect for the
material is like an eternal itch in the back of our brains,
reminding us that it's "not quite right."

Maybe this isn't really a conundrum about craft
versus art, but about heart, about how making some-
thing with love creates a living entity that goes on to wrap
the viewer in the love encased within it. Is it possible
that the touch of the weaver leaves a trace of humanity
in the weft and warp, and this touch is what makes you
want to run your hands across it more than you would
over an industrially woven piece? Craft links us with our
ancestors and the processes that they developed over
the millennia: forging iron; baking with wild yeast; carv-
ing tusks into talismans—all so that we can move those
crafts and practices forward. They have made incalcu-
lable amounts of mistakes and discoveries so that we
don't have to. They have gifted us their knowledge freely.
So how do we do the same for the next generations? Do
we pass craft forward through the spiritual and loving
element, the one thing that we alone can provide—the
human element?

In 2009, my husband and I experienced William
Kentridge's work *Five Themes* at the Norton Museum

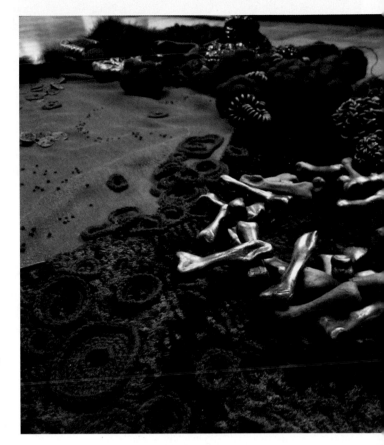

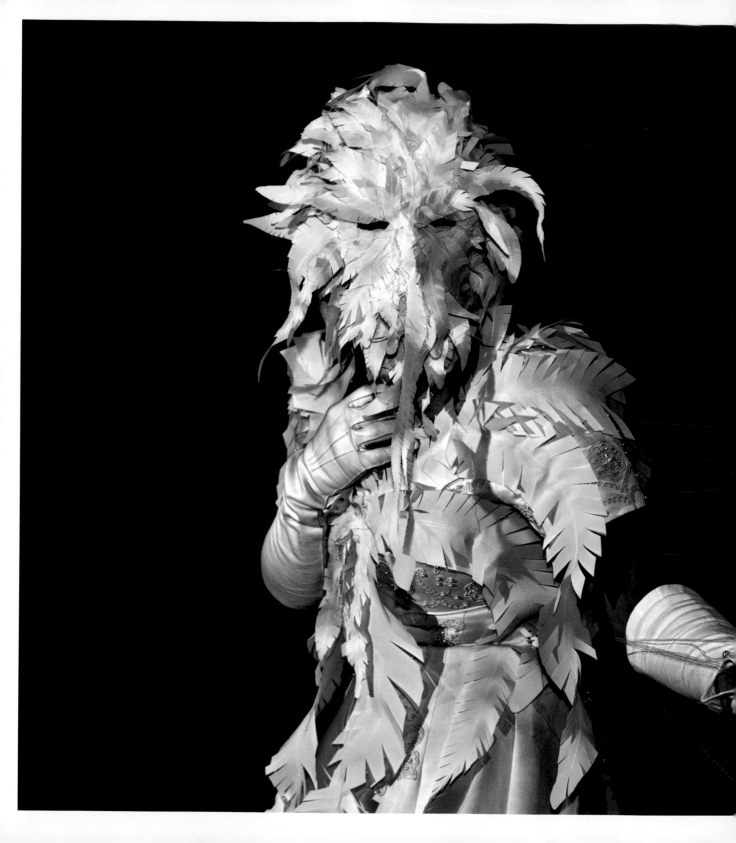

of Art in Florida. I was viscerally affected by the dark mood lighting, the black graphite and charcoal, and the discordant music. I had to leave the exhibition and sit in the gallery's garden to try and quell the sickness I felt. It wasn't revulsion at the content or a sense of being offended, but a discordant disharmony brought about by the deliberate tension within his work. A year later, we were invited to stage a show at the Richard F. Brush Art Gallery at St. Lawrence University in Canton, New York. We reasoned that if an artist focusing on the negative can affect the viewer as adversely as Kentridge's work had affected me, then he or she could also affect viewers positively. So we conceived a social experiment in the world of art and craft called *ELEMENTALS Birds.*

We devised a meditative discipline for creators to practice before they began to work. We then asked about 100 creators whom we knew and trusted to follow it. Each and every time they worked on one of the bird templates that we had provided, they were asked to focus on positive and loving thoughts coming from their hearts, down their arms, and into the piece that they were creating. They were instructed to focus this unconditional peace and goodwill out of the piece and toward the viewer. Could the birds that were created physically embody feelings of peace and goodwill and tangibly affect the showing environment?

A strange thing happened as replies to our invitations came in. Of the 100 invitees, a handful were unable to partake due to other commitments. A second wave of responses came as a great surprise to us: single, male artists began to contact us and say that they could not take part—not because they didn't want to, but because they couldn't wish peace and harmony to complete strangers; they didn't know how. A third wave of responses came in, mainly from graphic artists and painters, who asked for the templates. The fourth wave,

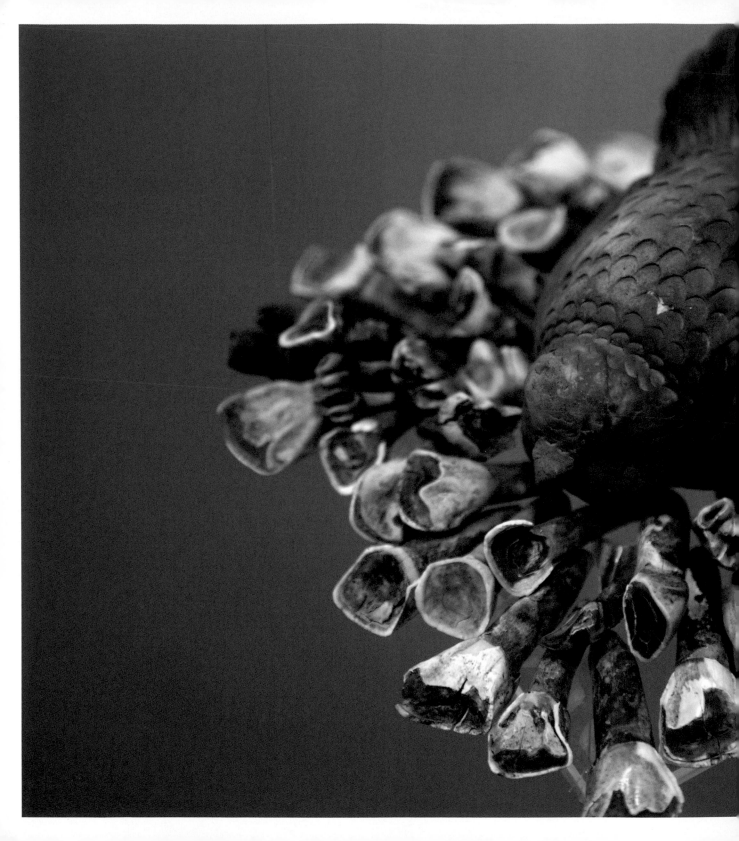

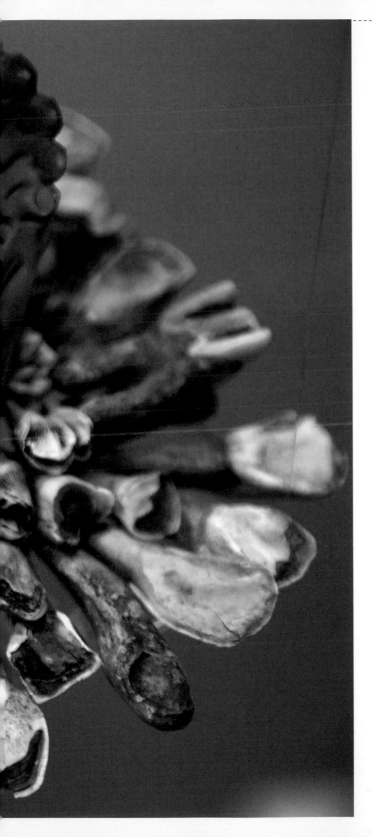

almost all past the deadline, came from the craftspeople. Their responses were late, many of them explained, because they had been consumed by the project itself. Few of the craftspeople wanted to use the templates, but went off-piste, sculpting, carving, assembling, and building the most wonderful birds—birds that played music, birds that raised money to buy sleeping bags for the homeless, birds that focused awareness on mental health issues, birds that challenged the value of money. These craftspeople began to place alternative currency parameters on the value of their birds. One charged "Ten random acts of kindness to a stranger"; others stated that the new owners had to "Begin their own project to help people in need in their own town"; another stipulated the birds had to be taken by "the person who falls in love with it most."

But we knew nothing about any of the creations until we arrived at the gallery to install them. We were placing our trust in the participants because we truly believed in our concept. When we arrived at the gallery, the exhibition showing before *ELEMENTALS Birds* was yet to be de-installed. Powerful, life-size photographs of the aftermath of Ground Zero on 9/11 filled the walls, chilling me to the very core with scenes of devastation, pricking my eyes with disbelieving tears. Amid these paintings, on a table in the middle of the gallery, we unpacked the birds. One by one, they made us gasp, and little by little, the 9/11 images shrank in size. People passing the gallery looked in and were immediately captured by this table of love and peace. Hairs stood up on necks. Promises and commitments were made. Birds found new guardians before they were even installed. And the small ripple of the exhibition began to grow. Professors on their way to classes changed their route to take in the gallery every day. Meditations were held amidst the installations. Students composed pieces of music and short films in

response to the installation. A blog was set up for the local community to find out more about the little ceramic birds that had been left on their porches and walkways, gifted to them by student-makers in loving gestures. New human connections began to form.

To date, the exhibition is the most successful show that the university has ever staged. People still reference it, and the show continues to grow. It moved to Northern Ireland in 2012 and then to Washington, DC in 2014. With each showing, it accumulates more participants and spurs more people to connect unconditionally with their community members. I don't care whether it's art or craft. I just care that we share heart.

~~~~~~~~~~

**INGA HAMILTON** *is driven by a life-long craft obsession. She travels the globe, gathering skills and applying them to unusual materials. While her large installations show in galleries, her transient, natural forms are left in woodlands for the elements to reclaim or passersby to take.*

*Inga has exhibited in the Chicago Cultural Center, the Hayward Gallery in London, UK, the American Irish Historical Society in New York, and The Ark in Dublin. Her US residencies include Pyramid Atlantic, Red Dirt, and Flux studios. Along with her husband Andy, Inga is the co-creator of ELEMENTALS Birds, a social and artistic experiment to see if creators can embody in an object feelings of unconditional peace and goodwill toward strangers and tangibly affect the showing environment. It's the easiest thing in the world to create art that shocks, but Inga tries to touch your heart. She wants you to become lost in her work's intricacy, seized with a childlike desire to be enveloped.*

~~~~~~~~~~

PHOTOS:

Page 26: Inga Hamilton, *Ancient Drinking Horn*, 2012, collection of the Library of Congress, Washington, DC. "These drinking horns must be soaked in ice-cold water so that they 'sing' before they can be supped." Photo: Inga Hamilton

Page 28: Inga Hamilton, *Herald the Feast/Beast*, 2012, hand-processed clay. Private collection of Sarah Nikitopoulos. "Hard-carved hart depicting the Englishness that beats in my chest, no matter where I roam." Photo: Inga Hamilton

Page 29: Inga Hamilton, *Shadows Grow* (detail), 2011, *Dubh: Dialogues in Black,* American Irish Historical Society, New York and Dublin. "Commissioned for *Dubh*, a conversation between contemporary Irish and American craftspeople." Photo: Inga Hamilton

Page 30: Inga Hamilton, *Expansion of My Soul*, 2011, performance piece, Turnpike Gallery, UK. "Costume and performance by the artist." Photo: Inga Hamilton

Page 32: Inga Hamilton, *Elemental Birds* (detail), 2011, Richard F. Brush Art Gallery at St. Lawrence University in Canton, New York. "Hand-sculpted ceramic bird, amid deer teeth nest in hanging nest city of forty birds." Photo: Inga Hamilton

Opposite: Inga Hamilton, *Monkey Spawn*, 2011, F. E. McWilliam Gallery Studio in Northern Ireland. "Hand-spun, woven, crocheted, and printed textile installation exploring evolutionary tweaks." Photo: Inga Hamilton

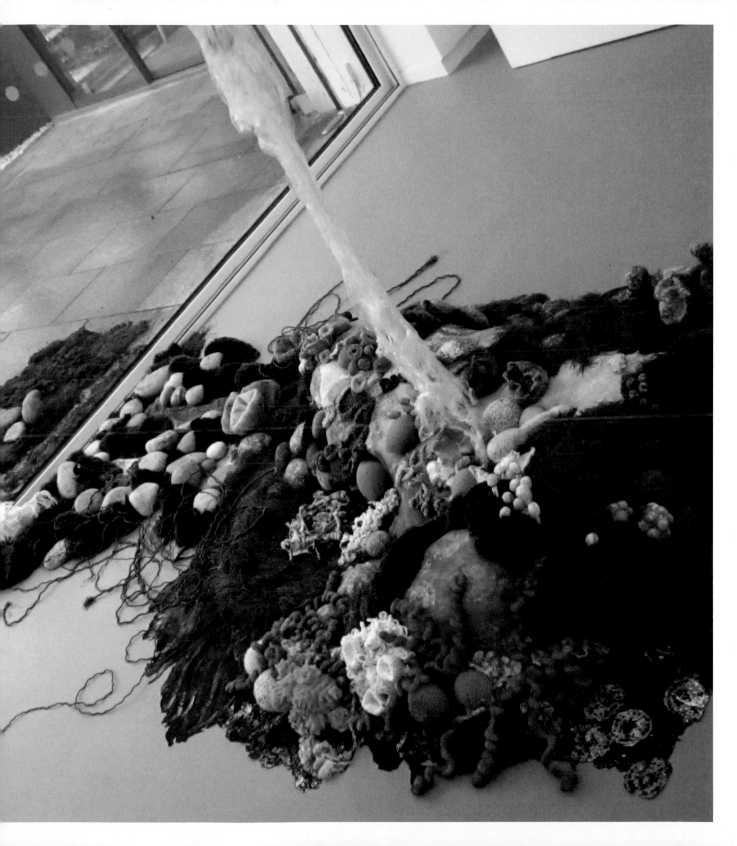

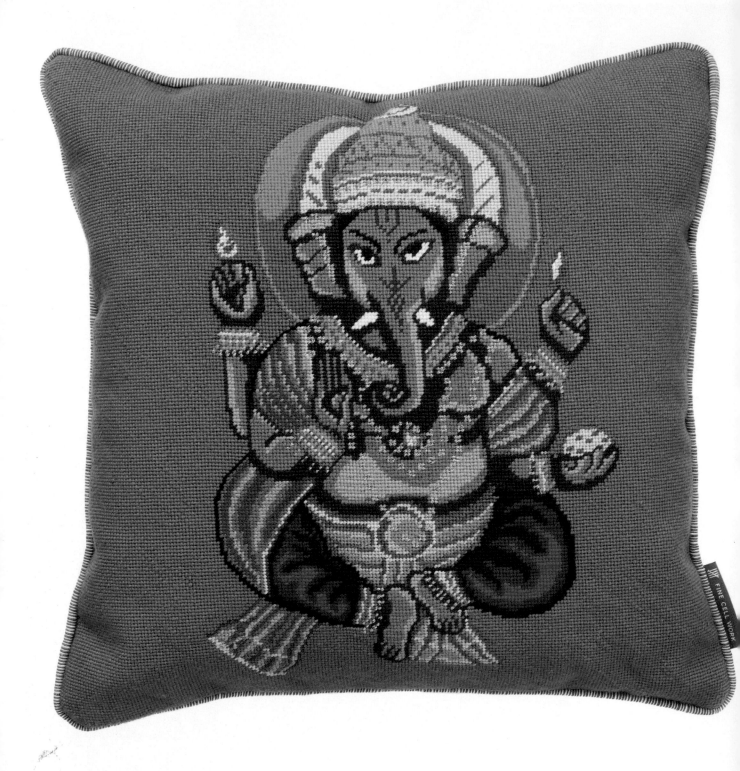

DON'T GET ANGRY, GET CROSS-STITCH!

Jamie Chalmers

Cross-stitch is one of the humblest forms of embroidery, yet within that simplicity lies a huge amount of power.

For as long as anyone can remember, cross-stitch has been part of our cultural heritage. Cross-stitched samplers from the eighteenth century were used to teach children basic handicrafts in school. These samplers often also carried with them religious and social messages, and we look back fondly on them when we find them, as they are windows into an era long since passed.

Thanks to the simplicity of its form, whether you are eight or eighty years old, cross-stitch is easily achievable, with a short, not very steep, learning curve that swiftly leads into the gentle process of stitching the tiny Xs. Many people believe that they lack the patience or skill to undertake cross-stitch, but when they try it, they adapt it into their own rhythm with surprising ease. Before long, they are lost within the creative space, stitching forward and backward across the fabric, creating pixilated images and artworks that are part of our cultural fabric.

The very act of cross-stitching promotes a meditative state. The process of guiding the needle and thread through the holes in the fabric in a repetitive motion forces slowness of approach and a natural rhythm that cannot be made much quicker. While there are many crafts that can be done at any pace, depending on the production process, there is such regularity and constraint within the traditional cross-stitched format that the rhythm becomes everything. Like the rhythm of breathing or waves upon the sea shore, the stroke of the needle inward and outward, up and down, can lead to a relaxed state of being.

"We all do find a feeling of calmness and we all do come together to help and support each other, just like a family, and these two things are so rare to feel and find in prison."[1]

Since 1997, the charity Fine Cell Work has worked with 300 prisoners across the UK to improve their experiences through the power of embroidery and needlecraft. Working with volunteers, prisoners are taught the skills of embroidery and provided with materials so they can stitch in their own cells. The testimonials featured on the Fine Cell Work website, like the one above, indicate the power of embroidery as a healing tool. These moving accounts describe how embroidery provides an escape from the darkness of the prisoners' lives; it is a creative pastime that gives them a sense of purpose and brings them a sense of joy that may have long since escaped them. One prisoner, for example, has written: "Lock-up was always hard for me as I was finding it difficult to cope with my brother's death, but having something to keep me busy helped deal with my own issues. Now, five years on, I have not self-harmed in three years. I have remained on the unit to do my courses, and went from a violent, disturbed prisoner to a respectable rule-abiding prisoner; ninety percent of that change has come from the great work and support the Fine Cell workers have given to me."[2]

Cross-stitch, as with all embroidery, is also bound into

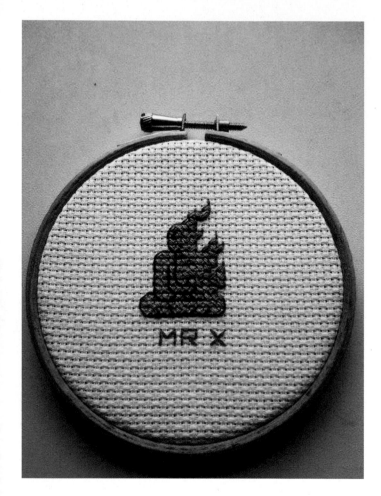

a socio-political debate about gender, as it is traditionally considered a pastime for women, particularly from older generations. This gender bias adds to the success of cross-stitch as a political medium; one cannot help but feel kindness toward cross-stitched pieces, as though they had been created by a senior matriarch. Therefore, when the cross-stitch contains a message of anger, activism, or social commentary, the impact is much greater than expected.

The Craftivist Collective (see also p. 203) uses cross-stitch as a simple tool in their battle for changing hearts and minds. The contrast between the gentle art of cross-stitch and the powerful act of political activism acts to amplify the message contained within the work created. The *#imapiece* craftivist jigsaw project, for example, inspired hundreds of people to create hand-embroidered jigsaw pieces containing messages of hope and inspiration. Their very nature as hand-made textiles made it hard to ignore the level of time and energy that went into their creation. As an ensemble installation, the jigsaw created an overwhelming sense of power and emotion for anyone who saw it.

"I've never really been politically active before," said Andrea, one of the crafters at the Milton Keynes, UK, *#imapiece* workshop, "but with this project, I'm able to make a statement and show how I feel about poverty."[3] Hers is one of many such statements that form a part of the ongoing narrative of the *#imapiece* campaign. Traditional forms of political activism can be overwhelming, and for many people they're simply not feasible. The gentility and familiarity of cross-stitch transforms political power into something more manageable. Sarah Corbett, founder of the Craftivist Collective, encourages crafters to reflect on the message they create, allowing the slowness and meditative processes of stitching to draw them into deeper contemplation of the content.

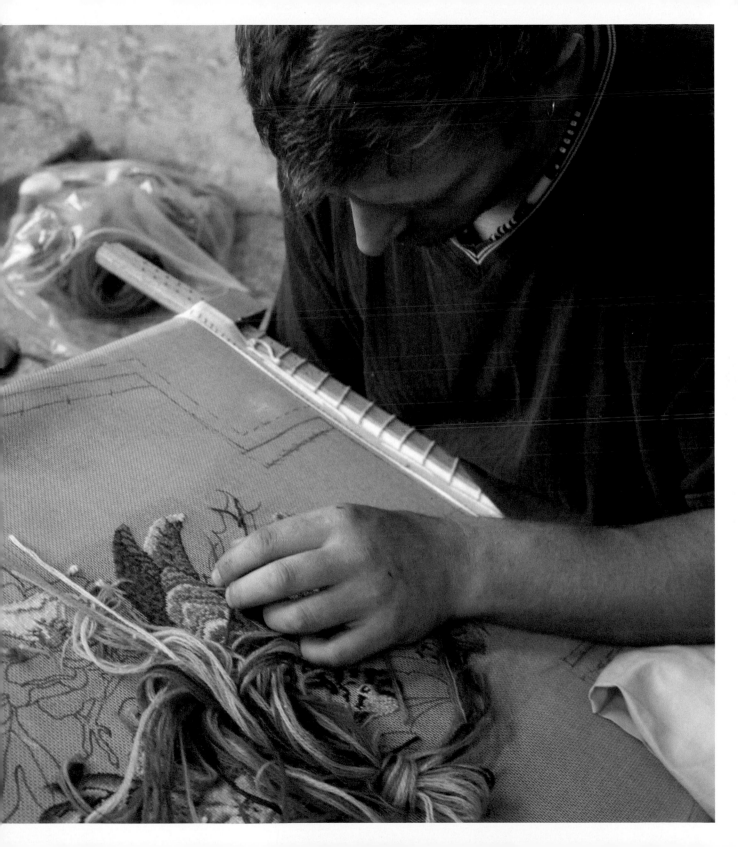

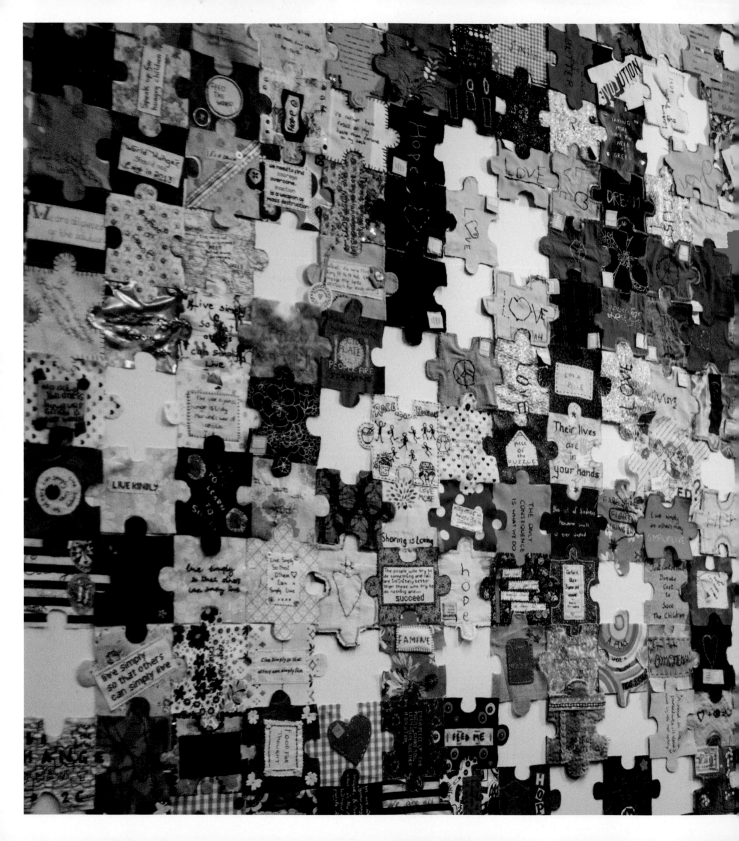

Thanks to the simplicity of creating cross-stitch, anyone can produce profound messages and make statements that really matter. Messages that take a long time to produce are a much-needed antidote to a world of instant gratification and political spin. The familiarity of the production process instills a sense of gravitas in cross-stitched work, as people recognize that the pieces were not created quickly. Images that might be hard to digest in printed or digital form become less overwhelming when translated to stitch.

The work of Noelle Mason (see p. 42), a mixed-media artist from Chicago, exemplifies the power of cross-stitch to amplify the impact of difficult subject matter. *Nothing Much Happened Today (for Eric and Dylan)* recreates CCTV footage from the 1999 Columbine Massacre. This piece delivers a double blow: the impact from the content of the image is followed by the impact when the viewer realizes that it took Mason five years to stitch this one piece.

Blogger and craftivist Rayna Fahey (see p. 115) writes: "Noelle offers no explanation on her site as to why she did this piece ... But it is quite obviously a respectful acknowledgement of what was clearly a very difficult time for all directly involved, as well as the wider community."[4] In many ways, the act of making this piece is enough — a further explanation from the creator would limit the responses, and by saying nothing, Noelle allows her work to speak volumes.

Noelle Mason's work is easily one of the most provocative cross-stitched works in recent years, but there are an increasing number of people using this medium to express themselves, make their views known, and challenge the status quo with a needle and thread. Each craftivist who shares their work inspires another, and as the momentum builds, it becomes clear that cross-stitch really does give power to the people to articulate their views in a way that makes it hard to resist.

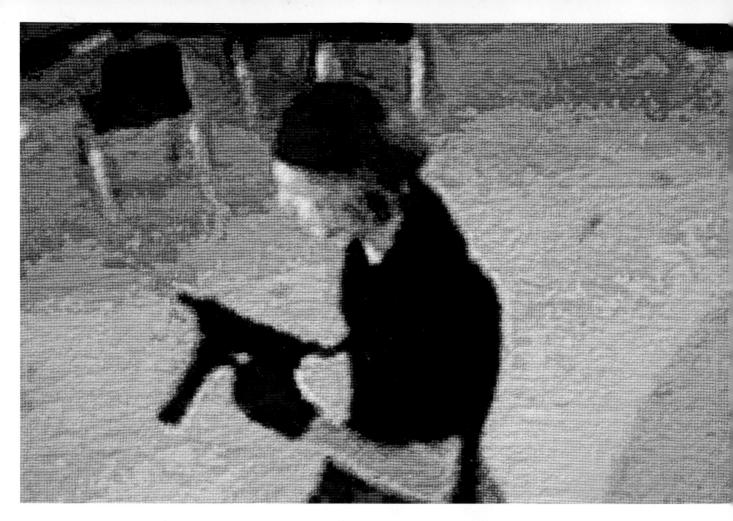

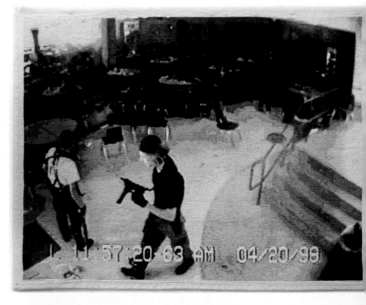

CRAFTIVISM: THE ART OF CRAFT AND ACTIVISM

Cross-stitch might be one of the most powerful of all the handicrafts. The gentle act of stitching combined with subjective reflection for both creator and consumer puts this humble craft in a league of its own, making it an ideal tool for exploring and digesting the modern experience. It does not easily sit within the world of high art, where the disconnect between audience and production perpetuates prestige; cross-stitch is inherently populist and can be made and enjoyed by all. This is the root of its greatness.

Notes:

1. Prisoner testimonial from *finecellwork.co.uk/prison_stories/ testimonials/160_kevins_story*

2. Prisoner testimonial from *finecellwork.co.uk/prison_stories/ testimonials/160_kevins_story*

3. Anecdotal quote from a member at the *#imapiece* workshop I ran in Milton Keynes in December 2012

4. *radicalcrossstitch.com/2009/06/02/x-stitch-awe/*

JAMIE "MR. X STITCH" CHALMERS *has been dubbed the Kingpin of Contemporary Embroidery. Since 2008, his website,* mrxstitch.com, *has showcased contemporary embroidery and needlecraft from around the world, taking the subject seriously, but not too seriously. Jamie is an internationally exhibited artist, specializing in cross-stitch, and a designer whose work has been featured in several magazines. He has written articles for* Surface Design Journal *and* FiberArts Magazine, *among others. In 2011, Jamie curated* PUSH: Stitchery, *a gallery book of thirty contemporary textile artists that has received universal acclaim. With TV and radio appearances under his belt, it's safe to say that Mr. X Stitch is one of the world's most recognized male embroiderers. He's nicer than he looks, which is fortunate.*

PHOTOS:

Page 36: Finished Ganesh needlepoint. Photo: Fine Cell Work

Page 38: Jamie Chalmers, *Immolation*, 2013, embroidery floss, Aida cloth. Photo: Jamie Chalmers

Page 39: Prisoner embroidering. Photo: Fine Cell Work

Page 40: The *#imapiece* installation at The People's History Museum in Manchester, UK, 2013. Photo: Will Steer

Page 42: Noelle Mason, detail of *Nothing Much Happened Today (for Eric and Dylan)*, 2009, counted cross-stitch, 32 x 40 in (81.28 x 101.6 cm). Photo: Noelle Mason

Better, Drawn

Simon Moreton

I've been making comics for about five years, but I've been drawing since I was little. Like many children, I learned to draw and to narrate my creations at the same time: "This is mum, this is us going into the car, that's us going on holiday." That's what a comic is to me—a way of communicating with someone through drawing.

I think everyone can draw: even with just stick people or doodles, a good story will always shine through. It's important to me to encourage people to draw as a way of tackling things they think they can't. I started *Better, Drawn*, a blog for people to share stories about long-term mental and physical illnesses, told in the form of comics. It's a way for people to write and draw about experiences that might be difficult to talk about, whether they consider themselves "artists" or not.

Sharing your stories builds community, too. With access to the Internet, or a photocopier and stapler, you can reach out to a new audience. With this in mind, I co-founded the Bear Pit collective, an ever-expanding community of makers in Bristol, UK. We put out a regular zine of stories by all kinds of people, some of whom who have never drawn a comic before. We hold events to get people drawing and run fairs so people can sell their work.

Drawing and self-publishing lets you be creative, take ownership of your own voice, and share your stories with others. That's powerful.

PHOTOS:
Simon Moreton drawing, 2010. Photo: Becky Unitt

UGLY ON PURPOSE: DEMYSTIFYING THE ENEMY

Kim Werker

When I was ten years old, I spent the summer at an overnight camp in upstate New York. There was a sign mounted on the lifeguard's chair at the camp's pool that read, "Welcome to the ool. Notice there's no P in it. Let's keep it that way."

In the first week of camp, every camper took a swim test. If you were able to swim eight short laps and tread water for ninety seconds, you would be allowed to swim in the deep end of the pool during free swim, and you could go in a boat on the lake without a counselor accompanying you. In other words, the swim test was your ticket to independence. The previous summer, when I was nine, I'd failed the swim test; I was not a strong swimmer. I couldn't do it, and anyway, it didn't matter because who needed boating? Boating was dumb.

The summer I was ten, I again failed the test. I stopped around lap number seven, breathless and exhausted. I sulked away into the shallow end, staring at my feet through the water. I made my way toward the steps of the pool while the other kids were already lining up at the gate to go shower and change. My counselor, Alissa, stood up from her lifeguard's chair and took off the sweats she wore over her swimsuit. She had brown curly hair and an infectious laugh and was both practical and fun. In the few short days I'd known her, I had grown to adore her. She got into the pool at the lap end and called to me. I waded back over to her, and I wish I could remember what she said to me. I think she simply told me we were going to swim some laps together.

As the voices of the other kids faded into the distance, Alissa sang songs while we did the elementary backstroke side by side. Every couple of laps, she'd call out a different simple stroke, and she'd tell me stories or sing more songs. I'm pretty sure we dog-paddled for at least a month. I didn't notice that we'd swum eight laps until she told me it was time to tread water. She held my gaze for the longest ninety seconds of my young life, singing and telling more jokes. In the end, I was exhausted and freezing. She didn't say another word about it, and I never failed another swim test. Turns out boating is fun, and so is independence.

Would I have so earnestly become a camp counselor a few years later if Alissa hadn't given me this experience? There's no way to know. But I do know that my approach to being a camp counselor was shaped more by half an hour in a pool with no "P" in it than it was by any other single experience. I know that I approached working with kids from a place of intimately understanding the effect I could have on another person's life, and it wasn't just the camp experience; it's affected how I see my place in the world as a human being. The words I say, the actions I take, can be used for good. Small acts can have a profound impact. I'm the only one who can tell me I can't do something, and I can achieve all manner of surprising and impressive feats if I can quiet that defeating voice.

I run a project called Mighty Ugly, and it has deep roots that go all the way back to that summer when I was ten years old. After I'd spent many years working in the crafts industry, encouraging people to take the risk of learning new skills, I often felt surprised and baffled

by people's resistance to trying new things. But one evening, I found myself at a crafts party, feeling intimidated by, of all things, sewing a doll. Despite all my efforts to convince people it's worth it to risk failure to learn something new, I was utterly terrified by the fabric I held in my hands and my vision of a doll that I was certain I couldn't achieve in reality.

Eventually, I decided to alleviate my fear of getting it wrong by intentionally making the doll ugly. My experience of this was so profound—a liberation from my own concern about being judged, from the pressure I put on myself to make things perfect—that I eventually made Mighty Ugly my main project.

Now I work with people to make ugly crafts on purpose in a continuing effort to challenge our definitions, perceptions, and expectations of failure. In the context of making ugly creatures, we discuss our experience of making things and explore how that experience is

similar to ways we feel in the workplace, at home, and in the world around us. We listen to the ugly voice inside our minds that tells us we can't do it, that it's not worth trying, that nobody will care anyway—the voice of perfectionism, self-doubt, creative block, fear of failure, procrastination. And then we tell that voice to quiet down.

Try this: Sit down with a bunch of scrap materials and stuff from your recycling bin and make an ugly creature. Not one that's cute-ugly. One that's ugly-ugly. It's not like anything else you've ever done, am I right? For some people, it's exceptionally difficult; for others, it's immediately liberating and fun. I've never met someone who wasn't glad they did it.

Although usually done in groups, making something intentionally ugly is a profoundly individual activity. It's amazing how together we feel when we let our guard down and talk about the struggles we have—because everyone has creative struggles, and these kinds of

struggles aren't very dissimilar to the struggles we feel when we consider speaking up about change in any area of life, whether for ourselves or on behalf of others.

We all have an inclination, at some point or another, not to take risks. In crafts, we convince ourselves not to make something because we're certain we don't know how or that we'll do it wrong, that it will be ugly or no one will like it. In activism, we convince ourselves that our voice isn't loud enough, our words aren't important, no one will listen, people will judge. In both instances, we do ourselves and others a disservice when we convince ourselves not to create and not to speak up. By holding back, we deny ourselves the opportunity to express something personal, absurd, funny, or moving. We deny others the opportunity to understand us better, to laugh, to be moved, to be inspired.

Sure, sometimes we make awful things and say dumb things. Sometimes we make and say great things, but no one notices. Sometimes people respond negatively, even meanly. But if we decide to give up, then we take away our chance to make or do or say something that will resonate. And as with my experience in the camp pool, even the smallest gestures can end up being profound.

In thirty minutes, when I was ten, a woman named Alissa changed my life. She took a doubtful, awkward, defeated child and made her realize she was strong and capable. More than anything, she showed me that I can be my own most powerful enemy, and she gave me the gift of proof that I can be strong anyway.

When Betsy Greer asked me to write an essay for this book about crafts and activism, my immediate reaction was that I don't know anything about crafts and activism except as an admiring observer of the intersection of the two. But I *do* know about crafts and activism, because my work is about helping crafters, artists, and ordinary civilians identify their own internal enemy, have a long chat with it, and be strong and creative anyway.

Whether expressed in craft or words, in art or on picket signs, our voice is the most powerful tool we have to effect change in ourselves and others. Quieting the ugly voice in our minds that tells us not to bother making or speaking up can be uncomfortable, but that's no reason not to do it. And sharing our voice with others can be downright terrifying, but that's no reason not to speak up. If there's even a small chance our creations or conversations will make someone smile or raise someone's consciousness or inspire reflection, that's reason enough to create or converse. Even if it's ugly. Even if it's imperfect. There's always the next version to make, the next conversation to have. It's in this manner that we change the world.

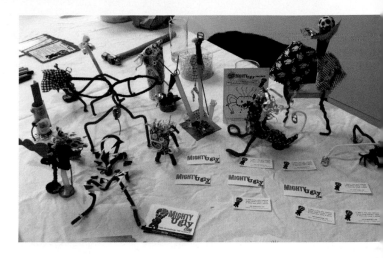

~~~~~~~~~~~~~~~~

**KIM WERKER** *is a writer, editor, speaker, and crafter. Through Mighty Ugly, she helps people and groups slay their creative demons. Her book,* Mighty Ugly, *is due out in 2014. Kim lives in Vancouver, BC, with a grown-up, a kid, and a mutt. See more of her work at* kimwerker.com.

~~~~~~~~~~~~~~~~

PHOTOS:

Page 46: *Ugly Name Badge*, at the Summit of Awesome in Portland, Oregon, 2010. Photo: Kim Werker

Page 48: *Joyce's Ugly Creature*, 2010. Photo: Kim Werker

Page 49: *Kelly's Creature*, at the Summit of Awesome in Portland, Oregon, 2010. Photo: Kim Werker

Page 50 (top): Make Something Ugly on Purpose at the One of a Kind Show, Vancouver, 2011. Photo: Kim Werker

Page 50 (bottom): *Mighty Ugly Creature*, 2010. Photo: Kim Werker

Above: Mighty Ugly at the *CreativeMix Exhibition*, Vancouver, 2010. Photo: Kim Werker

CRAFT: EMBRACING EMPOWERMENT AND EQUALITY

Faythe Levine

"There are no rules. That is how art is born, how breakthroughs happen. Go against the rules or ignore the rules. That is what invention is about." —Helen Frankenthaler[1]

"If nothing changes, it changes nothing." —Lisa Anne Auerbach[2]

When I was fourteen years old, I went to my first all-ages punk show. It was at a local teen center called the Redmond Firehouse in the suburbs of Seattle, Washington. The bands played on the floor to an audience crowded around them at eye level. Shows at the Firehouse, in basements, garages, living rooms, and any other available space, shaped what became my first creative community. This autonomous scene was based around music and embraced zine culture, direct action, and radical art-making practice. It was my introduction and gateway to a DIY lifestyle.

When I first saw zines—I'm not sure how else to describe it—they spoke to me. I just loved something about the format and the fact that, as someone told me, there were no rules. Zines were my first love. More than twenty years later, the zine ethos still influences how I engage and interact with the world.

I didn't know it at the time, but my social practice drastically shifted when I was given permission to not follow the rules; I was able to look at other people as equals. I look back now and realize that, as a teenager, it was very difficult to come to terms with the idea of my own self-worth and value. I didn't see that someone

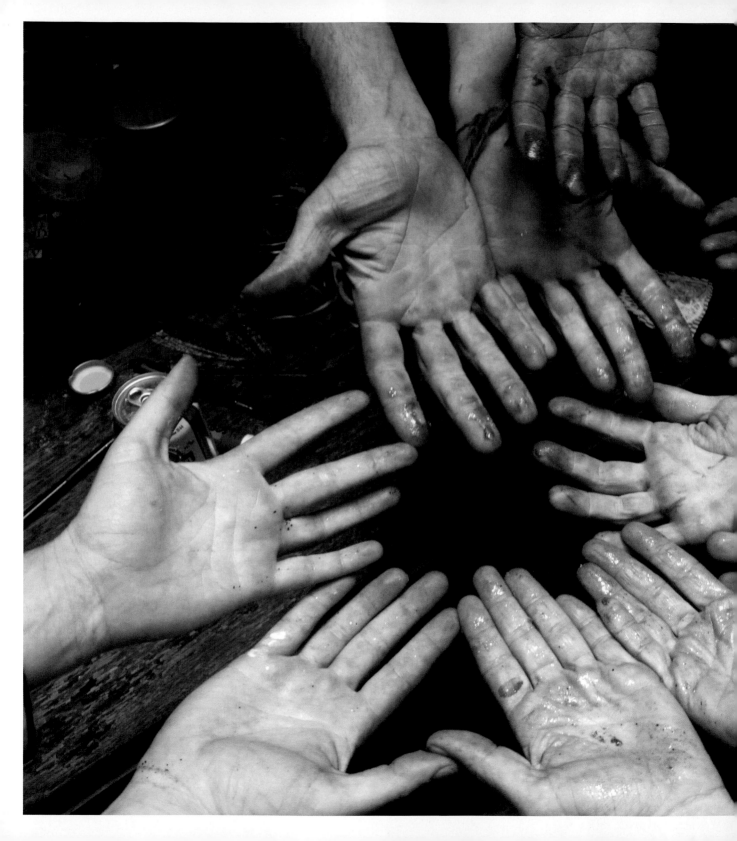

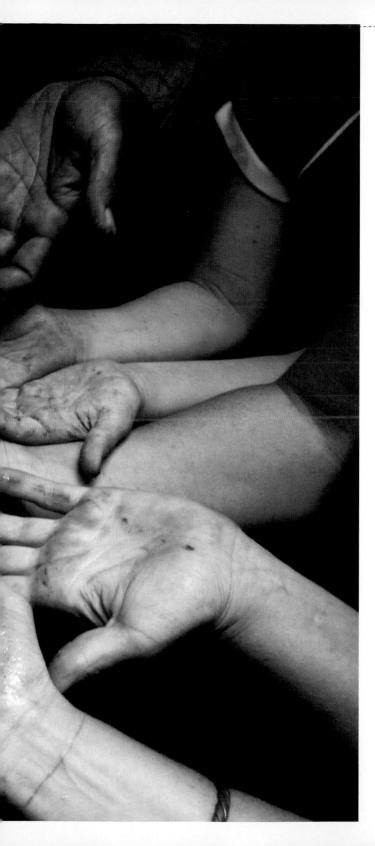

who was performing on stage or whom I admired was the "same as me." This was especially true with other women, because we are taught from a young age to compete and compare ourselves with others.

Those first formative few years of soaking in everything at all-ages punk shows shaped my creative art practice. Punk taught me many important life lessons and opened my eyes and ears to conversations surrounding gender, race, and radical queer politics. The power of communication and community began to take form and became important to me. I hadn't been familiar with feminist theory; punk also opened that door for me. I was excited to see women engaging in a community not only as equals, but also speaking out about their gender roles, as in the Riot Grrrl movement. As I began to educate myself about feminism, anarchy, and peoples' history, I started to look at and question my own upper-middle-class, white privilege and sexuality. Basically, my world was turned upside down, and even though I was raised in a very liberal, open-minded home, I wanted to question everything that was around me.

Despite my progressive upbringing and loving, supportive parents, the hierarchal power system that I learned in public school and through mass media had taken their toll. I had been brainwashed to not question those sources, but punk told me to question everything. I did, and everything began to shift. This started simply from being at eye-level in a room full of people who viewed each other as equals. Once you stop putting people on pedestals and realize that we are all just human, things suddenly become a lot more digestible. Craft, for me, is a digestible creative outlet. Through the sense of creative empowerment craft gave me, I saw a future and hope for change.

My personal relationship with craft is a direct lifeline

to my connection with the punk community. Although I had learned basic cooking and sewing skills from my mom, the punk community showed me alternative ways to do things. I also took advantage of the amazing art department at my high school. It was a phenomenal resource, with its own ceramics building, darkrooms, and art classes. I learned to silkscreen and began to see the value of wearing clothing that was unique; conversations were generated by wearing something whose story I alone knew. I can remember how important it felt to wear a shirt from a thrift store to school with a feminist slogan stenciled on in it in spray paint. Being able to use my clothing as a way to engage and challenge people about fashion ideals, politics, and sexism was incredibly exciting.

As I grew older, I realized that my role was not only as an artist and maker; it was also, and perhaps more importantly, as an organizer and historian/collector. I began to talk about why craft was important to me in public spaces, online, and in my local community. Seeing craft as an approachable platform, I realized that I had found the perfect way to connect with people. It was like those punk shows where I watched the bands eye-to-eye; craft can be put on a pedestal, but its reputation keeps it with the people and keeps it real. You can bring up the word "craft" with anyone and make a personal connection. Most people have a relationship with the word, even if they don't (at first) realize it. For example, they may have an afghan that their mom made or homemade Halloween costumes or holiday decorations. I took advantage of this and embraced craft as my voice, my way to reach out and form relationships. Reaching out to those around us builds community; making ourselves approachable and open to new things allows friendships to develop.

I ignored past definitions and scooped up what was

going on around me, inspired by the community I saw growing and had a hand in shaping. I was finding my voice and who I wanted to be. Once I realized it was up to me to create my own destiny, amazing things started to unfold around me. Craft allows us to build bridges, and the practice of working together through creativity is a powerful thing. By making my own work while simultaneously providing a creative platform for others, I could connect all the things I was becoming interested in. You can't expect support unless you give it, unless you find the magic balance between give and take where you can feed off the energy of others and let it fuel your own work so that you can have a positive impact on the world and hopefully inspire someone else. While creating these circles of inspiration, it's also important to think about a wider influence, outside your own familiar circle. For instance, if you decide to create a street-art campaign with a message of awareness, ideally you want to make a larger audience aware of their surroundings, drawing attention to the area where you placed the artwork. Hopefully, the imagery and message translates and makes people think about the larger picture so they can take action in their own way.

You can have a conversation with almost anyone about the process of making or about something that was handmade. By striking up a friendly conversation with someone about their jewelry or clothing, you may be surprised by what you learn or where the conversation takes you. I've heard stories about amazing people whom I would never have known just by telling someone I love their earrings. Craft has the power to take down the walls we've spent our lives building between each another.

Through punk I was shown that I could begin to make an alternate history to the one I was presented with in school and society. I saw examples of people making

real changes in their communities through direct action and education. This mindset stayed with me through my adult life and enabled me to take risks and start projects that I wasn't sure I could manage—like producing a large-scale craft fair and making documentary films. But punk told me that I could do anything if I tried and that leading by example was the way to go. I could take these empowering lessons into my daily practice. I didn't have to follow the rules that were being presented to me. Punk was a permission-giver and, in turn, craft became my vessel. Punk allowed me to connect with others and formulate how I wanted my future to look through creating approachable artwork, blogging, making my work understandable through personal stories, starting my own gallery, becoming an independent researcher, and making documentary films.

I want people to realize that they have the power to make their lives what they want them to be through simple personal choices. In 2008, I was interviewed by Sabrina Gschwandtner for an article in *American Craft* magazine. I said, "I believe the simple act of making something, anything, with your hands is a quiet political ripple in a world dominated by mass production ... and people choosing to make something themselves will turn those small ripples into giant waves." I still believe this: once you empower yourself through the act of making, you begin to want others to feel the same. By sharing our own work, our seemingly simple acts can become turning points not only in our own growth, but in that of others.

Notes:

1. *http://habituallychic.blogspot.ca/2011/12/in-memoriam-helen-frankenthaler.html.*

2. *http://printedmatter.org/news/news.cfm?article_id=335.*

FAYTHE LEVINE *works as an independent researcher, multi-media artist, curator, author, and collector. Levine's project* Sign Painters *is a book (Princeton Architectural Press, 2012) and documentary (2013) about the trade of traditional hand-lettering in America. Levine curates Sky High Gallery in Milwaukee, Wisconsin, where she produced the annual event Art vs. Craft from 2004–2013. Her artwork, photographs, and writing have been exhibited and published internationally in both formal and renegade outlets. Levine's first book and film,* Handmade Nation: The Rise of D.I.Y. Art, Craft and Design *(Princeton Architectural Press, 2009), received widespread attention. She keeps track of her work with slightly obsessive updates via various social media channels and on her website,* faythelevine.com, *where she documents her community-based projects, travels, and experiences.*

PHOTOS:

Page 52: Scraps, North Carolina, 2012. Photo: Faythe Levine

Page 54: Hands, group craft session, North Carolina, 2012. Photo: Faythe Levine

Page 56 (top): Black Cat Café, Seattle, Washington, c.1997–98. Photo: Faythe Levine

Page 56 (bottom): Flyer designed by Faythe Levine for a benefit, Seattle, c.1995–96. From author's personal collection. Photo: Faythe Levine

Page 57: *Butterfly* zine, Issue 4, 1995, collaborative project with Ellery Russian. From author's personal collection. Photo: Faythe Levine

Refashioning Craft

Unlike art, craft has its roots in everyday utilitarian things—ceramic teapots and rag rugs and caned chairs—items that are needed in order to drink tea, keep your feet warm, and sit down, items that have a purpose and a function, instead of just aesthetics. Craft also plays a big part in the clothes that we wear and how we adorn ourselves, although the personal part of clothing production has been almost entirely erased by industrial production. Although we now take it for granted that we can pop into the nearest store to buy a sweater or dress or jewelry, it wasn't always so.

From personal stories about the making process and what it can give to us, we come, in this section of *Craftivism*, to how craft is used to decorate and adorn the body. The thing about craftivism is that, when it's wrapped around your body, there's sometimes no obvious connection to activism. However, in this era of mass production and consumption, those who dare to step outside the fast-fashion mill also dare to start a conversation. We are daring someone to notice a sleeve mended in gold thread or to ask, "Where did you get that?" By adorning ourselves with unique pieces that have equally unique stories, we invite conversations with other people. In this journey from internal to external, we open up what craftivism is. These essays are about items produced with hands still at work behind the scenes (and at the seams), and how hand-making is still valuable. We journey from upcycling and the importance

of reuse to knitting with brainwaves and machines, and we take a look at how both can be used to make the world a better place. With Thoreau and Gandhi as inspiration, we see how we can make fashion our own, and then see it again through the eyes of a dressmaker whose biggest allies are patience and time. From a metalsmith, we learn how handcrafted jewelry has a place in our lives, and then read why a journalist makes stitches in everything from his clothes to his daughter's teddy bear. This group of essays ponders why it's important to keep the very construction of what we put on our bodies in mind.

THE POWER OF UPCYCLING

Becky Striepe

Crafters talk a lot about upcycling or creating upcycled projects, but what does this word really mean? Why is it important?

Upcycling didn't start as a crafty concept. The word comes from William McDonough and Michael Braungart's book *Cradle to Cradle: Remaking the Way We Make Things*. We often see consumerism and environmentalism as at odds with one another, but the authors believe that, through good design, there's a better way, and it's not a new concept: McDonough and Braungart compare the lifecycle of a product to that of a cherry tree, which grows, uses resources, and eventually drops its flowers and leaves onto the ground below—but those fallen leaves and flowers are not trash; they have a purpose and enhance the world around the tree. The authors describe this as a "cyclical, cradle-to-cradle biological system [that] has nourished a planet of thriving, diverse abundance for millions of years."[1] On the other hand, when we throw materials into a landfill, they serve no useful purpose but, rather, pollute our environment. Crafters can help transform the lifecycles of everyday products when we reap that waste and use it to create something new.

Is it really upcycling?

Some crafters use the term "upcycling" to refer to using something in an unusual way. But if you buy a new pack of plastic toys to make a mobile, you didn't upcycle those toys. Although you probably made an awesome, adorable mobile, you didn't make an upcycled one. Misusing a term like upcycling can also mislead your customers if you're running a crafty business. Since "upcycled" isn't a regulated term, you can call anything upcycled. Customers need to trust that when they buy handmade, they're getting what the artist says they're getting.

What's the difference between upcycling and recycling? The distinction is all about quality. According to McDonough and Braungart, when we send materials to the recycling center, what actually happens would be better described as *down*cycling rather than *re*cycling, as the recycled products reappear in the consumer system in a more diluted form. For example, recycling centers can't melt down plastic water bottles to create more plastic water bottles. Instead, they are used in lower-quality, flimsier plastic products, such as thin plastic bags. After a few rounds of recycling, that plastic becomes too low-quality to recycle at all, so those trips to the recycling center are really just pit stops on the way to the landfill. In contrast, upcycling is a product-design concept; the idea is to create products with reuse built right in. A good example is the HangerPak, a cardboard T-shirt package designed to turn into a clothes hanger.[2] Instead of being destined for the recycling bin, the packaging has a planned use beyond the store, making the cardboard relevant beyond its first lifecycle.

In the crafting world, upcycling has evolved to mean taking something that's landfill-bound and giving it a new life. When you upcycle, not only are you diverting waste from the landfill, you're also saving energy and preventing pollution created by the production of new materials. Any new product we buy—whether it's fabric, plastic, metal, or paper—takes energy and resources to produce. Therefore, when you choose reclaimed

materials, you're doing double duty to reduce your crafty impact. When a crafter upcycles a plastic bottle, she creates a new lifecycle for something that would have otherwise been garbage or recycling. Crafters are picking up the slack where conventional design has failed, using components, packaging, and other "garbage" to design things that are usable and new.

At *Crafting a Green World*—the green crafts site I edit—Bonnie Getchell wrote a useful and simple project tutorial for upcycling a plastic water bottle. She cut down the bottle, filled it up with sand and stones, and nestled an LED candle in the top. *Voilà!* A Zen votive holder that kept that plastic water bottle out of the waste stream. My friend Shannon Mulkey is another champion upcycler. She makes beautiful use of reclaimed fabrics for her clothing and accessories line, Patina. Shannon finds vintage sweaters and other second-hand fabrics and transforms them into dresses, scarves, gloves, and tops. For a fashion show a few years ago, she even created a line of dresses using old canvas dropcloths.

A big part of getting into upcycling involves rethinking what defines craft supplies. For a lot of crafters, stocking up means heading to the craft store and buying supplies, but for the crafty upcycler, almost anything in the recycle bin, on the side of the road, or at the thrift store can be a craft supply. One of my favorite examples of this kind of upcycling is a decoupage lamp that the folks at WonderRoot Creative Reuse in Atlanta, Georgia, created using a KeyKeg. Small breweries sometimes use these miniature kegs, which are plastic orbs with a bag inside filled with beer. They cannot be reused, so the savvy people at the WonderRoot partnered with a local bar to upcycle them. To make their lamp, they cut the tap and bag out of the KeyKeg, decoupaged it with vintage dress patterns, and then used a light kit to turn it into a pendant lamp (see page 65). You can find the

details by searching for "bubble keg" on their website: *wrcratl.wordpress.com.*

Tackling the plastic problem

Upcycling is about reducing waste, and keeping plastic out of the waste stream is one of the most powerful ways that we can craft a greener world. When it's neither upcycled nor recycled, it's actually a best-case scenario if a plastic bottle makes it all the way to the landfill rather than ending up on the sidewalk or road. It may take months, but much of the loose plastic trash can make its way into our waterways, washing into lakes, streams, and rivers, and that's when the big problems start. Fish will often mistake trash for food; their bellies fill up with plastic, which doesn't provide any nourishment or work through their digestive system, and they starve to death.

Much of the plastic floating in rivers, lakes, and streams eventually finds its way into the ocean, where the problem gets compounded even further. Natural ocean currents create areas called gyres, which are huge, slow-moving whirlpools. Our oceans now have five massive, swirling plastic gyres—some that are larger than the entire United States—and each one is growing in size every day.[3] These areas are toxic dead zones; most marine life can't survive amid so much plastic.

However, when you upcycle waste plastic (or any other salvaged material), you're helping to break that cycle of waste and pollution. High five!

Here's a quick list of some of my favorite resources for upcycled materials:

Your recycle bin: Empty cans, clean glass bottles, and even discarded junk mail make great craft supplies.

The thrift store: Hack up an old muumuu and repurpose

the fabric, find old books to use in your collages, or hit the housewares section for picture frames to include in your next crafty adventure.

Estate sales: You can find all kinds of fun materials, from old dishware to used furniture to yards (or even bolts) of vintage fabrics.

Creative Reuse Centers: These non-profit organizations specialize in collecting and reselling used craft supplies. To find one near you, try Googling your town's name and the phrase "creative reuse center."

In your travels: That old chair by the side of the road or that big wooden pipe spool about to be discarded from the construction site near your house might be trash to the person discarding it, but to the upcycler, it's crafting gold. Keep your eyes peeled!

Notes:

1. McDonough, William, and Michael Braungart, *Cradle to Cradle: Remaking the Way We Make Things*, New York: North Point Press, 2002, 92.

2. See *http://greenupgrader.com/7437/ hangerpak-shirt-packaging-doubling-as-a-hanger/*.

3. See *http://5gyres.org*.

My name is **BECKY STRIEPE** *(rhymes with "sleepy"), and I am a crafts and food writer from Atlanta, Georgia, with a passion for making our planet a healthier, happier, kinder place to live. My life's mission is to make green crafting and vegan food accessible to everyone. I believe in the power of little changes: using cloth napkins instead of paper, a reusable bag instead of a plastic one, and eating vegan, even if you're just starting with a few meatless meals each week. Things like this add up to make a big impact.*

I also believe that cooking and crafting go hand in hand. What's craftier than whipping up a delicious meal or tasty treats to share with your friends and family? In November 2012, I released my first book, 40 Days of Green Smoothies!

PHOTOS:

Page 60: WonderRoot Creative Reuse, *Bubble Keg Lamp (detail),* 2011. Photo: Abby Gaskins

Page 62 (top): Bonnie Getchell, Zen votive candle holder, 2012. Photo: Bonnie Getchell and Crafting a Green World

Page 62 (bottom): Shannon Mulkey, dropcloth dress, 2010. Photo: Shannon Mulkey

Page 63 (top): Shannon Mulkey, upcycled dress, 2010. Photo: Shannon Mulkey

Page 63 (bottom): Shannon Mulkey, upcycled knitwear, 2010–11. Photo: Shannon Mulkey

Page 65: WonderRoot Creative Reuse, *Bubble Keg Lamp,* 2011. Photo: Abby Gaskins

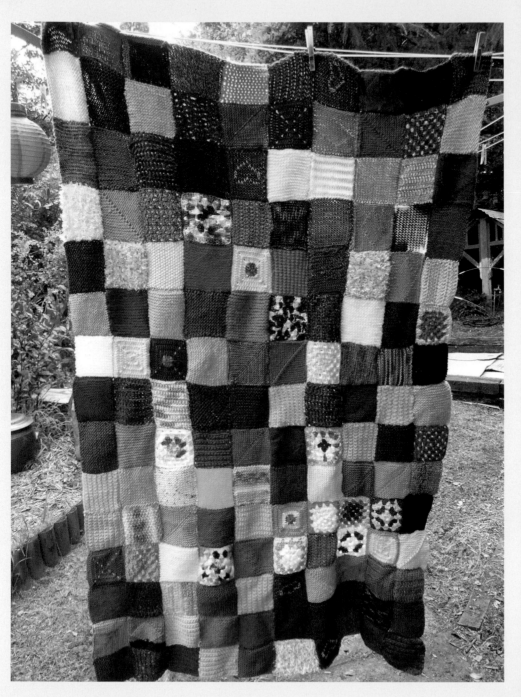

Stitching for Sisters

Rebecca Addison

In March 2011, I was immersed in the painful process of learning how to knit. I was also reading Dr Catherine Hamlin's book, *The Hospital by the River,* about her work in Ethiopia with women suffering from obstetric fistula. As I sat in my living room trying to twist an unwieldy piece of yarn into something like a scarf, I thought about the women in Ethiopia—mothers just like me—who were suffering greatly from the shame and discomfort their condition caused them. While not a great knitter, I am an experienced sewer and all-round crafty person. I knew that somehow I wanted to combine my passion for craft and community service, and I did so with Stitches for Sisters.

Our first project coordinated the donation of four-in (ten-cm) squares of knitting or crochet. These were made into blankets to give to patients at the Addis Ababa Fistula Hospital, where Dr Hamlin worked. Support for the project was overwhelming. Our goal was to make one blanket from 150 squares, but we were blessed to be able to donate eighteen beautiful blankets. It's our hope that the women who received them feel the love and care that went into them and the support of a global community of women.

Stitches for Sisters has opened my heart in more ways than I could have imagined. As women from around the globe send me their contributions, so beautifully and carefully made, I think to myself, they care. It has been an empowering experience to see what a group of women can do. We may not know or ever meet each other, but together we're united by craftivism. See *facebook.com/Stitchesforsisters*

PHOTO:
Woolen patchwork blankets made of 150 squares donated by women from the US, Canada, Australia, New Zealand, Switzerland, and England, 2011. Photos: Rebecca Addison

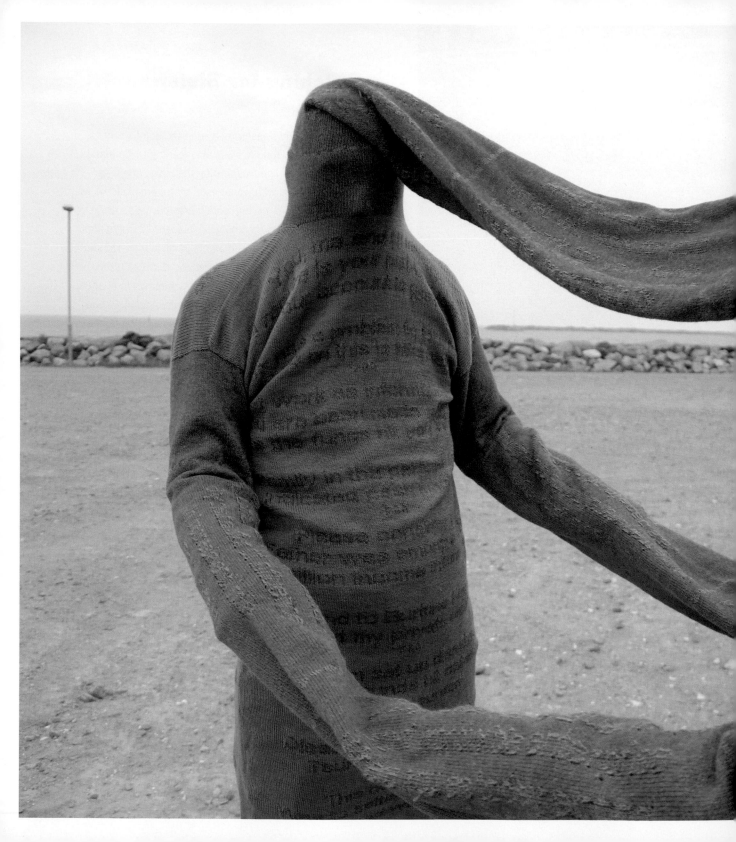

INTERVIEW with Varvara Guljajeva and Mar Canet

Q: How did the two of you meet?

Varvara: In 2008, I asked a friend of mine, who used to study in Barcelona, if I could stay at her place for a night. It turned out that she had left Barcelona, but she put me in contact with a nice guy, who was Mar. He hosted me at his place for a night and showed me around the city, which is his hometown.

Q: What are your individual backgrounds?

Mar: I studied digital design and electronic art for five years at ESDi at the Universitat Ramon Llull in Barcelona. My second undergrad degree is in computer game development from the University of Central Lancashire in the UK. Currently, I'm finishing a master's degree in Interface Cultures at the University of Art and Design in Linz, Austria. Since I am involved in so many exciting projects, it will take me a bit longer to submit my final thesis, but I'm getting there. Besides formal education, I have large project- and research-based experience as an artist, freelancer, and creative coder. For example, I worked for two years at the Ars Electronica Futurelab in Linz.

Varvara: My bachelor's degree in Information Technology is from the Estonian Information Technology College. I did my masters in Germany in Digital Media, and

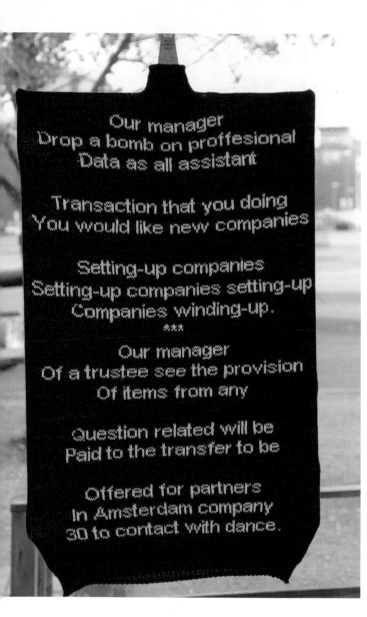

after working and teaching in Interface Cultures at the University of Art and Design, I enrolled in a PhD program in the Art and Design department at the Estonian Academy of Arts.

Q: How did you become an artist duo?

Varvara: In 2009, Mar and I moved in together. Mar was studying and working in Linz, and luckily, I got a job offer at the university there. We used to discuss our artistic work and ideas a lot and often helped each other. At some point, we discovered that we really complete each other's ideas and work well together.

Mar: Our first work as an artist-duo was *My Name is 192.168.159.16*. We got a prize for that work in the Stuttgarter Filmwinter festival. The next year, we made two works together, and since 2011, we work on almost every project together. I am also part of two other art collectives, Derivart and Lummo.

Q: Do you think that working together has strengthened your work?

Varvara: I have learned a lot from Mar. I think the most important things are self-confidence and believing that everything is doable and learnable. Mar is great medicine against my laziness. Two heads are better than one in every aspect—from concept to realization.

Mar: Varvara cheers me up and motivates me when I'm down. Sometimes she sees a solution to a problem when I feel lost or I'm out of ideas. Her different interests and views make our work richer.

Q: *A lot of your work uses knitting machines. Why did you choose to work with them?*

Varvara: Our crazy idea was to knit poetry generated from spam emails. As artists we are inspired by, and our work talks about, the digital age. The idea was to recycle spam algorithmically. We wanted to find an original method or approach to this concept.

Mar: Spam is the first digital waste from the information era, and knitting machines are the first home-use digital fabrication tools. After seeing a documentary by Becky Stern on how to hack a knitting machine, we thought it must be easy to reverse-engineer a similar machine. Well, the reality was that we had to spend a lot of time to understand how these obsolete machines work. Knitting machines are fascinating!

Q: *Was the connection between digital technology and craft an important contextual basis for the pieces?*

Mar: The first electric knitting machine appeared in homes in 1976, just three years after the personal computer. Conceptually, this fact is intriguing and inspiring to us.

Varvara: Introducing craft to modern digital society is important for us. We want knitting machines to be remembered and integrated into the makers' movement.

Q: *The machines that you work with are no longer in commercial production. Do you see a connection between the ways that (before this century) craft was seen as obsolete and now (in this century), these machines themselves are in danger of becoming obsolete?*

Mar: In the last century, within the paradigm of Fordism, craft was probably seen as inefficient compared with industrial production, and society did not value the uniqueness of crafted objects. Today, customers appreciate handmade and unique products. We have moved to a post-Fordist paradigm, to a third industrial revolution.

Q: *In* SPAMPoetry, *you created "dysfunctional" pieces that were sweater-like, but not actually sweaters.*

Varvara: The dysfunctional nature of *SPAMpoetry* is a reference to the uselessness of spam. We considered which form to knit for a while. Mar wanted to make a sweater with spam, but I was not as enthusiastic about it. I knitted *SPAMpoetry* as a sweater without sleeves. And this was it; we found the form we liked. By exploring the knitting field further and getting more skilled, we discovered that we can knit almost any form, so we started to knit more sculptural and installation-like forms.

Mar: It was important to keep the pieces connected to a very concrete form, not a number of unconnected pieces, so we chose the sweater form. This was a very important artistic decision for us.

Q: *Was the knitting itself an integral part of the piece?*

Varvara: Bringing together the immaterial and material is always exciting, but knitting machines are also primitive computers, which means that we did not mix two entirely different fields.

Mar: Through knitting, we discovered new connections. For example, the logic of knitting: one pixel is one stitch. This craft is very mathematical. By making a test gauge, one can calculate whatever form and size anyone wants.

Q: What was the significance of the piece called Kombi, *in which you knitted a version of the Volkswagen Kombi in 2012, the last year of its production in Brazil after seventy-eight years?*

Varvara: Kombi is a location-specific work, because it talks about Brazil. The Kombi was the first car produced in Brazil, and thanks to VW's lobbying efforts, the country has networks of roads, rather than an extensive railway. Brazil is a totally car-ruled place, and the Kombi is really a symbol of that.

Mar: And the funny thing is they keep postponing the last production date of the VW Kombi, which we discovered after making this piece.

Q: For this piece, you walked inside the knitted Kombi on the streets of Brazil. You wrote that it was "a statement of pedestrians' rights in the city ... [as] we had to drive a car in order to get equal treatment by the other vehicles." What kinds of reactions did you receive?

Mar: Brazilians in the city of Belo Horizonte are quite relaxed and have a sense of humor, so we didn't see much aggression. In fact, it was the other way around; people found it a very funny and smart solution. Also, we went out in our knitted Kombi on a Saturday, in order to avoid angry rush-hour drivers.

Varvara: We had only one obstacle, and that was trying to get into the park. You can't even ride a bicycle in the park, much less drive a car, so the security guard was not sure whether he should allow us in. He also wondered whether this was a VW promotion. But in the end, he let us through, and everything was fine.

Q: What was the activist goal of this piece?

Varvara: It was to underline the rights of pedestrians and environmental values. The knitted structure of *Kombi* added a value and carefulness to our ideas. We hope that some people understood our ideas, and probably, some people just had a great laugh that day.

Mar: Our host organization in Brazil, Marginalia+Lab, had a good experience of the public intervention method; it opened their minds to different concepts and possibilities for future projects.

Q: What is Knitic?

Varvara: Knitic is an open-source knitting machine that controls a Brother electronic knitting machine via an Arduino, which is an open-source prototyping platform designed for artists and other designers. We use end-of-line sensors, an encoder, and sixteen solenoids from a knitting machine. With Knitic, one can knit as long a pattern as desired and modify the pattern on the fly. Knitic is the new "brain" of a knitting machine.

Q: Why is it open source?

Mar: We never thought about closing the Knitic source code. We are using open-source tools for developing Knitic, and it would not be smart or fair to make it close-sourced. Also, our idea is to make it grow through and for community use. We started the idea of Knitic, but we hope that other people will pick it up, use it, and develop it further.

Q: Was this the first idea you had about working with knitting machines?

Mar: Yes, it was the first, and now we are thinking about producing one using digital fabrication tools. It would be great to have a replicable knitting machine!

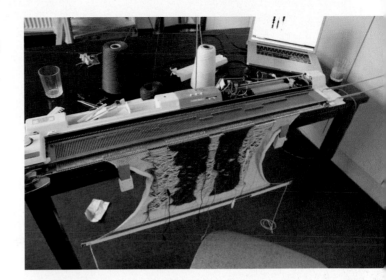

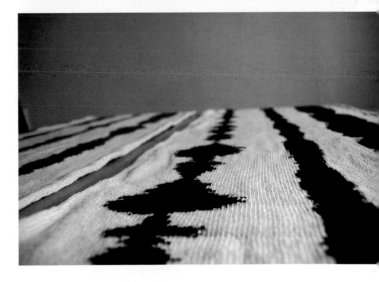

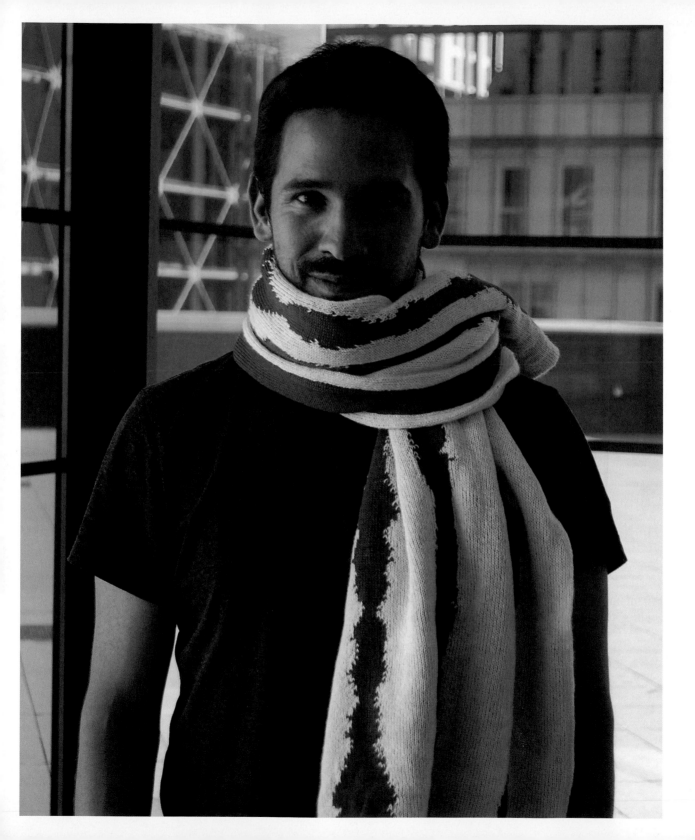

Q: In the piece NeuroKnitting, "every stitch of a pattern corresponds to a unique brain state simulated by the act of listening." How did you come to work with brain states?

Mar: We noticed a lack of innovation in this field of craft and, at the same time, the potential of this medium. We have been always interested in the development of technology and its possible new trends. One day, after exchanging some ideas with other people involved in techie textiles, like @Bitcraftlab, we thought that we should make something extraordinary and crazy with knitting. We got the idea to connect neuroscience, human physiology, and craft. Our friend, Sebastián Mealla, who is a researcher at the Music Technology Group of Universitat Pompeu Fabra in Barcelona, works with multimodal human-computer interaction based on brain and body signals. He brought his expertise on physiological and affective computing to this project and explored the role of music as a concrete example of how affective reactions to a given experience (in this case, the act of listening) can be measured through electroencephalography.

Q: How can NeuroKnitting *be used in an activist capacity?*

Varvara: One example is that when demonstrations against the redevelopment of Taksim Gezi Park in Turkey were taking place, we received an email message from there saying, "If I were you, I would pick some people at Taksim Gezi and have them listen to the [Turkish] national anthem, and [using their brainwaves], knit a scarf in red and white (our flag's colors). It could be interesting!" I think this shows that *NeuroKnitting* can be applied to a number of very different concepts, including activism.

VARVARA GULJAJEVA *and* **MAR CANET** *have been working together as an artist-duo since 2009. They have exhibited their art pieces in a number of international shows and festivals. The artist-duo is concerned about new forms of art, innovation, and the application of knitting in the field of digital fabrication. They use and challenge technology in order to explore novel concepts in art and fabrication. Research is an integral part of their creative practice.* varvarag.info/; mcanet.info/; knitic.com.

PHOTOS:
Page 68: Varvara Guljajeva and Mar Canet, *SPAMpoetry* (detail). Photo: Varvara Guljajeva

Page 70: Varvara Guljajeva and Mar Canet, *Dysfunctional Wearable*, 2010. Photo: Mar Canet

Page 72 (top): Varvara Guljajeva and Mar Canet, *SPAMpoetry*. Photo: Varvara Guljajeva

Page 72 (bottom): Varvara Guljajeva and Mar Canet, *Knitted Kombi: Public Intervention in Belo Horizone, Brazil*. Photo: Varvara Gujajeva

Page 73 (top): The knitting process for *NeuroKnitting* with Knitic. Photo: Mar Canet

Page 73 (bottom): Varvara Guljajeva and Mar Canet, *NeuroKnitting*. Using human physiology for textile design. Photo: Sebastián Mealla

Page 74: Varvara Guljajeva and Mar Canet, *NeuroKnitting* scarf. This unique pattern was generated by capturing brain signals. Photo: Sytse Wierenga

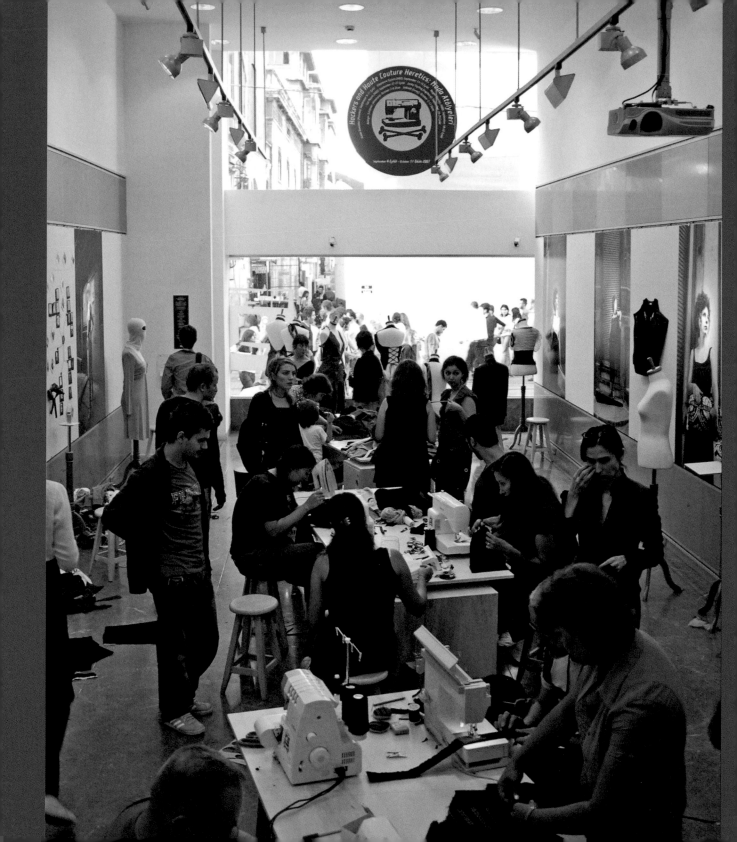

CRAFTING RESISTANCE

Otto von Busch

"*Injustice anywhere is a* threat to justice everywhere. We are caught in an inescapable network of mutuality, tied in a single garment of destiny. Whatever affects one directly, affects all indirectly." —Martin Luther King Jr[1]

Since the turn of the century, we have seen a resurgence of both the craft and Do-It-Yourself (DIY) cultures. Many who experienced the waves of activism in the 1970s and '80s make comparisons between the crocheted fashions and dropout cultures of the hippies or punks and their community actions, such as the Greenham Common Women's Peace Camp in the United Kingdom in 1981, and today's craft and activism resurgence, which has much in common with earlier forms of resistance cultures. It can be traced as far back as the nineteenth-century American author Henry David Thoreau's self-built cabin at Walden Pond.

Today, we see a tendency to primarily judge the outcomes of such actions for their aesthetic signature, for their forms and the quality of their craftsmanship. But just as it would be wrong to gauge Thoreau's endeavors based on his skills as a carpenter, it would be wrong to evaluate today's craft only by its merits as objects. Through acts of craft, we still shape forms of resistance. They are examinations of the seams in our social fabric and acts of disobedience.

Thoreau and resistance
In his essay *Resistance to Civil Government* (1849), Thoreau suggests that it is our fear of punishment that makes us reproduce injustices. Our fear of punishment is our prison, not the prison structure itself. "Under a government which imprisons any unjustly, the true place for a just man is also in prison."[2] Thoreau believed that we must govern ourselves by our conscience and not seek to be ruled, even democratically. "Even voting *for the right* is *doing* nothing for it. It is only expressing to men feebly your desire that it should prevail."[3] To Thoreau, democracy was only a convenient delegation of power and responsibility to a parliament so that we could acquit ourselves from taking necessary action for justice. In other words, by not participating more actively in the fight against injustices, we become complicit in them.

In his epic work *Walden* (1854), Thoreau documents his experiments in what it means to be autonomous. Early in the book, he discusses the role of fashion, pointing out how we are dependent and controlled in this area by the opinions of others. As Thoreau points out, clothes and fashion play an important role in our society, producing a lot of anxiety; they may even act as a cover for conscience: "No man ever stood the lower in my estimation for having a patch in his clothes; yet I am sure that there is greater anxiety, commonly, to have fashionable, or at least clean and unpatched clothes, than to have a sound conscience."[4]

Clothes are not seen as unimportant; they are instead remarkable instruments from which to build independence, and they can reveal our relationship to power if we take them seriously. Thoreau sees our dependence on fashion as reluctance to see that we have power, even though we uncritically adhere to the authority of trends. Not only are our clothes "assimilated to ourselves,"[5] but wearing simple clothing and adopting a critical relation to trends can allow us to have a more independent life.

For Thoreau, our relationship to fashion lies at the core of our independence, as it mirrors our relationship to both government and power. Obeying fashion without conscience is the same as obeying laws we have not set ourselves. By putting our conscience back into the equation, we can remind ourselves of our autonomy. Taking on fashion through craft is more than an issue of expressing identity; it is a way to tackle our relationship to our compliance to being governed. It is a way to be free.

Turning resistance into craft

What Thoreau highlights is the struggle for independence inherent in clothing. Fashion may be an identity struggle between belonging and independence, but it is a struggle manifested as part of our social skin, and it is often made from materials open to our intervention. Craft, in the realm of fashion, is a tool that operates directly at the contested frontline of identity.

When one sees craft as resistance, it is far too easy to examine it from a perspective of anti-consumerism or an individualistic attempt toward self-sufficiency or homesteading. In such cases, it may seem that craft is yet another counterculture in the spotlight, another subcultural trend that is easily commodified. If we look at craft objects, they are indeed often treated as mere commodities. Even a great arena for craft resurgence such as *Etsy* is still primarily a venue for the exchange of goods for money, even if other values are also involved.

However, some of the crafts we see at *Etsy* can also establish other relationships to the world of objects by forming new connections between crafter and buyer. In these, it is possible to disarm some of the fear and social anxiety common throughout consumer culture. As Thoreau saw, the mechanisms of control are internalized in all of us through everyday fear. Peace researcher David Cortright notices that, "We fear the loss of job security or position; we worry how family, friends, and employers will view us. We are so entangled in the comforts of society that we find it difficult to take risks, even for causes we hold dear."[6] The passivity and obedience of the subjects forms the basis of how power is executed, as power is founded on obedience. Nobody "holds" power; it is reproduced by the subjects. The prison exists to hold as prisoners people on the outside, through their own fear. In this way, our own latent fear of isolation or even autonomy can be used against us. Therefore, resistance is aimed inward as well as outward—to withdraw fear and build inner courage, but also to inspire others, show what is possible, and engage in discussions on what to build together, to form new modes of togetherness beyond fear.

Resistance is thus a struggle against ourselves as much as against external power. Within the current regime of power in consumer society, we may consume sustainably just in order to keep on consuming. Sustainability is, in this sense, a promise to leave things as they were before—so that consumers have no real power except to "vote with our dollars." Consumers are left powerless and in a state of social anxiety if they don't "keep up with the Joneses." In other words, they are not engaged at all, but leave the decisions up to the prison guards. By giving us freedom, craft is training in *not being the prison guard of oneself*. Once we are free, we are then truly able to foment change.

How is resistance and activism enacted through craft? Gandhi's life gives us two well-known examples of craft as resistance against the British Empire. The first is his spinning of *khadi* (homespun cloth) to support the independence movement, thus bypassing the British monopoly on textiles in India. This example takes a frugal position in building autonomy, not unlike Thoreau's self-sufficiency. The other powerful example

from Gandhi's life is the Salt March, where justice was manifested through the hands-on craft of independent salt production. Gandhi proposed that, instead of buying British salt, which was taxed, Indians march to the sea to make their own salt. Every grain was a manifestation of Indian freedom, made from the abundance of salt in the Indian Ocean. The act itself was very simple, much simpler than spinning cloth, and easily reproduced; it was an action based on accessing abundance rather than signifying thrift. It thus resonates well with our time, a time of abundance, and may inspire us in how to "detoxify" consumerism.

Gandhi's strategy used several components to make it strong:

- The act mobilized participants through simple and palpable means.
- The act accessed a colonized source of abundance and made it public through craft.
- The act bypassed or was a non-reproduction of domination.
- The act exposed oppression by making useful but illegal things.
- The act showed how a tangible result, however small, can emerge from protest.
- The act showed how resistance leads to self-rule (which Gandhi called *swaraj*).

Even though the resistance was violently repressed by the British, the salt campaign was effective in many ways: It was creative and original, easily replicable without the need for extensive training, gave an experience of coherence to everyone involved, and enabled the movement to seize initiative and build momentum toward larger, strategic objectives. It was a craft of being free.

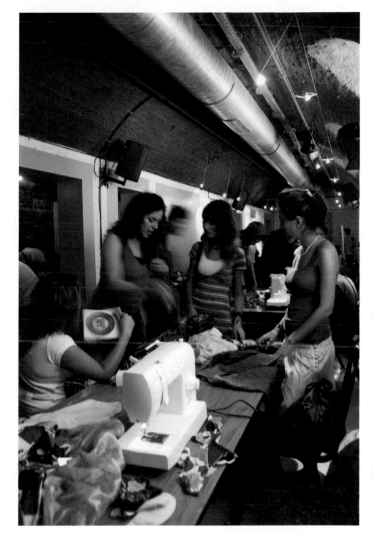

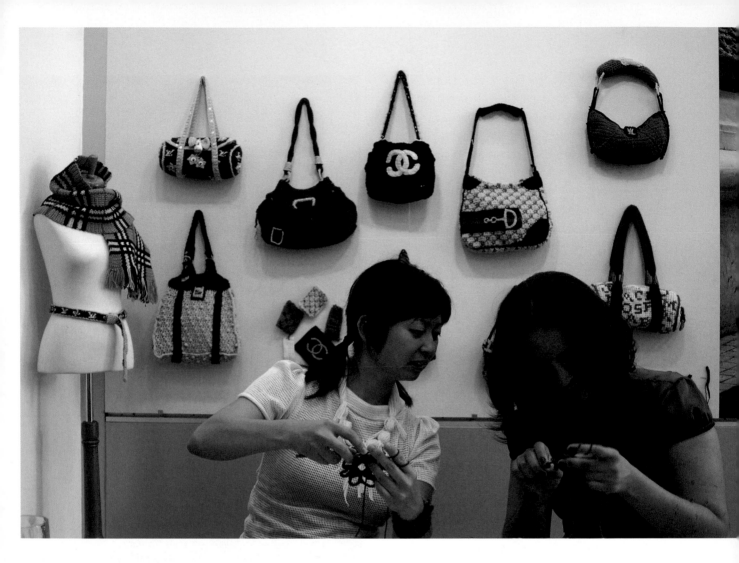

Resistance as the craft of two hands

The resistance proposed by Gandhi can be seen as a form of craft, as it was materialized into action in a constructive manner. It was done by constructing disobedience. Feminist Barbara Deming used a metaphor of the "two hands" to describe this form of resistance, which aims to control and reform the relationship between activist and opponent: "The more the real issues are dramatized, and the struggle raised above the personal, the more control those in nonviolent rebellion begin to gain over the adversary. For they are able at one and the same time to disrupt everything for him, making it impossible for him to operate within the system as usual, and to temper his response to this [...] They have as it were two hands upon him—the one calming him, making him ask questions, as the other makes him move."[7]

This double-handed craft is a refusal to respond violently to the repression of the action and to constrain the escalation of violence or desire for revenge, and to instead focus the action on its moral implications and

inform possible dialogue. The action builds the ground for change by incarnating change. One hand stops while the other constructs the alternative; one hand displaces injustice while the other enacts justice. A similar strategy was carried out in mixed-race sit-ins against segregated diners in the American south during the Civil Rights era. At a lunch counter reserved for whites, racism was temporarily displaced when a person of color sat there. In order to oppose the sit-ins, opponents had to stop the constructive act of desegregation, and by doing so, display their racism and reveal the violence of segregation.

Craft resistance in the world of fashion would mean withdrawal of fear from fashion, while not withdrawing from fashion. Instead, resistance is simultaneously crafting alternative forms of togetherness through fashion. This may take the shape of cleverly distributed counterfeit schemes, such as Stephanie Syjuco's *Counterfeit Crochet* project or the Milan-based open-source fashion network Openwear, which runs education, production, and pattern-sharing services for independent designers and users. It is through action that we test our democracy and government, as we touch the seams of society. Craft may, in this sense, act as resistance to obedience. It is a training camp for empowered autonomy. It is fearlessness toward the decrees of consumerism and peer pressure and, in its most expressive form, the violence of fashion. Craft can be a tool for overcoming fear. It is a way to be free.

Notes:

1. "Letter from Birmingham Jail," *Martin Luther King Jr Research and Education Institute. http://mlk-kpp01.stanford.edu/index.php/resources/article/annotated_letter_from_birmingham/.*

2 Thoreau, Henry David. *Walden and Resistance to Civil Government.* (New York: W. W. Norton, 1992), p. 235.

3. Thoreau, p. 231.

4. Thoreau, p. 14.

5. Ibid.

6. Cortright, David, *Gandhi and Beyond: Nonviolence for a New Political Age.* (Boulder, CO: Paradigm Publishers, 2009), 33.

7. Deming, Barbara. *Revolution and Equilibrium.* (New York: Grossman Publishers, 1971) p. 207f.

DR OTTO VON BUSCH *is a teacher and professor at Parsons The New School for Design, New York and Konstfack, Stockholm. In his research and practice, he explores how design and craft can be reverse-engineered, hacked, and shared among many participants as a form of civic engagement, building community capabilities through collaborative craft and social activism.*

PHOTOS:

Page 76: Junky Styling Wardrobe Surgery Workshop, Istanbul, 2007. Photo: Otto von Busch

Page 79: Giana Gonzalez explains the hacking-couture process at a clothes swap in Istanbul, 2007. Photo: Otto von Busch

Page 80: Stephanie Syjuco teaches counterfeit crochet in Istanbul, 2007. Photo: Otto von Busch

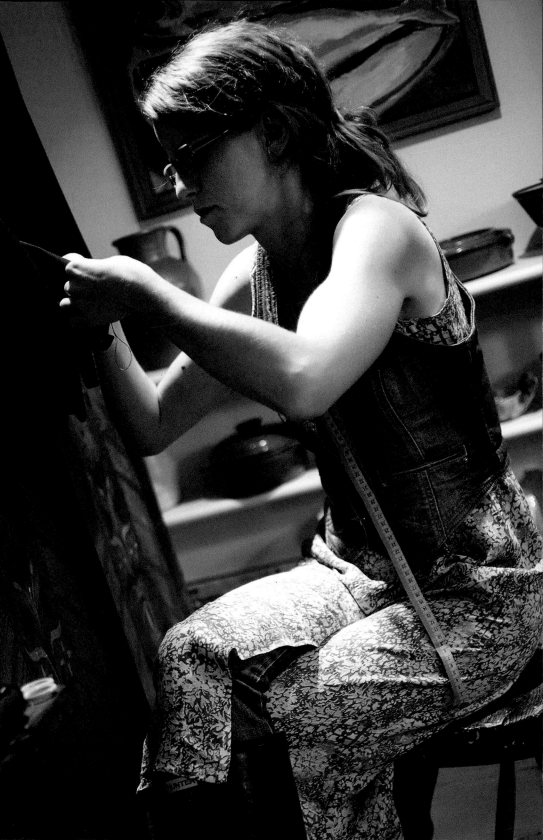

REAL TIME FASHION

Mila Burcikova

Are your clothes alive? I've always imagined that mine were.

When I see clothes drying on a washing line being blown around by the breeze, it seems as if a whole drama of invisible characters who temporarily inhabit shirts, skirts, and trousers is suddenly unveiled. One can watch these wind-powered marionettes rushing off to somewhere, talking, touching gently, quarrelling furiously, hugging each other, and resting again, all within a couple of minutes or seconds. And then this mysterious story played out by garments that otherwise feel so familiar is all over.

Or do they feel familiar? What springs to your mind when you imagine your own clothes hanging out on a washing line?

We all know that doing laundry may feel like a desperately mundane task, but there is also something quite extraordinary about it. Through the process of washing our clothes, the past and the future somehow seem to intermingle and merge. What has happened is rinsed out in anticipation of things yet to come. Much vanishes forever, yet something stays unchanged, and the story of the garment is carried on. Washing clothes is a process of care, and it is care that helps build and strengthen relationships.

We need to have relationships with our clothes. Contrary to what fast-fashion cycles try to make us believe, our wardrobes shouldn't be a noncommittal six-week circle of outfits thrown away without a thought just to make room for another lot of failed expectations. A wardrobe should be a continual process that grows with us and evolves as we evolve, holding memories of times past, good and bad, both those we wish to treasure for a lifetime and those we would rather soon forget. The clothes we wear are our second skin; we wear them every day next to our bodies. If we care about ourselves, how can we not care about our clothes?

Take, for example, a dress from my Giving the Past a Future line[1] made for a bride who asked me to make her a wedding dress inspired by the Czech countryside. The budget was somewhat limited for a bespoke dress made from scratch, but there is always a way. The result was an eclectic design consisting of a repaired 1950s little black dress (originally made by a Viennese dressmaking salon), decorated with 1930s sunflower buttons (made by a famous Czech button manufacturer), and a detachable apron with a piece of embroidery of unknown origin, which I'd had in my treasure box for a long time. All of these items with histories long-forgotten became part of something new and exciting. Anonymous bits were transformed into a garment that witnessed a large change in someone's life. The bride looked gorgeous and happy. I doubt that anyone concerned themselves with whether or not her outfit followed the latest catwalk trends. The wedding day will be long remembered and the dress with it. The washing instructions I sewed into the dress read: "You're washing the past and the future together, so please take your time and wash with care at 30°C."

It's the bond between the past, present, and future that makes fashion so fascinating. It allows one's wardrobe to be an ongoing creation and part of a ceaseless flow through time. You cannot rush this; it's a process that requires patience and perhaps a bit of thought, too.

This is why, all too often, fast-fashion produces anxiety and waste. The anxiety starts with designers who are hard-pressed to keep coming up with new collections and producers who struggle to meet the ever-shorter collection-release deadlines. At the other end, this is met by yet more anxiety in consumers, who desperately try to fit their non-standard bodies into the standardized off-the-rack garments of the latest fashions. This is a waste of energy, self-esteem, and resources, all along the way. As a result, these ill-fitting, poor-quality garments fail to make us feel comfortable with ourselves, so they end up in landfills, and the whole cycle of consumption starts all over again.

Meanwhile, time seems to be slipping between our fingers, and we think we can't afford to wait. Waiting feels both distracting and regressive. To wait for the perfect shirt seems futile. One can get dozens of shirts that don't feel quite right but happen to be cheap, numbing us to the fact that we're not getting what we actually want. These purchases often look dismal after a couple of washes and never get repaired if they're torn; buttons don't get sewn back on—in this fast-fashion cycle, it doesn't seem really worth it.

"I don't like these trousers enough to make it worthwhile to repair them," a friend tells me the other day. When we don't like something enough, we don't care. We dispose of our clothes without a single thought or regret. We don't enjoy the look of them hanging on the washing line; there are few items (if any) that we look forward to wearing again because there's always something newer out there.

I've just realized that, while writing this, I'm wearing the same dress you see me wearing on page 82. I bought this dress on my first visit to London as a student with some extra money I had saved up for the trip. I wore it a lot, and now it's got a tear at the armhole. It

would certainly be worthwhile for me to repair it, but I've somehow grown to like this particular hole. It feels part of the dress now; it shows that the dress has a history, that it has been worn and liked. So while I'll leave it there for the time being, perhaps one day I'll feel the need to repair it, and then a new episode will start.

Just because our wardrobes aren't solely about the endless acquisition of new garments, they don't need to be stagnant, either. Fashion is an exciting, organic process; it thrives on changes and variations, but these changes don't necessarily have to come from trend forecasters. It is so much more rewarding if we take our part, too—caring more about what we buy, how we use our clothes, and how we care for them. We need to allow a little more time for our clothes to evolve with us and become our familiar allies rather than stress- and anxiety-generating enemies.

A customer once ordered a dress from me during a very busy period; she told me that she didn't mind how long it took for me to make it, she just wanted a dress made by me. For her, patience was a part of the excitement of getting a new dress. Symbolically, perhaps, patience also was present at the very start of my dressmaking career. This story, which took place many years before I launched my label, might have well started it all. It's important because it's just one example of how handmade items often have stories behind them. It goes back to the washing on the line and wondering, *Where have these clothes been? What stories do they have to tell?*

Almost twenty years ago, my mum brought home some fabric to make a tablecloth. It was flowery material with nothing particularly distinctive about it except that it had such a lovely drape. From the first moment I saw it, I really wanted to use it for a dress. However, my mum also liked the fabric and didn't appear particularly

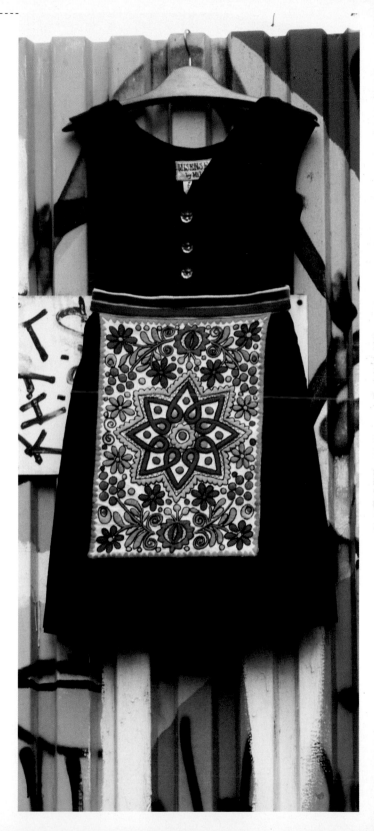

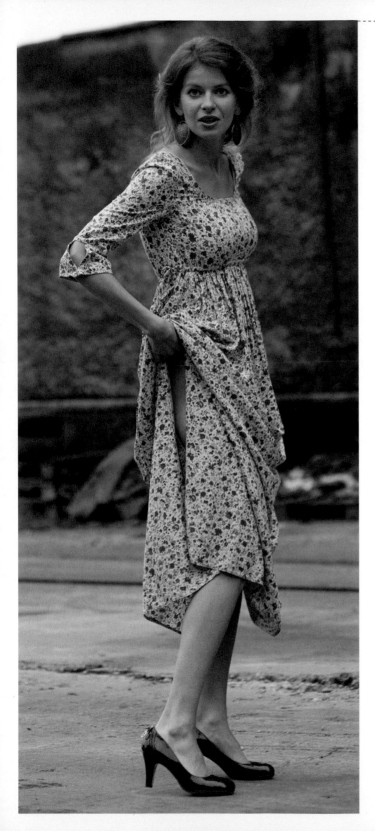

pleased with the thought of giving up her tablecloth. So we made an arrangement: the fabric would first be used to make the tablecloth and then, if it wasn't badly stained after two years, I could have it to make the dress. I waited patiently. Luckily, there was not even one stain on the tablecloth—even after all my parents' summer parties with their artist friends who liked red wine; it was actually quite miraculous.

I made the dress and wore it as often as I could. It was very comfortable, and I often was asked about it when I wore it. Quite a few times I was asked to sell it, but my friends always persuaded me not to, saying that it was a dress everyone associated with me. In this way, I became part of the story of the dress, a part of the value of its inherent uniqueness.

I've made and repaired dozens and dozens of garments since the story of this dress began. My label, MISENSE by Mila B (*misensefashion.co.uk*), launched in 2011, has recently become a fully certified member of the Ethical Fashion Forum's Fellowship 500, which unites pioneering innovators in fashion and sustainability. With MISENSE, I approach fashion as experience and service, rather than as object or product. Materials are carefully sourced to make sure the clothes last for a long time and are easy to care for. I believe that by offering a unique personal service, including alterations, repairs, wardrobe consultations, and styling advice, my customers will always leave with a garment (either new, reclaimed, or repaired/altered) that they will enjoy and cherish for many years to come.

I try to help them find their version of that perfect shirt. Outside the shopping malls (in which there's rarely time to think of what we really want or need), I'm allowing two stories to be told: mine, as the maker, and the customer's, as the wearer. We are both intertwined in this one shirt, stepping out against fast-fashion and

daring to choose things that really please us, things that we care about and are ready to care for.

We all can make the current fashion world less anxious and less wasteful and create more room for a sense of wonder. A very wise man I once met said: "It has taken me thirty years to understand that what I need to subvert in the first place is me, myself—my own assumptions." Once we've stopped assuming that fashion is something beyond us upon which we have no influence, we will be well prepared to go further. We can then start our wardrobes and choose our perfect shirts.

Garments worth having are garments worth waiting for. They will evolve with us and get better over time. The fashion that has the power to make us feel comfortable with ourselves is actually neither fast nor slow. Just like our lives, it is a fascinating mosaic of moments past, present, and future, and it all happens in real time.

Notes:

1 *Giving the Past a Future* line is a part of the *Rusted* project—a design and research collaboration between Mila Burcikova and Steve Swindells. *Rusted* collages pre-used fabrics with new material, creating designs that travel across time and space to explore the tension between tradition and innovation in fashion. The project aims to animate current debates on the role of functionality, storytelling, and emotional attachment to textiles in extending the lifecycle of clothing. More on *rusted.org.uk*.

MILA BURCIKOVA *is a cultural theorist, author, designer dressmaker, and founder of* MISENSE.

PHOTOS:

Page 82: Mila at work, 2011. Photo: Petra Lajdova Photography

Page 84 (top): *Washing Line*, 2013. Photo: Mila Burcikova

Page 84 (bottom): *To Repair Or Not To Repair?*, 2013. Photo: Mila Burcikova

Page 85: MISENSE by Mila B, *Wedding Dress*, 2012. Photo: Mila Burcikova

Page 86: MISENSE by Mila B, "*Tablecloth" Dress*, 1995. Photo: Petra Lajdova Photography

Yarn Bomb Yukon
Jessica Vellenga

In the spring and summer of 2012, the fiber-arts collective Yarn Bomb Yukon partnered with the Yukon Transportation Museum and the Yukon Arts Centre Public Art Gallery to yarn bomb the DC-3 plane owned by the transportation museum.

The purpose of this interactive project was to transform a historic aircraft into a large-scale public art project, foster an appreciation for fiber arts, and teach knitting and crocheting to adults and children. Over a period of four months, the Yarn Bomb Yukon collective hosted more than thirty-five workshops on how to knit, crochet, and yarn bomb at the Atlin Arts and Music Festival, Riverside Arts Festival in Dawson, and in Whitehorse at many other events, festivals, and sit-and-stitch nights. More than 100 people volunteered to knit, crochet, and sew the yarn bomb together. Knitted and crochet contributions came from all over North America. Our blog and social media were our main forms of communication.

The giant yarn bomb demonstrated the power of working together and the ability of community art to provide a new way to interact and view museum artifacts. This interactive art project is an excellent example of partnerships between museums, galleries, arts collectives, and the public.

PHOTO:
Covering the DC-3, 2012. Photo: Tyler Kuhn

INTERVIEW with Gabriel Craig

Q: What was your first activist act?

A: My first activist act was to take my jeweler's bench out of my studio and set it up on the street. I didn't think of it as an activist act at the time, to be sure. Training as an art jeweler—in a formal academic setting—I was frustrated with how far removed this vernacular form of cultural production was from everyday folks. Interested in sharing what I was doing in a very direct way, in *The Pro Bono Jeweler*, I confronted people in a public space with craft, showing them how to make a ring, and if they engaged with me, I would find a way to relate this seemingly antiquated and unapproachable form of manufacturing to their contemporary lives. Ultimately, I would give away simple silver rings, consciously imbuing them with experience and conversation.

Q: Was this a way to dialogue with others about the value of the handmade, about giving jewelry away to people who may not be able to afford handcrafted pieces? Or was it a rejection of capitalism?

A: *The Pro Bono Jeweler* is about access—to a specialized skill set, to an antiquated form of manufacturing, to a specific cultural dialogue, and yes, access to handmade jewelry. I set out to show how multivalent and relatable jewelry-making can be, so the project does wear a lot of hats.

Q: Does giving away the rings signify the continuance of a discussion, that is, is your work, done in public, part of the ring itself?

A: Jewelry, and rings in particular (think about signet rings or wedding bands), have long acted as signifiers or containers onto which we project memories, emotions, and meaning. We are already disposed to think of jewelry in that way. During *The Pro Bono Jeweler*, I would activate that attitude by simply asking the person to remember our encounter and our conversation when they wore or saw the ring. At that point, the ring became a vessel for containing that experience. It's amazing how readily people accept jewelry as a vehicle for memory. It is certainly the most charged moment of any performance—this exchange where I honor their time and curiosity by giving them something material. But also, I ask so much more of them than they realize; they must go away to think indefinitely about craft. Somehow, they always think they got an incredible gift, but I feel as if I always get the better deal.

Q: What is your personal definition of craftivism?

A: This is something I have always struggled with—defining craftivism. I think that making things as an alternative to consumerism, making things as a form of counterculture protest, is valid. I find myself doing this all the time, trying to unplug from corporate America by growing my own food, pickling and canning it, making my own furniture, kitchenware, clothes, etc. That kind of self-sufficiency is really a personal grassroots protest, but moreover, it's a lifestyle choice. I think that only when you join with others to start advocating and agitating does the act of making start to resemble activism. I don't consider my lifestyle activities as activism. I have always called myself a metalsmith, writer, and craft

activist pretty consciously because I wanted to convey that my activist projects go beyond just making. A good example was my 2011 project *The Prospects of Slow Gold*, where I took a jeweler and a to-be-married couple to the Black Hills of South Dakota to prospect for gold to make their wedding bands. I documented the project through a four-part video series, a magazine article, and a blogged essay. The project was a dramatic examination of material sourcing in jewelry; it was all about making things, but the product of the project was its documentation, which was used to advocate for ethical material sourcing.

And here is my point; an activist project like *The Prospects of Slow Gold* is a wholly different form of craft activism than making something. I do not privilege one form of activism over the other. In fact, I think that the more kinds of craft-based activism there are, the better. However, I do recognize a difference in their conception, implementation, audience, and effectiveness as advocacy tools. Part of being a successful craft activist today is having a big toolbox.

Q: What was the main goal of your video work, The Gospel According to Craft?

A: I like to come at an idea from multiple angles. The idea of dynamic craft advocacy was something I was quite interested in at the time. I wanted to see how far I could push my audience. I think that question—how extreme of an advocate could I be before people rejected my message?—spurred the performance, which ended up being something else entirely. In the end, it became a humorous meditation on craft advocacy and messaging.

Q: What types of reactions did you get from the public? Any experiences in particular stand out?

A: The moment that always stands out for me—my adrenaline kicks in even when I talk about it—is when I started to talk to an actual preacher who finally, finally called me out on my ruse and I quavered. He was a large man—as tall as I am while standing on my handmade soapbox. The video clip is short, but that conversation went on for while. It was really intense because he considered what I was doing blasphemy. It took a lot of talking and smoothing over before he felt comfortable with me. The conversation ended with him agreeing that craft does have a place in the church, and he took my card so we could talk about me making a crucifix belt buckle for him.

Q: Do you think that such performances help improve the cultural value of craft?

A: That is a big mantle to wear. No, I don't think craft performance improves the cultural value of craft by itself. My first beef with craft, when I came into the profession, was that it was a rarefied place. It was about making fancy things for fancy people. It was about the individual genius of the artist. Functional work was admonished. As I started to study craft history seriously, and its connection to function, utility, and quotidian use, I thought to myself, "Shit, we have really lost our way." I have always needed to be the person who shakes things up—not for the hell of it, but because I have to be right with my conscience.

Today, I see craft as a spectrum. On one end, there are people making art objects using traditional materials and techniques, and on the other, there are people activating the conceptual and cultural tenets of the practice. Craft as performance is certainly on one end of that spectrum, though less so as time goes on. As an aside, I see craft as social practice increasingly emerging and, in some ways, subsuming craft as performance. We'll see how that evolves.

By bringing any and all strategies for craft under one umbrella—projecting the practice as far and wide as possible—and creating as much cultural capitol as possible, we can improve the position of craft within our society. Performance is one important tool to have in communicating the potency of craft.

Q: What would your perfect project be if money and time were irrelevant?

A: Since about 2010, I have been approached by museums and other institutions to stage performances. Most folks have seen *The Pro Bono Jeweler* and want an encore performance, but I have found, over the years, that a guerrilla project doesn't quite fit conceptually within an established institutional setting. I am thirty, and I am much less angsty now than when I started performing *The Pro Bono Jeweler*. At first it was about finding ways to connect to the public outside of institutions. In many ways, I have been folded into the craft (and jewelry) establishment through articles, exhibitions, and so on. As I have gotten older and wiser, I have realized that I can connect with people in a public setting, like with Raising Awareness, while doing targeted performances within institutions. If the goal is advocacy, education, and engagement, then an all-of-the-above strategy is no doubt the most effective.

One thing you should know about me is that I am a huge history buff and always have been. I read historical nonfiction for fun. I particularly love decorative arts (craft) history. So given all of that, and that I am still receiving and soliciting opportunities to work with

museums, over the past year I designed a project that engages the context of the museum. In *Reforming the Collection*, I select a work from the permanent collection of a museum and set up a metalworking studio in the gallery. I recreate the original piece myself while leading museum visitors through the steps to create the piece as well. In the end, there are three objects; the original, my attempt at a facsimile, and the piece that visitors created cumulatively. I also create a video document of the project.

In many ways, it is my dream project. It engages my love of history and of metalsmithing, it engages and deepens people's knowledge and understanding of making and manipulating materials, and perhaps most importantly, it confounds people's expectations of what a museum is and how a museum works. It makes the collection accessible in an intimate, tactile way. After working on a piece and physically experiencing what it takes to make a work in a museum's collection, the visitor goes away with a deep understanding of how and why the work is important. It is really easy to walk by boring metal objects in an art museum. *Reforming the Collection* is about bringing these objects to life and insinuating them into people's lives. It's like the difference between watching sharks on TV and swimming with sharks. One is a mediated artificial experience, while the other is visceral and unforgettable. The work premiered at the National Ornamental Metal Museum in 2013, and I am currently working to bring the project to other collecting institutions.

GABRIEL CRAIG *is a metalsmith, writer, and craft activist. Craig's performative use of craft engages diverse audiences in discussions about self-sufficiency, labor, consumption, and tradition. His work has been exhibited nationally, including recent exhibitions at the Renwick Gallery of the Smithsonian American Art Museum in Washington, DC, the National Ornamental Metal Museum in Memphis, Tennessee, and the Museum of Contemporary Craft in Portland, Oregon. His critical writing has appeared in prominent craft publications, including* Metalsmith, American Craft, *and* Surface Design Journal. *He has lectured throughout the country on his own artistic work, decorative arts history, and contemporary craft. He has held residencies at the Houston Center for Contemporary Craft and the Savannah College of Art and Design. Craig received his BFA in metals/jewelry from Western Michigan University and his MFA in jewelry and metalworking from Virginia Commonwealth University. In 2012, Craig co-founded Smith Shop, a dynamic community-centric metalworking studio in Detroit with his wife and fellow metalsmith, Amy Weiks.* gabrielcraigmetalsmith.com; smithshopdetroit.com.

PHOTOS:

Page 89: *Raising Awareness*, Grand Rapids, Michigan, 2012. Photo: Amy Weiks

Page 90: *The Pro Bono Jeweler*, Houston, Texas, 2010. Photo: Amy Weiks

Page 92 (top): *The Pro Bono Jeweler*, San Antonio, Texas, 2011. Photo: Gary Schott

Page 92 (bottom): Still from the film *The Gospel According to Craft*, 2009. Photo: Gabriel Craig

Page 94: From *The Prospects of Slow Gold*, 2011. Photo: Amy Weiks

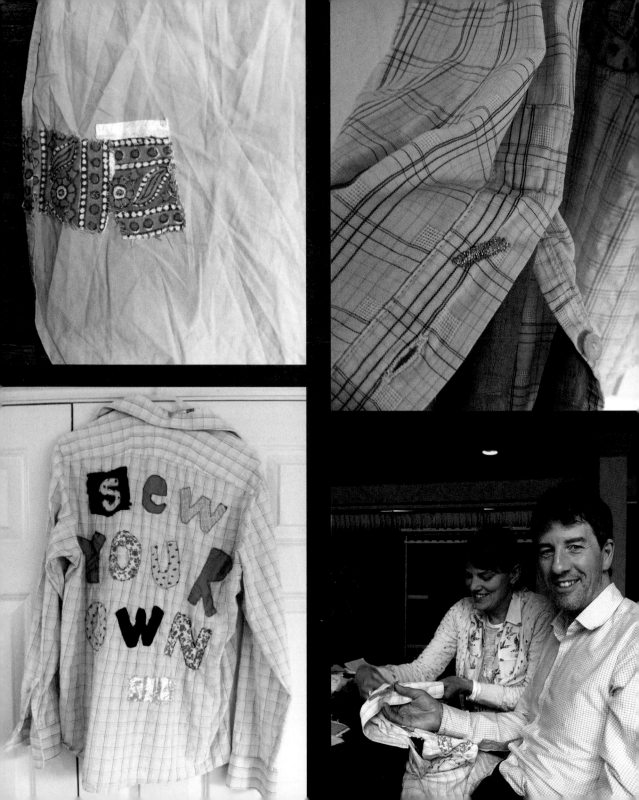

ON GOLDEN JOINERY AND MENDING

JP Flintoff

This morning, I spent half an hour darning my shirt—my pink shirt. It has a tiny L-shaped tear on the front of the right arm, in the bicep area, and a bigger L-shaped tear at the back, at the bottom. I've ignored the big tear for weeks, and only today, sitting down to mend it, did I notice the smaller one.

I've been looking forward to doing this darning for weeks. I know how odd that might sound: looking forward to doing a chore. But I don't think of darning as a chore. I think of it as immensely satisfying creative work. Like meditation, it gives us a space in which to ponder things that really matter.

For me, that often includes thinking about the item being mended so today, I've been thinking about my shirt. Pink shirts always remind me of a woman editor I once worked for (I'm a journalist, mostly). This happened about fifteen years ago, when I owned and sometimes wore another shirt that was pink (with no tears or darning on it, in case you were wondering). I was about to go on a trip to interview various people in Leeds, a town in the north of England whose inhabitants have a reputation for toughness and plain-speaking. My editor told me that I absolutely mustn't wear my pink shirt on that trip. If I did, she insisted, I would get my head kicked in. The implication (I can't recall if she said it in so many words) was that the pink shirt was unmanly.

Because I don't like to be told what to do, I wore the pink shirt to Leeds and returned home without injury. But to this day, the act of putting on a pink shirt rings a tiny alarm bell in my head: will people think I'm unmanly? And what, exactly, does it mean to be manly?

You may be thinking that a man who worries about being manly but writes about the pleasures of darning clothes (and teddy bears, as you will soon see) is a very confused man indeed. And you may be right. But perhaps that just shows the price I'm prepared to pay to write about how much I value darning. When you darn something, you repair it. You make it good. You give it new life. Better still, you take something that may have been mass-produced and generic, and make it unique. You make it your own. And that's a political act, regardless of gender.

I learned a lot about this recently on a trip to the Netherlands where I took part in a workshop led by two brilliant women, Saskia van Drimmelen and Margreet Sweerts. They asked me to introduce myself to the other attendees. (Every one of them was female. Not for the first time, in the clothing and textile universe, I found that I was the odd man out. But I said nothing about that.)

I started by saying I had never been all that interested in clothing until a few years ago when I started learning to make my own clothes as a response to the twin threats of climate change and resource shortages—and how I learned to value the acts of making, and repairing, for their own sake, not because of some grand political plan—and that I went on to write a book about it. This got a few polite smiles and several rather blank looks. But perhaps they hadn't understood my English. So I held up a Thomas Pink men's shirt I had customized by writing on the back with appliqué letters the title of my book, *Sew Your Own*. There were more smiles this time.

Then the workshop began. Saskia told the participants about her background in high fashion. Margreet

said she came from theater. Today, they collaborate on various projects, including what they call Golden Joinery—a "brand" (they said) that is fully open-source, for anybody to play with. And what it comes down to is this: not *in*visible mending but fully visible mending, using patches of golden material and golden thread. As Saskia described this and held up examples of the work, I fell in love with the idea of Golden Joinery—of turning the flaws and broken parts of a garment into jewel-like embellishments.

Then the group set to work on the flawed and broken garments we had brought with us. Sitting beside me, Saskia stitched the Golden Joinery "brand logo"—an embroidered golden oval—onto the placket of my Sew Your Own shirt's left arm. At the same time, I stitched bits of golden material onto the threadbare areas on the same shirt's collar.

We worked together for a while, intermittently chatting and in silence, and I was reminded of something that many women (and one man) have told me: how much fun it can be to do mending and needlework as part of a group. But then I was called away to run a workshop of my own, which had nothing to do with textiles. I left my shirt with Saskia ... and when I came back, I found that somebody—nobody could remember who—had stitched a golden patch onto the back of my shirt just beneath the appliqué lettering. I smiled, but my unspoken inner response was: "Yikes! I'll unpick that as soon as I can."

I didn't like the idea of a patch where there was no tear. After all, hadn't Saskia said: "A visible, imaginative repair actually adds value"? If there was no repair under this patch, it didn't seem "right." I remember feeling slightly crushed. But shortly my mood changed: I decided that even if it was not strictly a repair, the golden patch still added value. Somebody unknown to me had put work into embellishing my shirt. So the

patch stayed, and over time I have gradually moved from tolerating it to actually valuing it.

When I returned home to England, I found a store that sells thread and bought a reel of golden yarn. At last I would be able to darn the big L-shaped hole at the back of my pink shirt!

And that's what I did, this morning. I did Visible Mending with golden thread on the bicep area, and on the back of the shirt I joined the L-shaped tear using golden herringbone stitch.

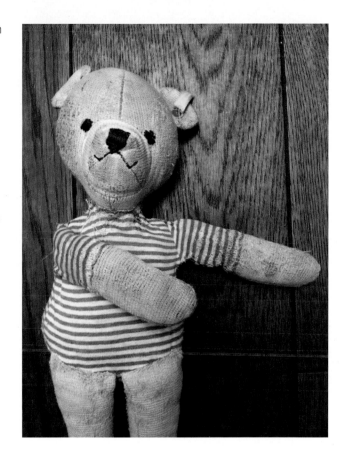

And then I did something else: I added a patch made from an offcut of a skirt that belongs to my wife. After doing this, I would be able to think of my wife every time I put the shirt on. (Is thinking of your wife a lot a manly thing to do? Is telling people you do that manly?) The patch is strongly patterned, with lots of blue, and stands out dramatically on the shirt. It deliberately avoids any attempt to look invisible. It's not golden, but there are no rules in this game: remember that anonymous mender who placed a golden patch on my shirt where there was no tear? All the same, when I'd finished, I decided to pick out some parts of the patterned patch in golden thread.

What next? Where else might I extend my Golden Joinery?

One answer was supplied by my daughter, Nancy, who announced that the body of her favorite bear, Rosie, had several new holes. "A stitch in time saves nine," she said solemnly, repeating back to me what I had told her. I asked if she would like to darn Rosie herself. "No, thank you," she said. (I have demonstrated the essentials to her more than once, and sat watching as she did it, but she prefers that I do it for her.)

In places—on the face, the ears, the neck, and all over the arms—Rosie now consists of more darning than of the original fabric. I asked Nancy if she would like me

to darn Rosie with golden yarn: I was careful to check because I didn't want her to feel the unhappiness I'd felt (if only briefly) when I saw that golden patch on my shirt. She thought about it carefully for a moment and declared that she would rather I didn't use the golden thread everywhere on the bear, maybe just on one area, on the back of one arm.

So I started work. It took nearly an hour and, as I worked, I thought of the many other hours I have spent stitching patiently to keep this most beloved bear in one piece. I thought that perhaps one day, in the distant future, Nancy will look at her bear and realize how much work I did. She might think, if only for a microsecond, that it was unusual, even at the start of the twenty-first century, for a man—manly or not—to darn a teddy bear. Perhaps she might even think of my stitching as a tiny political act, invisible to all but her (and you, if you have read this far). Or perhaps not. It doesn't really matter what she thinks, or even what you think. Because I know what I think.

I don't want to be too solemn about this. In the end, I actually enjoyed the work: darning is fun. It gave me a chance to be meditative and to think about what really matters to me. What pleased me most, when I'd finished, was not that Nancy looked relieved—as she always does when Rosie's been repaired—but that she flipped over that one arm, saw the golden patch, and said with great pleasure, "Ooooh—bling!"

JP FLINTOFF *is a journalist who knows how to sew everything.*

PHOTOS:

Page 96 (top left): JP Flintoff, *Darned Pink Shirt*, 2013. Photo: JP Flintoff

Page 96 (top right): Saskia van Drimmelen, Golden Joinery brand logo, 2013. Photo: JP Flintoff

Page 96 (bottom left): JP Flintoff, *Sew Your Own* shirt, including golden repairs to neck and pointless golden patch, 2013. Photo: JP Flintoff

Page 96 (bottom right): JP Flintoff darning with Saskia van Drimmelen, 2013. Photo: Painted Series

Page 98: Rosie's bling (behind), 2013. Photo: JP Flintoff

Page 99: Rosie's bling (front), 2013. Photo: JP Flintoff

Bare Root Studio
Angie Lanham True

"Johnny, don't forget!"

My husband and I are moving a tray of signs outside to dry. "Baby," "Love," "Home," "Peace," they read, in various languages, painted on dumpster wood. We've lettered each by hand. We'll sell this batch through Hope Tank, a Denver charitable boutique.

We're not going to make much money on them. We don't make much money, period. Our tiny business, Bare Root Studio, makes signs for independent shops and community nonprofits, who are charged token amounts, and for home decor.

"Forget what?" John asks. He's trying to keep the cat indoors.

I meet his eyes. "Always ... make. Market. Share."

He grins.

Artists' salaries alone don't get a family far. Yesterday, therefore, I attended my employer's annual pep rally. The CEO handed out placards to be affixed to computers and minds. "Make Market Share," it read, above "Care With Compassion." Call me a pinko, but these two statements seem not only syntactically strange but contradictory for the healthcare field. Especially while documenting my patients' human vulnerabilities, which I share, as do you. I affixed the placards to our refrigerator instead. Bare Root Studio laughed until it cried.

Why paint signs when you can machine-produce cute phrases by the gazillions? Why spend decades learning a craft or trade? Negative profit margins there. Well, some things can't be faked. Our signs hold warmth. Makers, receivers, and passersby alike register, on whatever level, the humor in reducing people to "consumers," healthcare or otherwise.

Love, Baby, Peace, Home, indeed. Our collective home.

PHOTO:
Craftivism signs, Denver, Colorado, 2013. Photo: Bare Root Studio

Craft as Political Mouthpiece

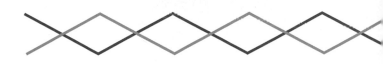

Here we open up the craftivism conversation even further, to the realm of politics. From an exploration of how one tiny knitted mouse made its creator an activist to a Q & A with a craftivist who has literally covered her house with images of and statements made by prisoners, these essays invite you to be more directly involved with others in the conversation about craftivism. The work of another craftivist shows us that we need to keep the conversation going about AIDS, and by delving into the world of the women in the Adithi Collective of India and the *arpilleristas* of Chile, it becomes clear that for some, craft can be literally life-saving while also risky.

All of these essays contain an element of risk because their authors speak overtly about political change. While the process of craft is still incredibly important, here the product takes center stage as causes are highlighted. Whenever political views are shared, there is the risk of turning people off and having them turn away from the conversation. But the power of handmade objects shines through; they have a way of inviting people back into the conversation. While you may not agree with the cause, you may wonder why the heck someone made an object and how they came up with the idea for it. These essays show how the "craft" part of "craftivism" helps continue potentially challenging conversations instead of silencing them. This works precisely because of craft's utilitarian roots. Its familiarity helps bring even those reluctant to be political to the table, if only because they want to know how a handmade piece was constructed.

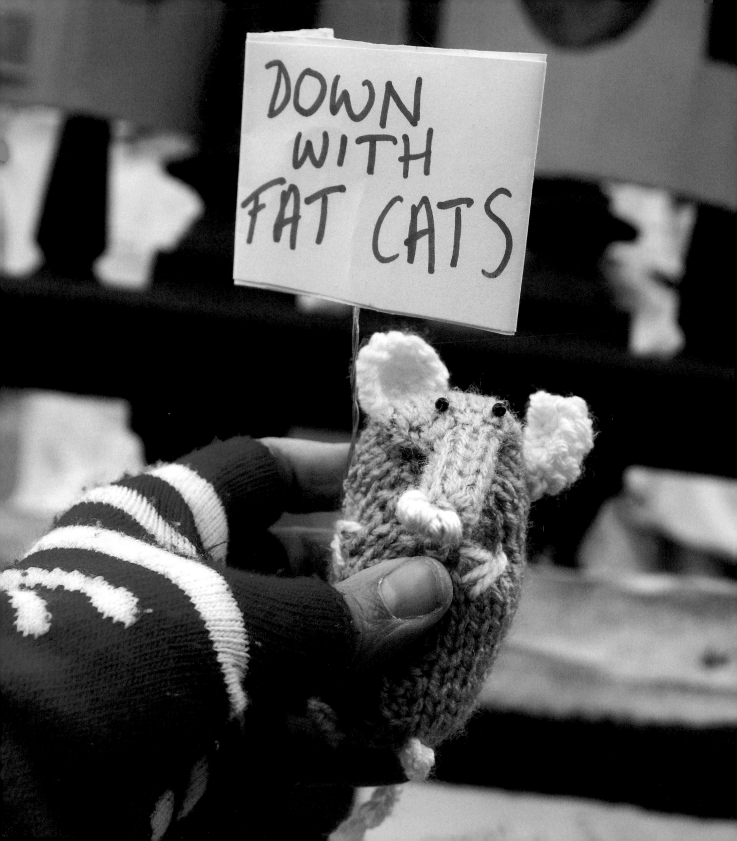

HOW A KNITTED MOUSE MADE ME A CRAFTIVIST

Lauren O'Farrell

I will always remember the moment when my craft got hopelessly tangled in the world of art, and I realized I was never going to be able to untie the knots. I was kneeling in front of a signpost on the mezzanine of the Whale Room in the muffled buzz of London's Natural History Museum, the stuffed bodies of taxidermied sea life floating eerily above my head. My hands, shaky with adrenaline as I anticipated hearing, "What on earth do you think you're up to, young lady?," were fastening a short, hand-knitted, Dr. Seuss-stripy sock around the long metal neck of the sign. I was desperately trying to ignore the sense that the hand of a museum security guard would yank me to my feet at any moment. The sock was my first attempt at graffiti knitting or "yarnstorming" as I had come to call it (the term "yarn bombing" sounded a bit too destructive for my liking). I fastened the sock to a location that I had walked through and wondered at half a hundred times, never without a little inner squeal of lucky-to-be-alive. I've now been a graffiti knitter and crafter for a good few years, and I still get a buzz from doing it, but this comes with a whole world of unexpected feelings that amplify that inner squeal so loudly that I can barely hear my fear.

I make art—cuddly, crazy, woolly, and oddly lovable art, but all the same, it is art. The fact that I make art means that I am changing the world. All of us are world changers in every little thing we do, from our first morning yawn to the last fluff of our pillow at bedtime. We are adding our part to the whirlwind of living around us. This wasn't how I thought before I put that sock on the signpost, as obvious as it seems to me now. But

sometimes it takes a little bit of craziness to make you stop and open your eyes.

To begin with, when my wool and words spilled onto the streets and onto the worldwide web, I was very certain about one thing: my art had nothing whatsoever to do with politics or changing the world. Nope. You weren't about to catch me bringing down oppressive regimes with a handful of acrylic yarn and a few well-placed safety eyes. I thought politics and activism was all about the battle between balding middle-aged white men in suits holding forth on something yawnsome over mahogany lecterns in rooms that smelled like ancient history, and angry, stony-faced, banner-waving, rage-filled freedom fighters. I didn't really see what my arty craft had to do with it. The mere fact that people kept insisting that my art take a side filled me with a little rage of my own. In my first book, *Knit the City: A Whodunnknit Set in London*, which documented the yarn-based London street art of my sneaky stitching collective, I was very clear:

> *Knit the City doesn't seek to change the world, stop the wars, egg the prime minister or ratchet up the trendiness of the over-sixties and their skills (though there isn't a knitting granny we don't take our handmade hats off to). It is true that we yarnstorm because it's just so much fun. London tempts us in with its long-forgotten sagas, its rarely glimpsed corners of creativity and its twists of tradition. We can't help but go, and can't help but drag the unsuspecting London commuter beast with us, take*

Visitors are kindly asked not to touch the whale specimen as it is fragile and easily damaged.

it warmly by its sweaty hands and worry it with our needles until it stands still and looks up.

I turned my back on changing how the world works and insisted that happiness, creativity, and freedom were all that I was about. There's that word "freedom" poking at me quietly from my own manifesto and waiting for me to notice that I'm using it. It took a while.

In the late summer of 2011, London exploded in riots. From end to end, London burned, shattered, and shook. The aftermath stamped across the country, leaving a trail of broken glass and cracked communities in its wake. It trickled into my world, as most of my news does, via the 140-character, twenty-four-hour cocktail party of chatter that is Twitter. I sat glued to my laptop screen and smartphone following the smoke across my beloved city and wondering, as we all did, how on earth this could happen here. Except that, deep down, I already knew. For years now, the foundations of our Great British Society had been chipped away at by bad government, greedy banks, and a basic lack of love for what made us so great in the first place—can-do spirit, the willingness to help anyone and everyone, creativity, and that world-famous stiff upper lip. When the smoke cleared and we were all in pieces, I wanted to do something, anything, to help make it better. I turned to the place I felt made most sense: craft.

A month earlier, my good friend Kaja Marie Lereng Kvernbakken, a wonderful writer and knitwear pattern designer from Norway, had created a pattern for hand-knitted hearts. She encouraged people to leave these hearts around Oslo in Sweden in the aftermath of the shocking bombings and shootings in that city and on Utøya island in the summer of 2011. Kaja and I had met as fellow artists (she was a writer and I was a graffiti knitter) collaborating on a project in Germany the year

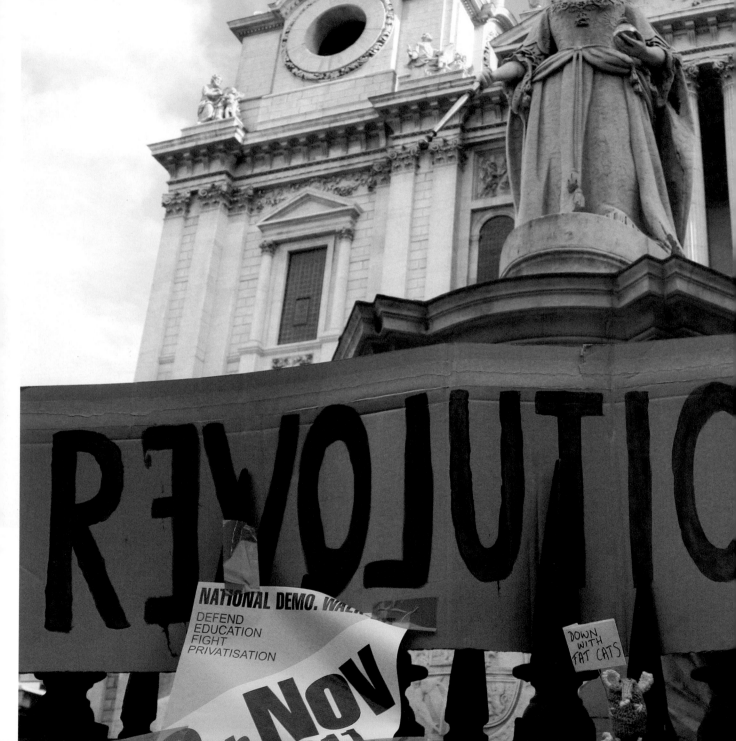

before. Her words and my wool found many similarities, and we were a big influence on each other at the time. Kaja turned to my yarnstorming to give hope where there was hurt in her world. I felt honored and inspired. When the London riots grabbed world headlines months later, another designer, Petra Thiemer from Belgium, contacted Kaja on the Ravelry social network to say she wanted to make a similar heart for the UK. Between them, they created the Union Jack Lovedon Heart "to give England a little love." I used my growing woolly Godzilla of social media, Twitter, Facebook, and the mailing list of my 12,000-strong craft community, Stitch London, to spread the pattern across the world, and the hearts were crafted everywhere.

I'd made a start on the path to becoming a "craftivist." Helping people place those handmade hearts around the country helped me stand up for hope—for a better future and an understanding that things had to change. But I wasn't quite there yet. Putting craftivism in the hands of others was all very well, but my own craftivism was lurking just out of sight.

In the autumn of 2011, the Occupy movement appeared in a flurry of tents, tear gas, and televised scenes of tragedy and triumph. It took all of a few hours for social media to tell me that this wasn't a storm in a very British teacup. The camp set up outside London's St. Paul's Cathedral had sister camps all over the world. From New York's Wall Street to Cairo to Mexico City to Tel Aviv, the list of occupied cities was seemingly endless, and the message was the same: something is very wrong, and the only way to make it right is to come together and say it out loud.

And so, I knitted a mouse, as I do in any situation where I'm not sure what to knit. I knit mice because they're misunderstood, and I like to give them a bit of good press. Yes, they're small and have sharp teeth,

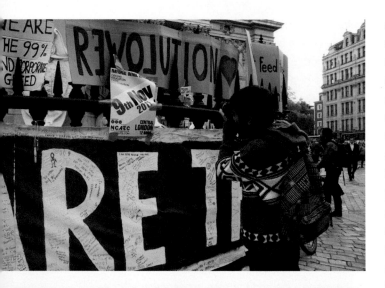

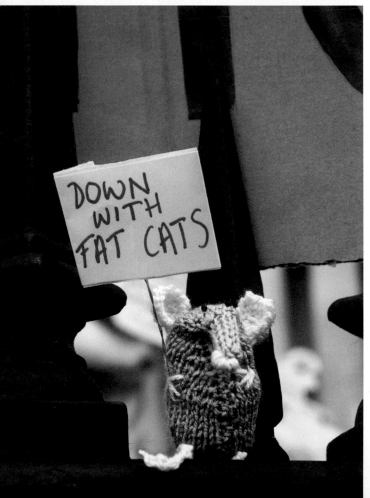

and they make ladies in cartoons stand on chairs shrieking at the sight of them. A mouse is the ultimate underdog, struggling to survive in a world of cats, traps, and screaming cartoon females. Once I had made my mouse, I went down to the Occupy camp at St. Paul's and wandered and watched. What I saw were all kinds of people, from all walks of life, sitting down together to demand that change was needed. They were tired of libraries closing, hospital waiting lists growing, and the promise of more hard times for little people. The little people, of which I was one, were standing together and saying it out loud, and it was heart-wrenchingly lovely to be a part of. That day, I sat down on the history-worn steps of my beloved St. Paul's, in the center of the city that has stolen my heart since I first moved here as a tiny, pen-waving, wannabe writer, and I made my first bit of conscious craftivism. Plucky the Protest Mouse was born.

After borrowing a pen and a piece of paper from some friendly neighboring protestors, I created a tiny banner for Plucky to wave. The banner said, as loud as a tiny banner can, "No more fat cats!" and Plucky and I meant it with all our hearts. As I fastened Plucky to the railings amongst all the other banners, snapped a photo, and sent out the image via my social media, I felt a part of something much bigger, much braver and, *egad*, really rather political. It wasn't about dusty balding white men in boardrooms or stony-faced placard pointers at all. It was about all of us—our books, our art, our everyday lives. Activism and craftivism were about making something that made a difference, even a very small difference. At this point, I was distracted from my woolly banner-waving rodent by a thunderous realization: I had been making something that made a difference with every single yarnstorm I had ever done (followed by the rather smaller realization that I needed a cup of tea and a sit-down right away).

This is what I learned from my tiny protest mouse: graffiti knitting, craftstorming, and all manner of street art, with or without crafty leanings, is about freedom of speech; freedom to take what you love, what you think, and most importantly, what you feel, and share it with the outside world. What you create is seen, and in that seeing you make a statement. Your inner thoughts echo in your hands and out into the world. Whether your work is waving a banner or not, you are saying something with each stitch: you are a part of this madness we call life and living; you care enough to share what you feel with the wider world; and even if no one is listening, you want to be a part of making the world a fairer place. To some this may seem a small, and admittedly squishy, way of helping to create a world in which we are free to share what we love and hope for a better tomorrow. This handcrafted cry for freedom, for everyone to have an opportunity for justice and equality, is a rather lovely way of saying out loud what I have had in my heart all along. My love of life, and my overwhelming need for others to have that opportunity, comes in the form of an army of protest mice and all the creatures I create and leave on the streets. One thread, two needles, and the world as an art gallery.

Not a bad start for a revolution.

LAUREN "DEADLY KNITSHADE" O'FARRELL *is an author, artist, graffiti knitting pioneer, and giant knitted squid wrestler. She began knitting in 2005 during a three-year battle with a rather nasty cancer, and emerged victorious, overly ambitious, and slightly radioactive. She founded Stitch London, a woolly Godzilla of a craft community with over 12,500 members in fifty-two countries worldwide, and is the author of four knit-flavored books. She also founded Knit the City, the UK's first knitting graffiti collective, and has made stitched street art around the world (with and without permission) under the Whodunnknit label. She lives in Crystal Palace, London, with her ancient cat and Plarchie, her twenty-six-foot (eight-meter) knitted squid. It is rumored she never sleeps.*

PHOTOS:

Page 104: *A Protest Mouse Is Born*, London, UK, 2011. Photo: Lauren O'Farrell

Page 106: Deadly Knitshade's first yarnstorm in the face of a humongous blue whale at London's Natural History Museum, London, UK, 2009. Photo: Lauren O'Farrell

Page 107: Kaja Marie, *Oslove Heart Spreads the Stitched Love*, Oslo, Norway, 2011. Photo: Kaja Marie Lereng Kvernbakken

Page 108: *A Tiny Rodent Revolution*, London UK, 2011. Photo: Lauren O'Farrell

Page 110 (top): *Protest Mouse Does Blue Steel*, London, UK, 2011. Photo: Lauren O'Farrell

Page 110 (bottom): *Mouse In Place*, London, UK, 2011. Photo: Lauren O'Farrell

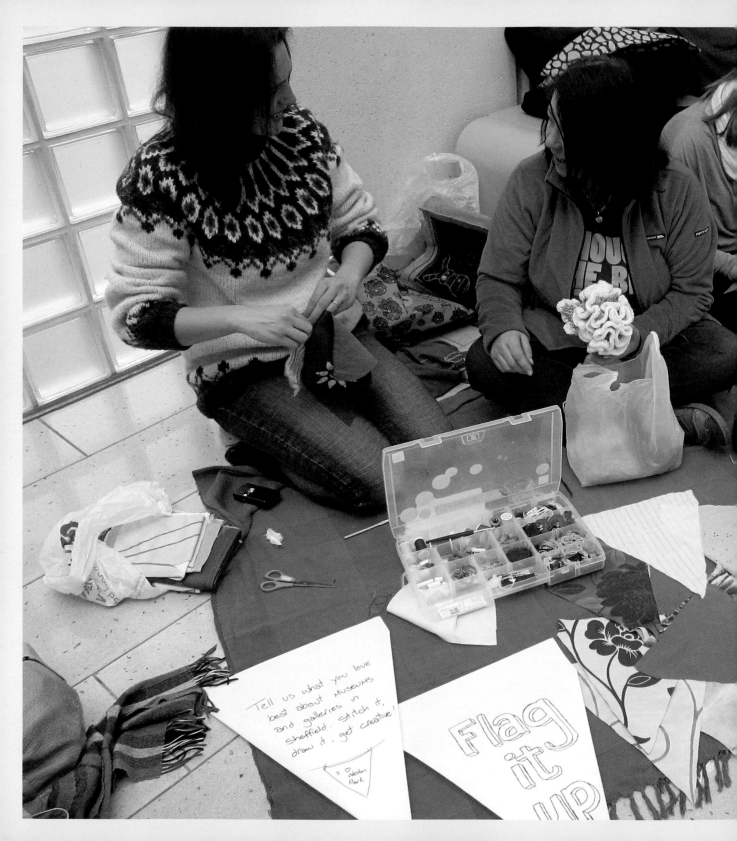

Tell us what you love best about museums and galleries in Sheffield. Stitch it, draw it, get creative!

= ♡ Weston Park

Flag it up

The Shefftopia Picnic

Abi Nielsen

The Shefftopia Picnic in the city of Sheffield, UK, was organized at short notice by local artist Pete McKee and held in a city-center art gallery to protest massive funding cuts to museums and galleries across the city in 2012. I made up a "Collaborative Bunting Kit" to take with me: paper, markers, tape, twine, pegs, a sewing box of needles, thread, embroidery silks, pins, scissors, and lots of scrap fabric.

My approach to craftivism is, "It is easier to ask forgiveness than permission," so I parked myself in the middle of the gallery and spread out my wares. I wrote a notice explaining what to do ("Make a flag, tell us what you love best about museums and galleries in Sheffield. Draw it, stitch it, get creative!"), taped the twine along one wall of the gallery, and pegged up my pre-stitched flag. People soon got the idea, and more than 100 flags were crafted throughout the afternoon. I was kept busy cutting out more flags and chatting about what we were doing. People drew, stitched, and pegged up their messages, and the string of protest bunting just kept growing.

All ages got involved, and people said it made them feel that they were doing "something real"; it made their protest creative and tangible, and it focused on what people loved, not what they were against. Gallery staff were moved by the show of support, and they asked to keep the bunting to show to funders.

PHOTO:

Flag It Up: Encouraging people to make their own bunting flag to show support for Sheffield museums. Sheffield, UK, 2012. Photo: Museums Sheffield

INTERVIEW
with Craft Cartel (Rayna Fahey and Casey Jenkins)

Q: What is your definition of craftivism?

A: Craft that challenges, provokes, and transforms the world we live in. Craft that is political. Craft that directly confronts the violent destructive world in which we live and actively creates a new one based on love and care for our earth.

Craftivism is also the conscious subversion of methods of making that have been inexorably (and often nonsensically) linked to gender, in order to expose deeper and more damaging gender assumptions, and a neat political tool to fuck with the fuckers' minds.

Q: How did the Craft Cartel get started?

A: We started the Craft Cartel in 2007 because we were aware of a bunch of lone crafters making incredible non-retail-friendly things (and we were making some ourselves), and we wanted a place where they could be displayed publicly. We knew that rent = boring, so we found a space where we could hold markets for free. It was a bar, so we got to drink beer while we bamboozled passersby with our kooky stuff.

The Craft Cartel was used as a vehicle for communicating all sorts of ideas about politics, whether about sweatshops, violence against women, economic speculation, or the environment. The more radical and challenging, the better, as far as we were concerned.

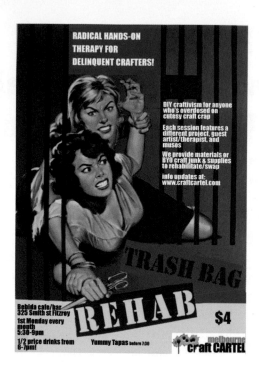

Q: What are your roles? Do you cover different areas?

A: Our roles have definitely changed over the years. We had a terribly sustainable approach of "do whatever you want to, and don't do what you don't want to." We also avoided The Man as much as possible. We didn't go anywhere near grants or funding applications, so we maintained our independence and were accountable only to ourselves.

When we got going, we tended to share most of our roles, but then Rayna had twins so she had to step back. Casey pretty much runs the show now!

Q: Who else is a member of the Craft Cartel?

A: Anyone who wants to be. We have sleeper cells everywhere! Seriously, Craft Cartel isn't an organization, it's an idea. We put ideas out there for other people to be inspired by and start their own radical craft groups in their own areas.

Q: Trashbag Rehab was one of your projects. What got that started?

A: We were a bit concerned that so many young people had never actually made anything. Culture was seen as something you buy as opposed to something you create. So we started a series of craft workshops in inner-city bars where anyone could come and give it a go. We wanted to shift away from the idea (promoted by markets) that the ultimate aim of craft is to create something commercially viable and to move back to the concept of craft skills being freely shared. Trashbag Rehab engaged people in the ideas we were exploring with our craftworks; we invited people to actively participate in their making rather than passively observing or buying the works. The focus was on the experience of making.

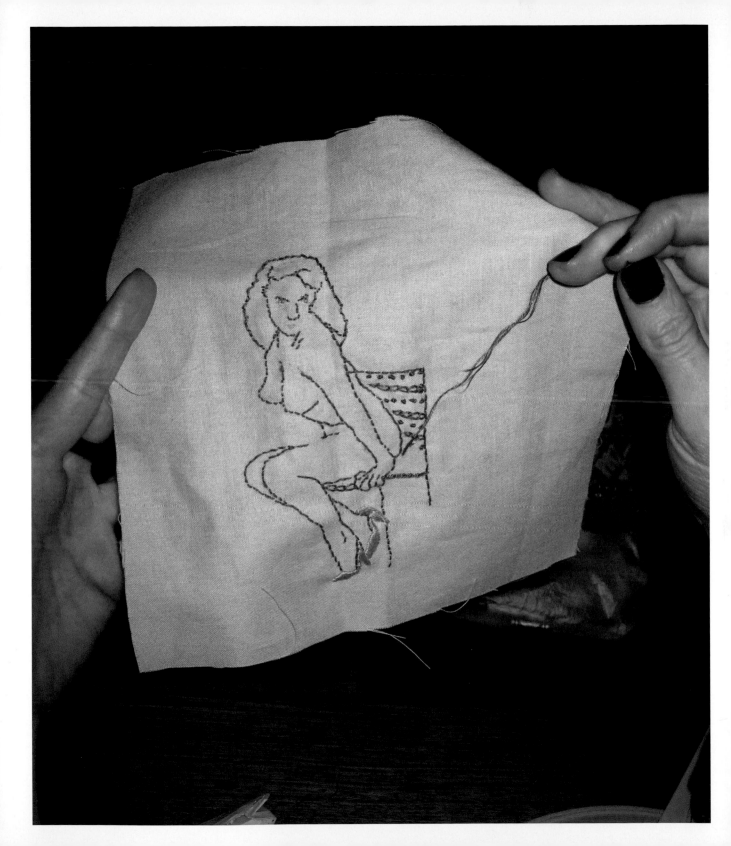

Q: What were the events like?

A: Bedlam! But absolute total brilliant fun.

Q: What were the takeaway lessons? Unique experiences?

A: Trashbag Rehab participants collectively worked on a group action or addressed a core issue while learning a specific craft technique, with entertainment provided by mime artists, rock bands, dancers, puppeteers, and poets.

For one session (*Massacred Media*), we taught basic decoupage by removing offensive bits from a stack of magazines (like dieting tips) and replacing them with often-censored words and concepts (like cunt) and then redistributed the improved mags around town. Stitching techniques and positive feminist sexuality went hand-in-hand for our *Embroidery Porn* session. Another session, *Bang, Knit, Purl KaPOW: Crocheted Explosives*, created a stockpile of woolly weapons, which proved an effective protest against a proposed pulp mill, demonstrating the powerful anger of gentle people toward the destruction of native forests.

Q: What about Femme Fight Club? How did that start? How did this align with craft?

A: Femme Fight Club (FFC) sessions are women-only, non-spectator biff-ups where we whack each other with destructible materials (like breadsticks and balloons) to break stereotypes about female passivity rather than break bones. FFC is a side project kicked off by Casey, and in a way, it's the diametric opposite of other Craft Cartel activities because it's exploring destruction, rather than creation. It relates to craftivism in the sense that it too confronts and subverts activities and expressions that society nonsensically binds to gender (in this case, fighting and aggression).

Q: What were people's reactions?

A: Pure joy from participants and a variety of reactions from non-participants, including respect, bemusement, and patronizing hostility.

Q: Your website says that the Craft Cartel is "for crafty types who don't dig scented doilies." Is it all about the irony?

A: Not irony but subversion. While most of the world may equate craft with sweet happy la-la faff, we do not. Craft Cartel is pretty much all about the subversion.

Q: Is irony negative toward the craftiness of former generations?

A: No, absolutely not. To say that is to suggest that former generations only made cutesy crafts, which is far from being the case. Militant craft activism was rife throughout the last century. In 1913, suffragette Emily Davison died trying to pin an embroidered protest scarf to the King's horse's saddle at the Epsom derby (craftivism!). A core tenet of the Indian independence and self-sufficiency movement promoted by Gandhi was *khadi*, the handwoven cloth that reduced England's power over India, ultimately helping to make it possible for India to give its colonizers the boot (craftivism!). The tapestries woven by Chilean *arpilleristas* depicting scenes of violence and distress helped to expose the atrocities of the Pinochet dictatorship (craftivism!). The thousands who have contributed to the NAMES Project AIDS Memorial Quilt have created a powerful work that honors a generation of dehumanized victims

(craftivism!). Conventional history may claim that the craft of the past has been benign and sugar-sweet, but this is not reality. Craft Cartel respects and admires the rad craftiness of former generations.

Q: In a post for the in.cube8r gallery, Rayna wrote: "One of the harder challenges for those of us makers is to ask ourselves if the world really needs the things we make ... We should ask if craft is directly unsaving the world." How can we make and save the world at the same time?

A: Humans need stuff; it's part of our basic set of survival needs. One of the critical challenges humanity needs to face is our relationship with stuff. Currently, we make far too much of it, we make it badly, and we make it to use once, then throw away. So I think when we're talking about craft in the context of anti-capitalism and anti-consumerism, we need to think deeper than hand-made = good. We also need to ask questions around the materials we use, the quality of our making, and the use of our finished craft objects.

Q: How can we satisfy both urges?

A: We can ask questions about the stuff we make: Does the world need any more of these things? If it does, can I make it out of a waste product instead of using new materials? Can I make it really well? We can also satisfy these urges by reconnecting with our radical crafty roots. You only need to spend a bit of time reading about things like the Arts and Crafts movement to understand that the quality of the stuff we have around us is directly linked to the quality of our lives. The more we make well-designed stuff from good materials to use in our everyday lives, the less we need shitty sweatshop-made stuff, and the happier we are!

Q: In an interview for broadsheet, *Casey noted that "craftivism was a very pragmatic way to have more clout than would normally be afforded to me." What kind of clout?*

A: The combination of craft and activism is still considered unusual and quirky enough that it grabs people's attention, catches them off-guard, and affords a moment of communication with people who normally wouldn't have you on their radar. Craft also comes with community, and a group of people is always stronger than an individual.

Q: When did you first start doing Cunt Fling-Ups?

A: On my thirtieth birthday. Birthdays are a great opportunity to exploit free labor, and I had a bunch of my mates construct cunts out of scraps of material and wigs as a self-appointed birthday gift.

Q: What first sparked the idea?

A: I was frustrated by censorship around the word "cunt." It is censored across mainstream media, though there is nothing remotely offensive about female genitalia. To use it in an offensive way is nonsensical, but you can't even discuss that because everywhere you go there is blanket censorship. The level of censorship is patronizing and offensive in itself. I got frustrated by it and decided to take it to the streets, and so Cunt Fling-Ups were born.

Q: Did you make lots of prototypes before you settled on one?

A: Yup. Fling-Ups reference the shoes flung over power lines by gangs, so the legend goes, to claim their territory. Cunt Fling-Ups are made to reclaim the streets

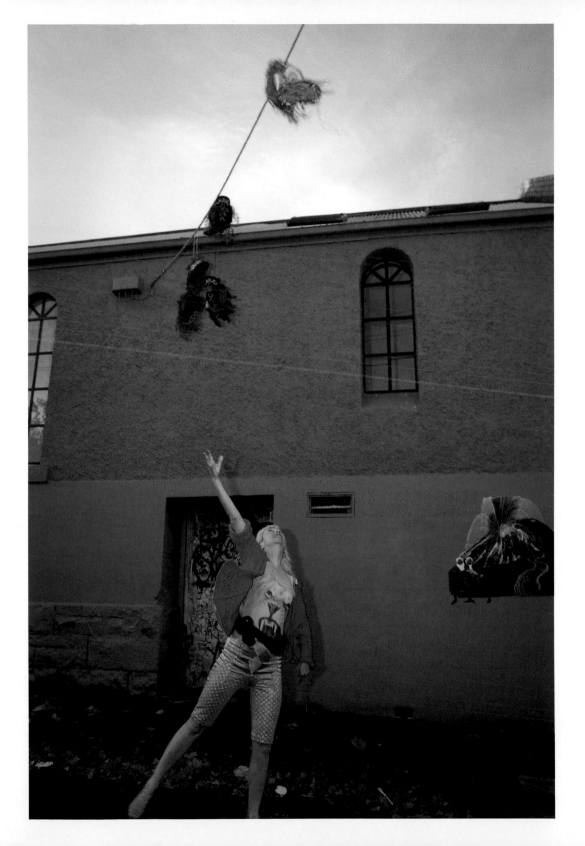

for feminists, but the initial models didn't have shoes attached—they were just two cunts joined with a shoestring, and the Fling-Ups had the weight they needed to fly up and wrap around the overhead wires. Now all Cunt Fling-Ups have shoes attached and are more aerodynamically sound. These Cunts can really soar!

Q: What were the initial making sessions like?

A: The making sessions have always been a ton of fun, and often quite inspiring. Craft Cartel has provided all the materials (pubes, clits, labia, pelvic floors, etc.) and a few broad diagrams, and people of all genders have gathered to stitch them together.

Sequins and soft folds of material are conducive to bright and gentle conversation, and while stitching, some of the revelations people have made about their experiences and thoughts around body image, sex, and gender have been profoundly moving. We had a young kid around ten years old who was stitching with his mother—it was probably only the second time in his short life he'd encountered a cunt, and he had a great time. His mother later told us how happy she was that his introduction to female anatomy had been such a light and positive one—very different, no doubt, to what he'll soon be experiencing on the web.

At another cunt-crafting session, a woman in her sixties crafted a cunt as a requiem to her partner of twenty years whom she'd recently lost to cancer and whose body and cunt she'd known as intimately as her own for that period of time.

Q: What have the reactions been to them?

A: From most of the media and official organizations and people who haven't seen the Fling-Ups, we've had strong disapproval, but from participants and people on the street, delight and amusement. The Cunt Fling-Ups are brightly colored and soft and sparkly. You have to work pretty hard to find them threatening. That is the beauty of craft—the connotations of comfort and kindness that the work carries are so powerful that it can open people up to viewing denigrated ideas in a positive light.

Q: What were the reactions of people in France and England?

A: Hugs in the streets of Paris and applause from little kids after stitching woolen slogans on fences about the impact of gender on wealth. I had the distinct impression that there was more enthusiasm for discussing art and politics in France than at home, but I was on holidays and may have been giddy on cheese and wine.

I was fortunate enough to meet up with French activist group La Barbe as well and join in on a couple of their protests. Their use of handcrafted beards is one of the neatest examples of crafty activism I've seen in recent years.

Q: How was your experience in France different than your experience in England?

A: In England I was lucky enough to find some rad crafters who were doing amazing things and keen to collaborate. Carrie Reichardt, who is an amazing street-mosaic artist, let me bunk down in her craftastic pad (see p. 143), and we did some fence-stitching with old shredded banners from Queen Elizabeth's Diamond Jubilee.

Q: What are the future plans for the Craft Cartel?

A: Craft Cartel is launching a traveling feminist craft workshop project called femiNEST. The workshops are

held in a massive mobile tent. The plan is to traipse around the country and further afield presenting queer- and feminist-themed craft workshops and inviting local feminists and craftivists to use the space to plot, skill-share, and multiply.

RAYNA FAHEY *likes to cross-stitch provocative and thoughtful statements on any canvas she can: new, recycled, fabric, or fence.*

CASEY JENKINS: *Artist, craftivist, and rabble-rouser, producer of female-only biff-fest Femme Fight Club, queer feminist podcast Cunts In Space!, traveling feminist boot camp femiNEST, and cofounder of rad craft group Craft Cartel, Jenkins is an active street artist, flinging crafted cunts around the globe.*

PHOTOS:

Page 114: *Cunt Fling-Ups* making session, 2013. Photo: Rayna Fahey

Page 116: *Trashbag Rehab Diet Pretty*, 2009. Photo: Mark Burban

Page 117: *Trashbag Rehab Embroidery Porn*, 2009. Photo: Rayna Fahey

Page 119: *Pussy Riot Solidarity Craft Fence,* 2012. Photo: Rayna Fahey

Page 121: Casey Demonstrating the perfect Cunt Fling-Up technique, 2013. Photo: Marlene Habib

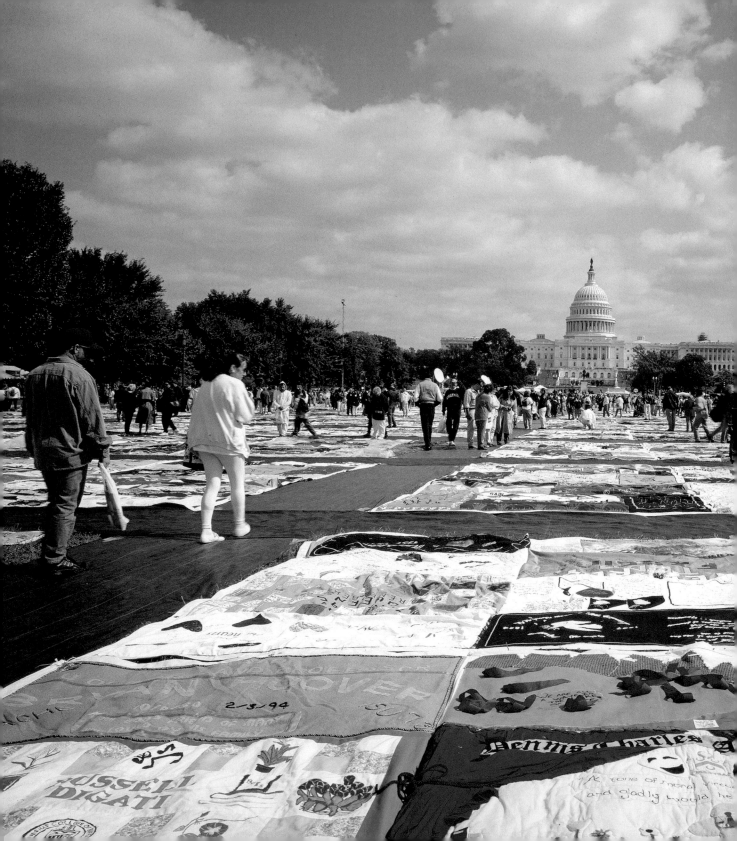

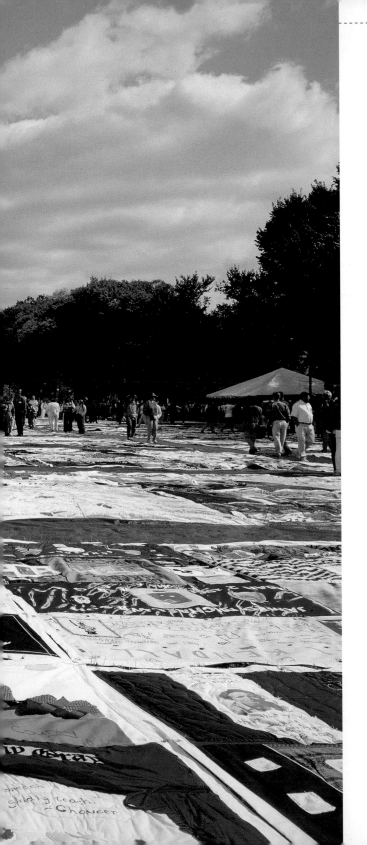

MAKING MIRRORS: CRAFT TACTICS IN THE AGE OF ONGOING AIDS

L.J. Roberts

I left home when I was thirteen years old. At first, I lived with another family and then I went to an all-girls boarding school affiliated with the Episcopal Church, despite the fact that I am Jewish. Of course, I stuck out—another instance of an awkward queer not fitting in. Eventually, I was kicked out. But something happened while I was at that boarding school that forever changed my life. In the back hallway of the main building near the Dean's Office, there was a bulletin board that had sign-up sheets listing weekend field trips. On one weekend, there was a trip to the National Mall in Washington, DC, to see the AIDS Memorial Quilt.[1] I remember the feeling that rose up in me—it was a rush of anxiety, fear, and excitement. I didn't sign up for the trip right away, but at the last minute mustered the courage to scrawl my name down. I was the only student who signed up for the excursion. A chaperone drove me from the Baltimore suburbs to Washington. I took off by myself when we got there and walked slowly through the maze of personalized panels. It was hard to look at grief in so many forms and personal expressions. At that time, I had just a rudimentary understanding of the crisis, so realizing how huge AIDS was felt shocking. It was the early 1990s; I was fourteen or fifteen years old, and the AIDS epidemic was at its height in queer communities in the United States.

At boarding school, I attended sex-ed class. We learned about heterosexual sex, and none of it made sense to me. I always felt defective in class because I was attracted to female-assigned people and wasn't being taught how the mechanics of being with them in

sexual and intimate ways would work. Walking around the AIDS quilt, I was exposed to both grief and various symbols that expressed queer identities, sexualities, and ways of being in the world that were not being discussed in sex-ed. There were pink triangles and rainbows and labryses and red ribbons. This was the first time I had encountered these queer signifiers. After I walked around for a few hours, taking pictures every so often of a panel of the quilt that touched me, I bought an AIDS Memorial Quilt/NAMES Project T-shirt. This textile was my first piece of queer ephemera. From the get-go of coming out, my queerness was tied to AIDS.

The alignments between craft and AIDS continue to astonish me. Stereotypes associated with craft and AIDS are aligned and function in similar ways. In the early 2000s, the word *craft* was erased from the nomenclature of multiple institutions across the United States.[2] This elision symbolized that craft carried negative connotations—such as femininity, queerness, and amateurism—as well as undesired associations with poor and working-class people, oppressed minority populations, people of color, and Third World populations. People living with HIV have been stereotyped in a similar fashion: as populations of queers, people of color, people living in Third World countries, and poor people.

Clearly, having your work shunned is demoralizing, but it is not the same as living with HIV. The comparison of stereotypes associated with craft and AIDS is not meant to overshadow the fact that HIV can be a death sentence. A diagnosis of HIV can incite both literal and systemic violence that includes discrimination, criminalization, physical violence, severe stigmatization, and denial of access to health care. However, I do want to highlight that both craft and AIDS fall under the heavy hand of blanket misogyny. Misogyny declares some bodies and some bodies of work invalid. When we use

craft to make work about AIDS, we are fusing issues with materials, techniques, and traditions whose stigmatization mirrors each other. Craft therefore becomes a visual tool that helps render misogyny, homophobia, classism, and racism nameable through materiality. That a large public craft project, the AIDS Memorial Quilt, became one of the most visible symbols of the AIDS pandemic makes perfect sense to me for a multitude of reasons: it has been the subject of much dialogue around HIV and AIDS; it is seen as a catalyst of healing, a site of public grief, and a political act. The quilt has also been the subject of criticism because some people felt it was not confrontational enough.[3] While I feel it's important to vocalize the connections between craft and AIDS and how the AIDS quilt was a manifestation of this, I want to expand our understanding of how craft has and can continue to contribute to HIV and AIDS activism.

As I've gotten older, I've realized that the ongoing AIDS crisis is a crucial lens that shapes my understanding of the world and global systems. HIV/AIDS is not just a vicious disease that wrecks the body; it is also intimately tied to war, the degradation of the environment, racism, sexism and misogyny, homophobia and transphobia, classism, the prison-industrial complex, health care, education, gentrification, ever-expanding capitalism, the global south, and so on. All of these systems are deeply intertwined with each other in an overwhelming tangle. Companies make enormous profits from jacking up the prices of HIV and AIDS medications, and this enforces systemic racism and power. Seeing these connections is eye-opening.[4]

In the 1990s, collectives like Gran Fury and fierce pussy were making art about AIDS that educated the public, put pressure on politicians and drug companies, encouraged intersectional community action, and made visible a fierce queer and feminist politic. Without

question, the art made by these collective activist-artist groups has been the most influential to my own craft practice. Art that addresses HIV and AIDS has proven to be a force to be reckoned with. It is so politically potent that it is censored time and time again, even as recently as 2011 when the National Portrait Gallery of the Smithsonian Museum of American Art censored David Wojnarowicz's piece *A Fire in My Belly*. In the past few years, there have been multiple shows and films made about AIDS activism of the late 1980s and 1990s. The show *ACT UP New York: Activism, Art and the AIDS Crisis 1987–1993* co-curated by Helen Molesworth, Maisie K., and James R. Houghton and the Gran Fury retrospective at New York University as well as the films *Vito, United in Anger, How to Survive a Plague*, and *We Were Here* were all produced within a few years of each other.

Why was there a surge of interest in this particular, painful period of time? While I've heard people throw around the word "nostalgia" to describe the ravenous interest in 1980s and '90s AIDS activism, I believe it comes from a desire to confront the pink-washing politics that have risen to international attention since 2000. The focus on the legalization of gay marriage in the US reads as a convenient erasure of HIV/AIDS and facets of queer culture that challenge heteronormative ideals. The anger and resultant tactics seen in the 1980s and '90s are vastly different than the assimilative push of the equality-rights movement today. Many of the struggles that AIDS activists originally illuminated, such as universal health care, remain critical and relevant in today's political and social climate.

Lately, I've been inspired by art and craft that addresses the political and social aspects of ongoing AIDS in contemporary life. For example, San Francisco artist Patrick Hillman's piece *Magic* (2008) employs simple craft techniques that confront homophobia, interrogate masculinity, and bust open stereotypes about AIDS. *Magic* is a crocheted portrait of basketball legend Magic Johnson. Stitched in purple and yellow yarn, Hillman's portrait is reminiscent of a sentimental afghan, lovingly made by an aunt or grandmother. Purple and yellow are the team colors of the Los Angeles Lakers, which Johnson led to multiple NBA championships. The amateur, feminine, and soft aesthetics of the crocheted portrait are in sharp contrast to the untouchable, heroic aura that usually hovers around the mug of the basketball all-star. Johnson retired from basketball after he learned he was HIV-positive. When Johnson revealed his sero-positive HIV/AIDS status to the public during a press conference, his heterosexuality was made explicit. The fact that Magic was not a back-alley homosexual lurking around on the "down-low" was emphasized, though he also generated awareness about heterosexual transmission of HIV/AIDS. Hillman's *Magic*, reminiscent of a blanket and suggestive of domesticity, also projects ideas of illness and even hospice. Since the early 1990s, Magic Johnson has been a poster child of a PWA ("person with AIDS") who has lived a "full and healthy" life. Johnson publicly divorced himself from ideas of sickness and fragility, despite his HIV status. The sports star has not been publicly ill, and he has not spoken about the side effects many people experience from HIV/AIDS medication or the social impact of living with HIV. Hillman's portrait initiates a dialogue about homophobia, masculinity, fear, sickness, and AIDS through the fusion of a hyper-masculine heroic persona with the femininity and tactile softness of crochet craft. Hillman's work exemplifies one of the ways that craft can become a material device to confront, interrogate, dissect, magnify, and/or name stigmas such as AIDS while reflecting empowerment.

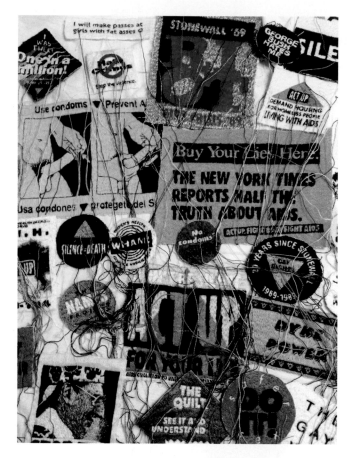

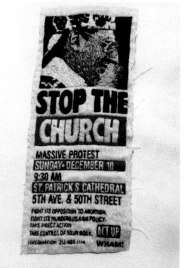

Visual AIDS is an organization in New York City that presents exhibitions and events pertaining to the ongoing AIDS crisis and archives the work of artists who have died of AIDS. In 2013, Visual AIDS interviewed video artist Alexandra Juhasz on the subject of queer archive activism. In the interview, Juhasz states that her biggest concern is that both AIDS and AIDS activism are "understood as things of the past; as if AIDS is not of the present." She continues, "We have also lost the power (in the face of hopelessness or death) from that earlier period: the felt belief that our activities and activism matter to AIDS and each other: our actions could change AIDS and ourselves, not privately, but socially and communally."[5]

In 2011, I was gifted a friend's ex-partner's collection of radical queer ephemera. Deb, whose trove of stickers, pamphlets, and buttons I inherited, was an active member of ACT UP and the Women's Health Action and Mobilization during the height of AIDS activism in the late 1980s and early 1990s. Deb's collection illustrates the cross-pollenization of lesbian activism, fat activism, body and sex positivity, the fight against AIDS, safer sex, queer history, gender self-determination, and trans empowerment. It encapsulates the mix of humor, grief, and militancy that was present during that era. One of my current projects, *Portrait of Deb 1988–199?* (anticipated completion in 2014), is a single-strand embroidered collage based on stitched replicas of Deb's activist paraphernalia. The archive I embroider in *Portrait of Deb 1988–199?* highlights the intersectional activist organizing that was crucial to confronting an epidemic rife with injustices. With this project, I utilize embroidery to stitch an example of what scholar Tirza True Latimer calls a "dissident" archive.[6] I embroider Deb's collection as both a portrait of her and of an era of angry activism. When I transform Deb's objects from paper and plastic

into textile collage, my choice of material references queer and feminist histories. My use of textiles magnifies feminist and queer histories through materiality and also shifts the marginalization of craft into a site of recognition and agency. As Hillman does in *Magic*, I utilize craft as a tactic to mirror empowerment and disenfranchisement in this era of ongoing AIDS.

Notes:

1. The 1996 exhibition of the AIDS Memorial Quilt covered the entire National Mall in Washington, DC, and was the last time that the quilt was laid out in its entirety. So many panels have been made for people who died of complications arising from HIV and AIDS that it is now too big to lay them all out at the same time. For more information, see *aidsquilt. org*.

2. Soon after I began graduate school at the California College of Arts and Crafts in 2003, a few members of the board of trustees and the president of the school made the decision to drop the word "craft" from the name of the school, and it was renamed California College of the Arts. A number of other institutions across the United States erased the word "craft" from their official names around this time too, including the American Craft Museum, which became the Museum of Arts and Design.

3. Writings that provide extensive analysis of the AIDS quilt include the essays "Mourning and Militancy" and "The Spectacle of Mourning" in *Melancholia and Moralism: Essays on AIDS and Queer Politics* by Douglas Crimp (2004); "White Glasses" in *Tendencies* (1993) by Eve Kosofsky Sedgwick; *Tangled Memories: The Vietnam War, the AIDS Epidemic, and the Politics of Remembering* (1997) by Marita Sturken; and "The Kitschification of AIDS" in *The Rise and Fall of Gay Culture* by Daniel Harris (1999). Also see an interview with Daniel Harris conducted by Ted Kerr for Visual AIDS at *http://oasisjournals.com/Issues/9712/ feature-harris.html*.

4. ACT-UP page about Pfizer: *http://www.actupny.org/reports/pfiz-ernyc9-00.html*. A more recent article: *http://stopaidscampaign. org/2012/02/activists-to-novartis-stop-trying-to-legalise-murder/*.

5. Alexandra Juhasz interviewed by Ted Kerr of Visual AIDS from a pamphlet from the event Time Is Not a Line, which was held at The New School for Social Research on March 10, 2013. The interview between

Kerr and Juhasz can be found on the Visual AIDS blog at *visualaids. org/blog/detail/when-act-up-is-remembered...other-places-people-and-forms-of-aids-activism#.UfqQ8GT71e0*.

6. In her article "Life in the Archives," which appeared on January 27, 2012 on the San Francisco Museum of Modern Art's Open Space blog, Latimer asks, "Can we imagine archival practices that exercise poetic license to make the invisible visible, render the unthinkable intelligible, and articulate the unspeakable?"

~~~~~~~~~~

*L.J. ROBERTS is a writer whose work bridges craft and queer theory and an artist who creates large-scale knitted installations and small intricate single-strand embroideries. Their work was included in 40 Under 40: Craft Futures at the Renwick Gallery of the Smithsonian American Art Museum in 2012. ljroberts.net.*

~~~~~~~~~~

PHOTOS:

Page 124: *AIDS Quilt*, Carol M. Highsmith Archive, Library of Congress, Prints and Photographs Division, Washington, DC. LC-DIG-highsm-13502. Photo: Carol M. Highsmith

Page 128: Patrick Hillman, *Magic Johnson #1*, 2007, acrylic yarn. 36 x 48 in (91.44 x 121.92 cm). Photo: L.J. Roberts

Page 129: Patrick Hillman, *Magic Johnson #2*, 2007, acrylic yarn. 36 x 48 in (91.44 x 121.92 cm). Photo: L.J. Roberts

Page 130 (top): L.J. Roberts, detail of *Portrait of Deb 1988–199?*, 2013, single-strand embroidery on cotton. Photo: L.J. Roberts

Page 130 (bottom): L.J. Roberts, detail of *Portrait of Deb 1988–199?*, 2013, single-strand embroidery on cotton. Photo: L.J. Roberts

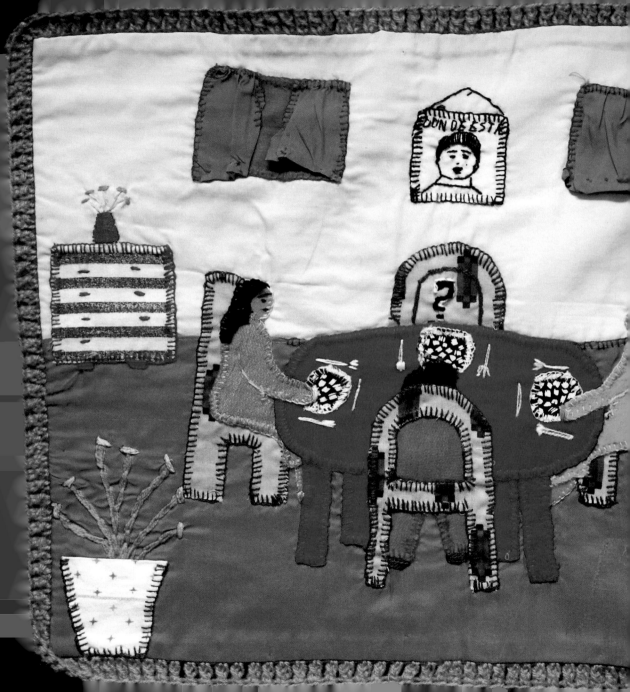

SEWING VOICES: THE *ARPILLERISTAS* AND THE WOMEN OF THE ADITHI COLLECTIVE

Heather Strycharz

"We wanted to do something different. We didn't want to make something that would function as a decoration ... We wanted to embroider our story, the harsh and sad story of our ruined country." —Violeta Morales, quoted in *Tapestries of Hope, Threads of Love: The Arpillera Movement in Chile*[1]

Dark issues are illustrated with bright colors in works by both the Chilean *arpilleristas* (creators of the tapestries known as *arpilleras*) and the quilters of the Adithi collective in India. Whether the topic is torture, female infanticide, AIDS, or imprisonment, their pieces invite the viewer in. Traditionally, non-confrontational materials create a welcoming entry into the world of the maker. Both groups of artisans share a matter-of-fact take on heavy subjects that are usually avoided in conversation. Because of their materials, arresting images, and powerful content, these creations are hard to ignore; they call out to the viewer, demanding our attention.

While there has been some writing about the *arpilleristas*, very little is known about the Adithi collective, yet both groups have created important works of craftivism that have been overlooked for too long. They deserve to share the stage with the pink knitted tanks, confrontational sweaters, and yarn bombs of contemporary craftivism. This essay covers the history and circumstances of these crafters' lives in order to provide insight into their powerful works of craft.

Arpilleristas: Documenting the disappeared
During the rule of Chilean dictator Augusto Pinochet

from 1974 to 1990, approximately 3,000 individuals were reported as murdered or "disappeared" and an estimated 28,000 suffered unwarranted incarceration and torture. Society was controlled through intimidation tactics, manipulation of the press, and the dissolution of rival political parties. Because of the regime's economic policies and political structure, many citizens were forced into extreme poverty. The majority of the disappeared, murdered, and incarcerated men were the sole providers for their families. Under this repressive regime, and in a culture in which women had limited social and financial roles, many Chilean women struggled to find ways to survive.

Fortunately, the Roman Catholic Church stepped in to assist the victims of the Pinochet regime. Under Chilean law, the church was recognized as an independent political entity and a sanctuary. This protection allowed the church to become one of the last remaining safe havens for those desperate to survive under the totalitarian government. Within the protection of the Archdiocese of Santiago, Cardinal Raúl Silva Henriquez established the pro-democracy agency Vicaría de la Solidaridad (Vicariate of Solidarity). The Vicaría provided legal and occupational services for individuals and sponsored *arpillera* workshops.

Arpillera is the Spanish word for "burlap" and the name of the colorful embroidered tapestries that are a traditional form of art in South America. The tapestries are created using embroidery and appliqué. Scraps of recycled fabric and colorful thread are used to create images, which are mounted on a foundation of burlap. Before the Pinochet government, *arpilleras* sold to tourists included images of pleasant pastoral scenes depicting rural Chilean life. After Pinochet came to power, *arpilleras* became documents of the human rights abuses and hardships that Chileans faced during his

regime. The *arpilleras* gave women a voice and an outlet for their grief and sense of injustice. Those who spoke out publicly against Pinochet risked imprisonment, torture, and death. *Arpilleras* were a way to circumvent this censorship so that the women could record the loss of their loved ones, the brutal violence of the military, and the daily oppression they faced. These women were not just crafters, they were *arpilleristas*: makers of *arpilleras* and dissenting voices who documented the unpublished history of the dictatorship of Chile.

At first glance, the *arpilleras* look like bright and colorful folk art. Further inspection reveals the presence of graves, chains, blindfolds, and bloodshed. One doesn't have to be fluent in Spanish to make out the words "torture," "disappeared," and "exile" stitched into the bright squares of fabric. Sometimes the *arpilleristas* sewed secret pockets with notes stuffed inside them onto the backs of their works. These notes described those who had disappeared in an attempt to keep their memories alive. Not all of the *arpilleras* depict such dark subjects; some are hopeful and show Chile in a world without Pinochet, depicting Chileans gathering at big feasts and walking in the streets without fear.

The Vicaría bought the *arpilleras* directly from the *arpilleristas* and, in turn, sold the tapestries abroad to researchers, museums, and non-profit organizations. The *arpilleras* made it past unsuspecting customs officials who never would have thought that the brightly colored crafts revealed the horrors of the Pinochet government. Thus the *arpilleras* defied censorship and were displayed in museums throughout the world. In this way, the *arpilleristas* maintained economic security while simultaneously acting as a strong voice against the Pinochet dictatorship.

Before Pinochet, many Chilean women were not politically active, but at the *arpillera* workshops, women

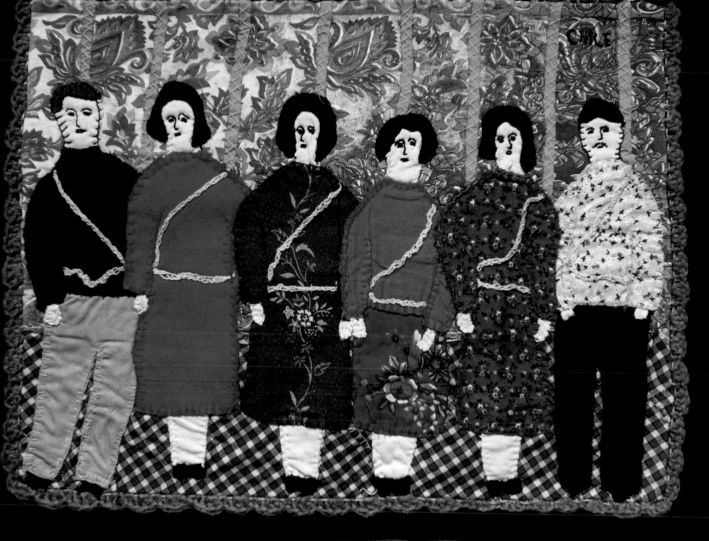
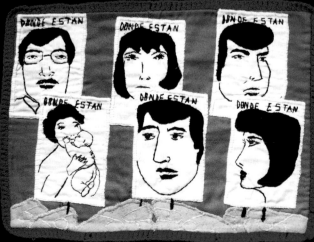

found emotional support. While they stitched, they spoke with one another about the family members and friends they had lost, the hardships they dealt with, and their feelings about the government. The workshops provided much needed solidarity for the *arpilleristas*. The women were from different parts of society who likely would not have met if it were not for the conditions that brought them together at the Vicaría. As the *arpilleristas* learned from each other and worked together, some began to stitch more daring, politically charged depictions and messages onto their *arpilleras*. Some *arpilleristas* became involved in other forms of protest, such as hunger strikes and marches. Even after Chile transitioned to a democracy in the 1990s, these women continued to be politically active.

Adithi collective: Finding a voice within patriarchal oppression

Adithi is a non-profit organization in the Bihar region of India that works to empower women living below the poverty line through programs that support economic and social development. In 1988, in the village of Bhusura, Kailash Prasad Singh and his wife Ramsati Devi started one such program called Mahila Vikas Samyog Samiti (MVSS, Women's Cooperative Development Organization). Through this program, they sought to revive the domestic art of quilt-making or *sujuni*, as it is known in the region, realizing that the quilts were a potential source of income for women living in poverty who were prevented from working due to social customs.

When the project first began, the handful of women who joined were met with ridicule but little resistance. Many people in the village were skeptical that the project would have any lasting effect. Men permitted their wives to participate because they viewed quilt-making as a woman's hobby, not a source of income. However, once the quilts began to sell and the women to earn money (around thirty cents a day), word spread about the program. The number of women involved grew from five in 1988 to around 600 ten years later.

Sujuni are created by stitching together scraps of colored cloth, old saris, and/or dhotis. They were traditionally given as gifts to newborn children because the softness of the worn fabric was more suitable than new cloth for swaddling infants. The quilts are filled with hand-drawn images that are transferred to the quilts using embroidery. The motifs are usually outlined with multi-colored chain stitching and then filled in with fine running stitches, with about 200 stitches per square inch (2.5 cm).

The founder of Adithi, the late Viji Srinivasan, along with visiting designers and researchers from abroad, encouraged the women to embroider images from their own lives. The women gradually moved away from depicting the pastoral scenes and religious imagery of Hindu epics typical of traditional *sujuni* and began to embroider images that reflected their daily lives and struggles. The women of the Bihar region live in an extremely oppressive patriarchal society; female infanticide and neglect is such a common practice that, between the years 2000 and 2010, there were an estimated 100 deaths among girls aged one to five for every fifty-six deaths among boys. Women are discouraged from leaving their houses, and when they do go outside, they must practice *ghunghat* (using a veil to cover the entire face). The marriage dowry practice is another major issue for women in the region; if her family cannot pay the dowry, the woman often endures abuse, even immolation, from her husband's family. Although most of the *sujuni* imagery focuses on cultural practices of the Bihar region and their direct affect on women, the

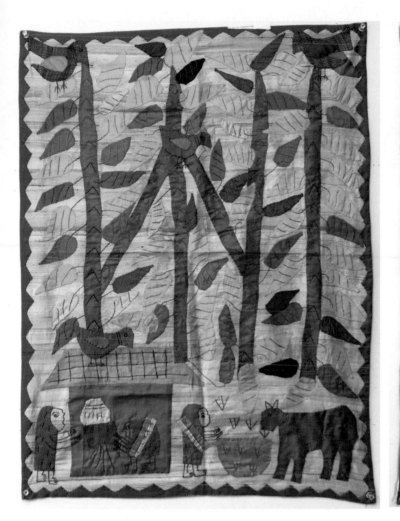

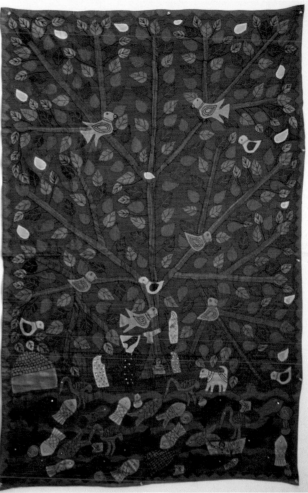

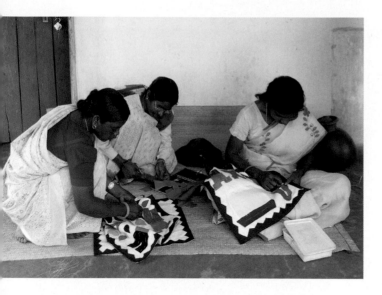

artisans also address other topics, such as the spread of AIDS and the detrimental effects of pollution.

The *sujuni* project quickly brought about positive change for the women who participated. Simply attending the two-week *sujuni* workshops in order to learn how to make the quilts was an achievement for women who had previously seldom left their homes. By earning an income, they became more empowered and met less resistance from men as they began to show more of their faces in public, participate in important family discussions, and in some cases even insist on marriage without a dowry. Subsequently, the age of marriage has risen, literacy and numeracy rates have improved, and these women finally have some disposable income over which they maintain control.

As part of the *sujuni* program, participating women attend monthly meetings to discuss the progress of their quilts. The collective also serves as a worker's union in which participants contribute a small amount of money each month to a joint bank account. These funds are loaned to individual members when emergencies arise. During the meetings, the women also discuss issues that affect the village. Like the *arpillera* workshops, the *sujuni* groups serve as a means to create solidarity and collective action where there was none before.

The *sujuni* project was the beginning of a chain reaction, but despite all the positive breakthroughs, the women of Bihar still have a long fight ahead of them. Although the Indian government outlawed the practice of sex-selective abortions, and non-profits have worked to reduce female infanticide, the ratio of females to males in the local population continues to decrease. According to a 2011 UN census report, Bihar has one of the worst sex ratios in the country, with just 916 females per 1,000 males. Dowry is still a widespread custom, and although literacy and numeracy among women is increasing, the

rates are still relatively low. Only time will tell whether the efforts made by Adithi and the *sujuni* artisans will bring about further developments for equality.

Finding a voice through craft

The women of Santiago, Chile, and those in the village of Bhusura in India prove that craft can be a successful tool for activism. The *arpilleras* defied the censorship of a powerful dictatorship by documenting and disseminating the horrors of the Pinochet government. The quilts of the Adithi collective helped to elevate women in an oppressively patriarchal society by giving them a way to earn a living and become more active within their community. Craft gave these women an outlet to address their fears and frustrations in circumstances that seemed hopeless.

Both groups were reintroduced to crafts that had been regional traditions, but the artisans were encouraged to move away from creating traditional pastoral scenes and instead share their own experiences and memories. Under the protection of doing non-threatening "women's work," they were able to gather and learn from one another. Craft was a unifying starting point, and during hours of painstaking stitching, the women found empowerment and solidarity. The *arpilleras* and *sujuni*—as documents that recorded the women's hopes and losses—serve as testimonies of their experiences, and through these artifacts their voices will be heard.

Notes:

1. Agosín, Marjorie. *Tapestries of Hope, Threads of Love: The Arpillera Movement in Chile, 1974–1994*. Albuquerque, NM: University of New Mexico Press, 1996.

Sources:

"Adhiti." *Parampara Project*. Center for Environment Education. *http://www.paramparaproject.org/institution_adhiti.html*.

Agosín, Marjorie. *Tapestries of Hope, Threads of Love: The Arpillera Movement in Chile, 1974–1994*. Albuquerque, NM: University of New Mexico Press, 1996.

Chari, Pushpa. "Voices from the Margins." *The Hindu: Magazine / Arts & Crafts,* March 5, 2009. *http://hindu.com/mag/2009/03/15/stories/2009031550310700.htm*.

Eshet, Dan. *Stitching Truth: Women's Protest Art in Pinochet's Chile*. Brookline, MA: Facing History and Ourselves, 2008.

Gabriel, Mary. "The Embroidered Truth: Women from Rural India Find their Voices through Quilt-Making." *National Post*, March 30, 1999.

McCracken, Sarah. "*Arpilleras*: A Visual History of the Poor Under Pinochet." *Prospect Journal*. August 24, 2011. *http://prospectjournal.org/2011/08/24/arpilleras-a-visual-history-of-the-poor-under-pinochet/*
Miller, Earl. "Interview With Skye Morrison." *Surface Design Journal* 24 no. 4 (2000): 10–15.

Morrison, Skye, Dorothy Caldwell, Laila Iyabji, and Viji Srinivasan. "Stitching Women's Lives: Sujuni and Khatwa from Bihar, India." *Textile Museum of Canada Collection and Exhibitions*. Textile Museum of Canada, 1999. *http://www.textilemuseum.ca/apps/index.cfm?page=exhibition.detail&exhId=172*.

Robinson, Ruth. "Needlework Stories Tell of Chilean Life." *The New York Times* October 22, 1989. *http://www.nytimes.com/1989/10/22/nyregion/needlework-stories-tell-of-chilean-life.html*.

"Sujani Embroidery of Bihar." ARCH Academy of Design. *http://resources.archedu.org/sujani_embroidery_bihar.html*.

United Nations Development Program, *About Bihar. http://www.undp.org/content/india/en/home/operations/about_undp/undp-in-bihar/about-bihar/*.

~~~~~~~~~~

**HEATHER STRYCHARZ** *is an independent designer and researcher living in New Haven, Connecticut. She has a BFA in media arts from the Hartford Art School and recently graduated from The New School in New York City with an MA in media studies. With a background in fine arts, design, and art history, Heather is fascinated by craft and its ability to connect, heal, and transform.*

~~~~~~~~~~

PHOTOS:

Page 135 (top): Violeta Morales, *Pancartas*, c. 1993, cotton blended fabric, acrylic yarn, and sackcloth, Santiago, Chile. Photo: *cachando-chile.com*

Page 135 (bottom): Gala Torres, *Encadenamiento / Enchainment*, c 1990, cotton blended fabric, acrylic yarn, and sackcloth, Santiago, Chile. Photo: *cachandochile.com*.

Page 133: Violeta Morales, *Cena Familiar / Family Dinner*, c. 1992, cotton blended fabric, acrylic yarn, and sackcloth, Santiago, Chile. Photo: *cachandochile.com*.

Page 137 (left & right): Khatwa made by the Adithi Collective, Photo courtesy of HomeWorkers Worldwide, 2003.

Page 138: Women sewing khatwa, Photo courtesy of HomeWorkers Worldwide, 2002.

Cleaning Beaches Project

Clare Thomas

The Cleaning Beaches project started almost by accident. One day, on my favorite beach, I found a piece of fishing net. Then I noticed more debris—plastic bottles, polystyrene, rope fragments, cigarette butts, shotgun cartridges, tampon applicators, and countless pieces of unidentifiable plastic debris. I began to pick it up and bring it home.

I started working with others. We cleaned beaches wearing red super-hero pants, made a tipi out of beach debris, and quadrats of bamboo and string for a citizen-science investigation of the beach. We took the ferry to more distant beaches and talked to other passengers about the trash in our rubbish bags on the return journey.

Picking up other people's trash in public places breaks the bounds of normal behavior and brings us face to face with the unintended consequences of plastic production. Beach cleaning is an act of repair. Craft allows me to tell the story of that repair: knitted strips whose patterns describe the different debris found on one beach; a scarf whose stripes record every beach cleaned over a year and a day; or a knitted swimsuit covered with debris to represent the plastic now found in every ocean on the planet.

With wool and cloth, I wrap plastic trash and transform it into something to be treasured. Taking beach debris and wool into galleries and shopping malls, I teach others to wrap, using the opportunity to talk to people from all walks of life about the challenges of ocean plastic pollution.

PHOTO:

Clare Thomas, Knitted beach cleaner's belt and amulet bags. Belts made from beach debris with hand-knit wool bags containing beach debris, Falmouth, UK, 2012. Photo: Clare Thomas

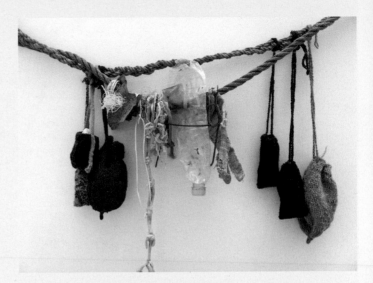

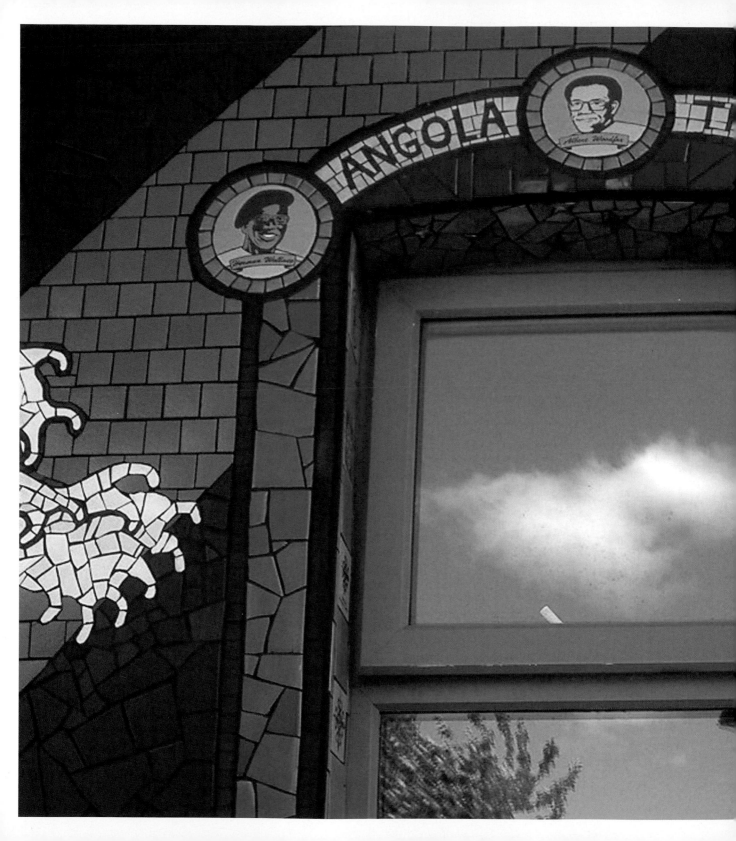

INTERVIEW with Carrie Reichardt

Q: What was your first activist act?

A: Between 1989 and 1991, I was at Leeds Polytechnic (now called Leeds Metropolitan University) doing a degree in fine art. I was very influenced by the Guerrilla Girls, Jenny Holzer, and a lot of 1970s and '80s feminist artists. Fellow artist Karen Wydler and I made a series of "word" art stencils during a time when there were many sexual assaults against women in the local area. We made slogans such as "Don't be scared, Be angry" and "Less Protected = Most Vulnerable." We wanted to spray them onto the paths that went through dark and oppressive spaces near the college, and we were really interested in the concept of reclaiming public space and empowering ourselves through our creative voices. We didn't do much actual stenciling, but those ideas became embedded in our consciousness as one way to express ourselves through guerrilla art tactics.

Q: What was your first experience with craft?

A: My mother was a very skilled and passionate knitter and introduced me to the joy of creating. All I ever wanted to do was make stuff—be it gluing, sticking, cross-stitch, working with clay, etc. Much later, I kind of drifted into a fine arts degree, though I really wanted to study film. I left Leeds in 1991 with a first-class degree in sculpture. When I was at college, there was a very clear distinction made between fine art and craft. Different art and craft practices were not integrated,

and all you could choose from was painting, print, or sculpture. It was not until the late 1990s, when I started to take courses in stained glass and mosaic, that I was really turned on to the power of craft.

Q: *How did you put the two together?*

A: It happened organically. In 2000, I was working as a community artist with Living Space Arts, along with Karen and her brother, Mark Wydler, and had just met my partner, Thayen Rich. He is also an artist and activist. I saw an advertisement in *Big Issue* journal from the non-profit organization Human Writes that asked people to befriend those on death row. I applied and became a pen pal to Luis Ramirez, who was on death row in Texas. Our friendship inspired me to mosaic the outside walls of my house and turn them into some mad, outsider-type grotto. I wanted to create a piece of public art that was uncensored and unsellable; I wanted to avoid the restraints encountered in community work. In 2005, I traveled to Texas to visit Luis on death row and spent the last couple of days with him just before the state of Texas put him to death by lethal injection. I truly believe that Luis was innocent of the crime for which he was executed. His murder compelled me to dedicate my creative energies to engage with others and raise awareness about injustice.

Following his death, I spent the next eight months creating a ceramic mural on the back of my house in his memory. This wall has inlaid porcelain tiles with his last statement on it, and his actual prison ID card is also embedded into resin in the wall. His family came over from Texas to unveil it on the summer solstice in 2006. I think this marked a turning point for me; I realized that my public mosaic work could have the power to convey a very political, social message and start to open a dialogue through art.

Q: *What are the Treatment Rooms?*

A: I used to work from a room in my house, and on its door was a "treatment room" sign that I had procured from an old mental hospital in Hackney [UK]. I liked the idea that my studio was where I went to heal myself. I decided to call my entire house the "Treatment Rooms" and awarded myself a blue plaque (placed on heritage buildings in which notable Britons have lived) from the English Hedonists. I started to collaborate with some fellow activist-artists—Karen and Mark Wydler, Lori Bell, Sian Smith, Kevin O'Donohoe, and Linda Griffiths—and we called ourselves the Treatment Rooms Collective. Now there are many others who have come to collaborate with us under this name.

Q: *I've heard you talk about the healing aspect of craft. How did it heal you?*

A: I have personally been greatly affected by mental health issues for much of my life. I have had two major breakdowns and spent quite a few years being emotionally and physically catatonic on Prozac. When I was a "fine artist," I used my art as a "last resort," a cathartic expression that stopped me from total self-destruction. But then I rediscovered craft. I have learned that the meditative, repetitive, and creative nature of craft is emotionally therapeutic.

Q: *How did you get into ceramics?*

A: I first tried mosaics in about 1998 and fell in love with it straight away. I had already started to work a little in stained glass and was interested in how traditional craftwork could be subverted. Then in 2003, I began to attend adult classes in ceramics and became totally hooked on it. I have spent many years just researching how to transfer images onto clay.

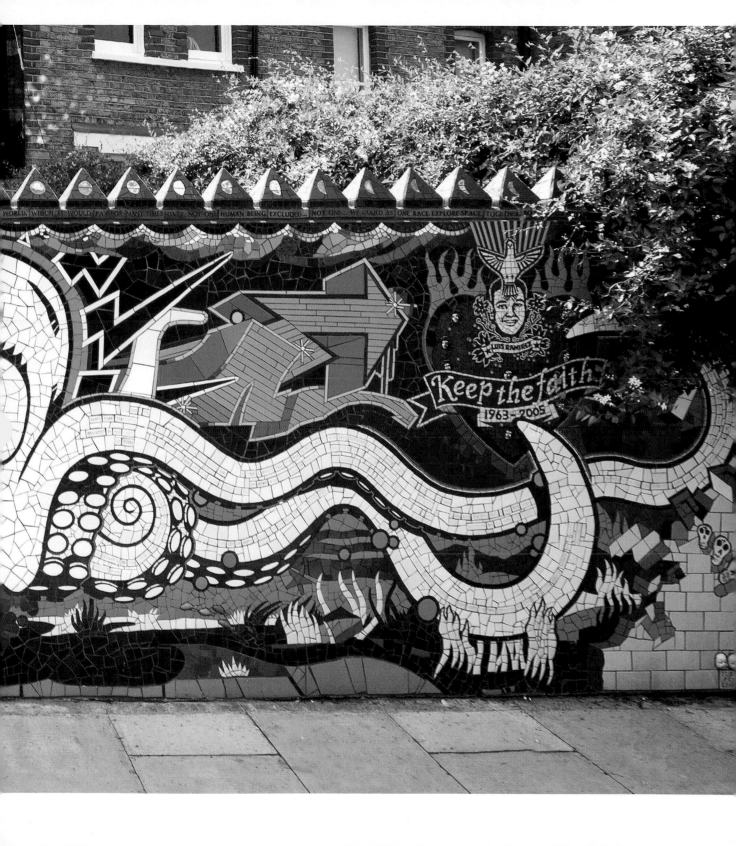

WORLD, WHICH IT WOULD PAY FOR MANY TIMES OVER, NOT ONE HUMAN BEING EXCLUDED... NOT ONE... WE COULD AS ONE RACE EXPLORE SPACE TOGETHER

LUIS RAMIREZ

Keep the faith

1963 - 2005

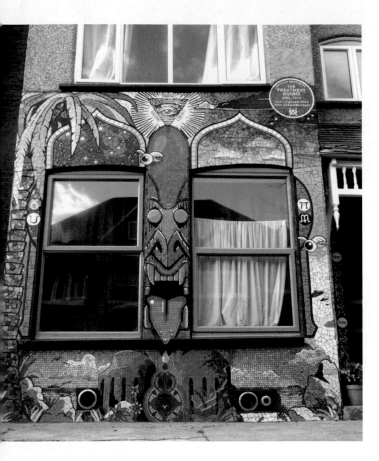

Q: What is the political/social/economic aspect of your work?

A: It depends on which work you are talking about. There is my private work that I sell, which tends to be very political in nature. I question the new colonial wars and want to make public statements about injustice. I was educated in the sphere of the individual artist, a kind of elitism, and I have tried to move away from that. However, marketing one's self and selling one's work as a name is still a capitalist tool that's hard to avoid. My community and public work has very real social and political implications, as I am attempting to help various communities find a creative voice that will empower them. My craftivist work is about working at a grassroots level to raise consciousness about personal social injustices that I care passionately about.

Q: How did you become involved in those causes?

A: My work has always been a reaction to personal events and is mainly driven by my involvement with injustice and fighting for my imprisoned friends. After Luis's execution, I started to write to political prisoners in Angola Prison (Louisiana State Penitentiary), former Black Panthers who have spent more than four decades in solitary confinement. Their names are Herman Wallace[1] and Albert Woodfox, two of the Angola Three (the third, Robert King, was exonerated in 2001). I have also corresponded with Kenny (Zulu) Whitmore. My involvement with the campaign for these prisoners became the driving force behind my early work on the Treatment Rooms. In 2008, Robert King unveiled a forty-foot (twelve-meter) tall mosaic mural on the back on my house that draws attention to their unjust imprisonment.

Q: *Has your work in these causes evolved?*

A: My work is a coping mechanism to deal with the horrors and injustices I see taking place across the globe. I can't separate my life from my work or causes. I don't even see it as a "cause"—this is personal. My close friends are held in barbaric conditions, and the best way I can help them is to use my creative skills to highlight their cases.

Q: *Some of your work is both public and permanent. What, if any, dialogue has this opened up with those who see the work?*

A: I believe that the public has a great love and respect for ceramics. When I started to mosaic my house, I expected to meet with some local opposition. I know a few people did not like what I was doing, but most— even those who did not agree with my political views— supported me. I believe that this appreciation of the craft and time that goes into my work allows me to be far more publicly political and radical than, say, if I was a painter. I also feel that it allows for a dialogue to open where there might not otherwise have been one. Issues such as the death penalty are usually polemic, and people already have entrenched views on the subject. The beauty of craftivism is that it hooks into a primitive part of our psyche, and that challenges the viewer both emotionally and intellectually.

Q: *Has this dialogue changed over the years?*

A: Yes, it changes as I change. I now find myself more often trying to facilitate others' ideas than merely expressing my own. I have, in the past, made a huge personal investment in creating my work, and I believe that this has enabled me to speak from a far more emotional and attached level.

Q: *Have you wanted to make any changes to any of these more permanent pieces?*

A: Once finished, my work is very permanent. The only way to "change" it would be to literally smash it up and remake it. I have never been so unhappy with the aesthetics of a piece that I wanted to do this. The essence of my work is about the emotional content, and I would always rather look forward to investing my energy in new pieces.

Q: *You also help others learn about the possibilities of the "ceramic revolution"—what unexpected lessons have you learned from these experiences?*

A: I have learned that collaboration always leads to a sharing of ideas. It always enriches you as an artist and pushes your own personal work forward. I have also discovered that people seem to have a universal, innate love of clay and ceramics.

Q: *What types of groups have you been able to work with?*

A: As a community artist for more than fifteen years, I have had the pleasure of working with many amazing and diverse groups, including people with mental health issues, homeless people, those excluded from school, orphans in Romania, street kids in Mexico, and most recently, with students in Argentina to produce a public artwork that commemorated those who went missing during the brutal dictatorship of the 1970s.

Q: *What were some of the more memorable experiences of some of the participants?*

A: In one of my earliest community projects, I ran two weeks of painting and mosaics workshops in a school attached to an appalling orphanage in Romania. I went

there with Living Space Arts. We visited the orphanage a few times and worked with a group of children who had been very badly treated. These were children who were rarely shown any emotional care and had never really been exposed to art materials before. At first, we were told that we could only work with the most "able," but we insisted on working with all of the students there. I will always remember one particular child called Serena. When they brought her to work with us, she was crooked and bowed over and could hardly make eye contact, clearly the "runt" of the group. We were told that she might even be blind. But she was gifted as an artist. As soon as she was given paper and paints, she started to literally blossom in front of our eyes. Over our three visits there, we watched as she metamorphosed into an upright, strong, and confident student. Clearly, her ability in art had raised her social standing—not just with her peer group, but with those who worked in the orphanage. I am sure what we did there helped to change the perspective of the people who looked after the children at the orphanage.

Q: What did these workshops teach you?

A: That art and creativity keeps us all sane and humane. It is the most powerful tool we have to bring about positive change and social equality in society. I learned that facilitating creativity has the power to change the course of an individual's life and massively improve their sense of worth within their own community.

Q: *What would your ideal craftivist piece be? Where would it be? Would it be a solo piece or something you did with others?*

A: I think the Tiki Love Truck, "our mobile mosaic mausoleum," is a great example of a craftivist piece. It was made collaboratively and is drivable—and therefore, it's moveable. In 2007, I was asked to be present at the execution of a friend of mine, John Joe "Ash" Amador. He was in the prison cell next to Luis Ramirez. I was close to Ash's family. My friend, the artist Nick Reynolds, came with me to make a death mask of Ash straight after his execution. Incredibly, Texas is the only state in the US where you can legally move a dead body, as long as you provide your own body bag. So we brought a bag, collected him from the mortuary attached to the prison, put him in a rented car, and drove him to a cabin in the woods where I assisted Nick in casting Ash's head. A copy of his death mask is now the centerpiece on the top of the Tiki Love Truck. Eight days after Ash's death, this truck drove through the streets of Manchester, as part of a parade, with over 30,000 people watching.

Notes:

1. After a judge overturned his conviction, Herman Wallace was freed from Angola State Penitentiary on October 1, 2013, and died two-and-a-half days later due to complications from liver cancer.

CARRIE REICHARDT *is a leading contemporary artist who works from a mosaic-covered studio in London, UK, called the Treatment Rooms. A self-titled craftivist, her work collapses the boundaries between craft and activism, using the craft techniques of mural, mosaic, and screen-printing to create intricate, highly politicized works of art.*

Carrie trained at Kingston University and achieved a first-class degree in fine art from Leeds Metropolitan University. She was artist in residence at Camberwell College of Arts in 2009, following this with a period as artist in residence at the Single Homeless Project. Carrie has been involved in community and public art projects for more than fifteen years and has designed and consulted on large-scale mosaic murals as a way to educate and celebrate local communities.

Inspired by William Morris and the long-standing tradition of subversive ceramics in the UK, Carrie created the "Mad in England" trademark. This branded series of affordable, subversive souvenirs, which countered the overwhelming patriotism of 2012 by celebrating the protestor, tapped into the mood of national dissent.

PHOTOS:

Page 142: Close-up of back of the Treatment Rooms, 2006. Photo: Thayen Rich

Page 145: Close-up of *Luis Ramirez Memorial Wall*, prison ID, 2006. Photo: Lairy Love

Page 146–47: The *Luis Ramirez Memorial Wall* at the Treatment Rooms, 2006. Photo: Wayne Youngman

Page 148: Front of the Treatment Rooms, 2005. Photo: N.J. Beatty

Page 150–51: Public community mosaic on the front of the Treatment Rooms, London, 2012. Photo: Mark Baker

Page 152: *Tiki Love Truck* on parade in Manchester, UK, 2007. Photo: Paul Herrmann

Activating Communities

When we make and take our creations public, we connect with community. As we've seen, people feel an innate connection with craft. We all have a story about craft that makes us smile and reminisce. The power of craft lies in this reminiscence, as it evokes warm memories and stories of items that were made with care, whether for us or for others. There is something in the essence of a handmade item, a vibrancy that doesn't emanate from mass-produced wares—maybe its colors were chosen because the maker liked them (not because they were trendy), or maybe the combination of materials is unique to the handmade realm. When you meet another maker in your community while wearing one of your own homemade sweaters or scarves, chances are that you've found yourself not only a new friend but a new ally.

While many of the previous essays have touched on broader involvement in craftivism, this last section is about directly engaging with your local community, whether by embroidering with passersby at a fair, running a shop or center that holds craft classes, or going out into the community to help its inhabitants and surroundings by doing crafts together. These stories remind us how important it is to have a sense of ownership in and be a part of our communities, the key to the meaning of craftivism.

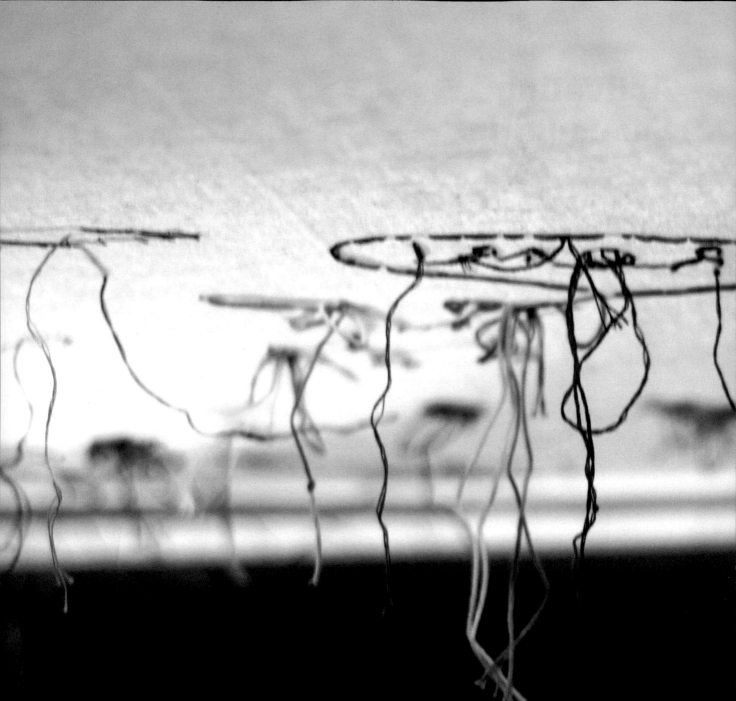

STITCHING IT TOGETHER

Leanne Prain

A few years ago, I set out to write a book on subversive embroidery. As my artistic tastes have always been considered a little bit offbeat, I wasn't too surprised by the sort of reactions I got when I'd mention that I was putting together a book on stitch work. There were the quizzical looks, the "who has time to do that?" question, or the "I tried that once, it was hard" comment.

Sadly, for most people, embroidery can seem irrelevant.

When Victorian ladies of the leisure class took up needle and thread in closed circles and private salons, the clichéd image of the strange spinster who embroiders alone began to emerge as a stereotype to mock the craft. What were those women doing, out of society, tucked into place on their own, without husbands? The image of a quiet woman bent over her stitching comes with a cautionary tale of loneliness and peculiarity and, as such, doesn't entice a person to want to stitch for fear of association. It is an unfortunate and inaccurate representation, as I've found that the stitching and embroidery community are anything but anti-social.

Many preconceptions around stitchwork techniques can also make embroidery seem off-putting. Some people are deterred from the craft because they have misconceptions of what embroidery should be—they see it as an unachievable type of perfectionism made of shiny threads and impossibly small stitches. Or they think that only people who have idle hours, days, and years have time to embroider. Some believe that an embroiderer must be willing to recreate the Bayeux Tapestry. The dedication required to stitch—in these misconceptions—seems far removed from modern-day

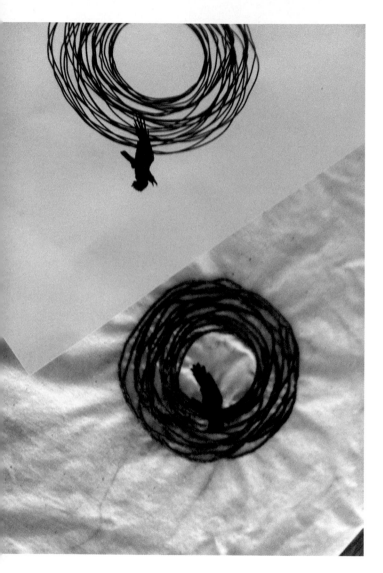

realities, when most of us spend our hours watching Netflix while surfing the Internet on our phones.

As a DIY author, I regularly give public talks about the politics of modern handicrafts. Many of the people who attend my talks would not identify as crafters or embroiderers—but they are interested enough in these themes to give an hour of their lives to hear me speak. More often than not, someone will approach me after the talk and tell me that while they admire the art of others and are interested enough to attend a lecture, they "can't" stitch. This kind of statement is usually accompanied by a story about the one time they tried to embroider (like the one time they tried to swim or drive a car, I guess—I bite my tongue) but they had to stop because someone told them they were doing it wrong. These stories always include a naysayer or a broken rule, or something else that the novice stitcher did wrong. It is heartbreaking.

As if all of this isn't enough to keep you from stitching, traditional embroidery books often contain gems like "never knot your thread," "never, ever lick your thread," and "always keep the back of your work as neat as the front of your work." As a self-taught stitcher, I am guilty of breaking each and every one of these rules. I encourage you to be guilty of breaking rules, too. Split some thread and tangle it, suck your needle eyes until they get rusty, do whatever you want—just as long as you try stitching more than once. Please try it more than once. Both you and your stitchwork need a second chance. Some of my favorite embroidery artists—Aubrey Longley-Cook, Alexandra Walters, and Ray Materson—prefer to use just one type of stitch to create highly arresting, provocative works that not only challenge your eye but also your intellect. If they'd listened to criticism or rules, we wouldn't have their artwork.

Embroidery is a language, and as my favorite artists

have shown me, you can use it to communicate. Each twist and turn of your needle becomes a vowel, where you choose to plunge your needle through the fabric, a consonant. Straight stitches, French knots, simple or complicated—you can express yourself by how you move your thread through the fabric.

When you experiment with stitching, sometimes you have to go it alone, on blind faith—just as when you make a shadow puppet for the first time or try out a new dance move. You don't really know what the end result will be until you try it. By trying things out, you have to appropriate the action. One small stitch builds on the next. Your project might turn out exactly as you expected, but it's possible that it will not. Either way, it's okay, as you'll have some sort of result that you can build upon.

I am a self-taught embroiderer, and while I admire fine craftsmanship, I'm always drawn to others with a self-taught ethos. My childhood was influenced by projects of trial and error. I was born in the mid-1970s on Canada's West Coast, surrounded by the DIY ethics of back-to-the-landers who just figured out what they were doing, step-by-step. They rebuilt search-and-rescue planes in boat sheds in their backyards, welded two cars together to make a camper van, created Chinese junk rigging out of plastic tarps, and formed sod houses. It was a time of experimentation and making things up as you went along—there weren't rules, because creating rarely has rules.

My first memory of embroidery was watching my mother embroider a white caftan with a satin-stitch border of purple johnny-jump-ups (a type of violet)—a gift for my liberated father who wore it with flip-flops and necklaces of seed beads. Later, she stitched my gym bag with the iconic Holly Hobbie. Embroidery was just something that my mom did. It wasn't meant to hang on a wall or be precious; it was something that adorned usable items, as simple as a kiss on the cheek or a homemade pie—a small token of affection—simple and not a big deal. A stitch might be out of place here and there—but did it really matter? The end result was something created by hand, something with the mark of the maker on it. Because of these memories, I don't think embroidery should be considered "artisanal" or twee; it should just be something people do to express and delight themselves.

The act of embroidery has been frequently compared to the act of meditation—both are restful ways to pass the time. I've found that the act of teaching someone else how to embroider has the same effect. Sharing your stitching skills does two things: first, it teaches you to put aside thoughts of not being good enough, and second, it makes you slow down. You have to talk through your actions. Explaining a craft can make you consider your choices—why you do what you do. Teaching someone else how to make a stitch demystifies the process—it makes the embroidery change from something "those" people do to something that anyone can participate in and enjoy. Democratizing these skills is a political act; it creates an understanding of what goes into creating this sort of work, which, in turn, enhances the value of handmade goods, both as finished artworks and as acts that defy the notion of time as a "luxury." Teaching embroidery can be a feminist act that celebrates the many hands of women who stitched through history. Providing embroidery skills to men, women, and children changes the paradigm of embroidery as "women's work" and places it into the hands of creators of all genders and ages. There's magic in teaching someone the basics of stitch work. Dividing a mercerized thread into six small strands and explaining how a finer thread will pass through tight fabric is a revelation.

There will likely be some failed attempts, but with a little encouragement, the student will try again.

People who craft together manage to find common ground, even when it seems at first that they have nothing in common. They may come from different backgrounds or religions or be different ages, but crafting creates a shared dialogue between them. Community gardens, food co-ops, and recycling coalitions are celebrated for bringing people of different backgrounds and cultures together, but embroidery also has the power to create a sense of community. When you stitch with a group of other people, you talk with them and learn about each other's lives.

Last year, I participated in the Vancouver (British Columbia) Mini Maker Faire, an expo and showcase of all things handmade. I wanted to create a craft project that would allow anyone to try embroidery, no matter what their skill level was. Inspired by the work of Liz Kueneke, an artist who stitches city maps, takes them into public spaces, and invites passersby to mark them with stitched icons of their own lives in a participatory act, I created a five by seven-foot (152.4 x 213.4-cm) canvas to provide the basis for a community embroidery table. Anyone could come and draw an image to be stitched or stitch an image that someone else had drawn. As I set my booth up for the day, among monster bike makers and pyrotechnic artists, I wondered if anyone would join me. With so much excitement in the air, would anyone want to stop and stitch? How could I compete with people on stilts and giant spider robots?

I was pleasantly surprised. Over the course of two days—amid the frenzy of duct-tape costume building competitions, 3-D printer demos, and steampunk tea parties—hundreds of people stopped by my booth. Many of those who joined me described the experience as a welcome pause in a fun but chaotic festival. Some

wrote their names on the cloth, wanting someone else to make it indelible in thread. Others spent three to four hours with me, stitching a personal symbol, a name, or selflessly stitching in a sketch made by a stranger.

As the weekend passed, I began to recognize commonalities between the stories and behaviors of participants. Embroidery makes people both emotional and thoughtful. There were those who had stitched since they were children and people learning for the first time. There were memories shared of beloved relatives who had stitched and created special gifts. Then there were the interactions that happened between people—the moments when someone explained to a stranger how to do a technique, the guesses of "who stitched what" when friends of an embroiderer at the booth stopped by, the patience of parents who helped a toddler's chubby determined fist grasp a needle.

Some people stopped to think long and hard about what they were going to stitch before they began, while others doodled as freely as if the cloth were a bathroom stall and they were adding some idle graffiti. The fabric panel became a canvas of stitched love notes, personal annotations, secrets, cartoons, well-wishes, and symbols. It was changeable, surprising, and, at the same time, predictable. I discovered, just as Liz Kueneke had, that a lot of people add their names. We all want to be recognized and remembered; it is inherently human. Embroidering in a group is like dreaming collectively; everyone adds their mark, a small hope or spark—each stitch has greater meaning in the presence of stitches made by others.

I believe that people are drawn to handmaking because they want to share a part of themselves. There's a benefit from upholding handcraft traditions in the digital era—a commercial embroidery machine can create perfectly crafted stitches with impeccable tension, but

the fabric won't have the patina of the maker's thoughts. Or sweat. Or tears. Only handwork has that.

When I meet people who tell me that they can't stitch, I hope that they can find simple joy in the process of creating, in making something that expresses themselves. When we seek perfection, we fail. By embracing our accidents, embroidery becomes less precious and is rather an everyday activity that fits into the small pockets of our lives.

It is so satisfying to see someone stitch their own project for the first time. A visible understanding of the mechanics of embroidery registers on their faces, and they can see how a craft they once thought difficult and unknowable can now be made in their own hands. They have the tangible evidence, and they are changed by it. Some of them may try it again later. And they might even see someone else trying to embroider and will tell them, "I did that once. Let me show you what I know."

LEANNE PRAIN *is the author of* Yarn Bombing: The Art of Crochet and Knit Graffiti *(coauthored with Mandy Moore),* Hoopla: The Art of Unexpected Embroidery, *and* Strange Material: Storytelling through Textiles *(available in 2014), all published by Arsenal Pulp Press. When she learned to knit in 2005, Leanne co-founded a stitch-and-bitch group called Knitting and Beer in order to expand her skills while knitting in a pub. Although the group has since disbanded, she continues to be amazed at what can be created with two needles and a bit of yarn. In 2006, she was introduced to the knit graffiti (a.k.a. yarn bombing) movement via the Internet, and the political and cultural aspects of modern handicrafts have turned into an obsession for her. She can be found online at* leanneprain.com.

PHOTOS:

Page 157: *Community Embroidery Canvas*, Mini Maker Faire, Vancouver, 2012, embroidery floss, linen, thread, grommets, wood, 5 x 7 ft (1.52 x 2.13 m). Photo: Emily Smith

Page 158: Leanne Prain, Illustration from *Addie Sinclair: Vortex of Doom*, 2012, embroidery, linen, and thread, 4 x 4 in (1.57 x 1.57 cm). From the collection of Kim Clarke. Photo: Leanne Prain

Page 160: *Community Embroidery Canvas*, Mini Maker Faire, Vancouver, 2012, embroidery floss, linen, thread, grommets, wood, 5 x 7 ft (1.52 x 2.13 m). Photo: Emily Smith

Page 161: *Community Embroidery Canvas*, Mini Maker Faire, Vancouver, 2012, embroidery floss, linen, thread, grommets, wood, 5 x 7 ft (1.52 x 2.13 m). Photo: Emily Smith

Page 162: Mini Maker Faire, Vancouver, 2012, main entrance. Photo: Emily Smith

INTERVIEW with Rachael Matthews

Q: How did you get started with craft?

A: My parents continuously built craft space for me in our English Lake District woodland. I tried different tools and materials, and they tidied up after me, pretending to be impressed.

Q: How did you get started with activism?

A: My family were political campaigners and advocates for historical interests. They founded the Windermere Steamboat Museum, and as children we had to promote the relevance for our times of early developments in steam power. Early Victorian craft and design holds to exquisite standards of perfection. I love it and rebel against it in equal measure. Sunsets with silent engines on calm waters were a sublime foundation for twenty-first century protest.

Q: When did you first realize you could combine craft and activism?

A: In the mid-1990s, I moved to desolate East London to teach unemployed women how to sew and make rag dolls as couture-fashion accessories. The artist Freddie Robins bought one, and she got me to start thinking differently about knitting. Big Art was primarily about Sensationalism in those days.

In a coffee shop on Brick Lane, our community grew. Ella Gibbs, Amy Plant, Anna Best, and Tomoko Takahashi taught me "socially engaged" artworks; we

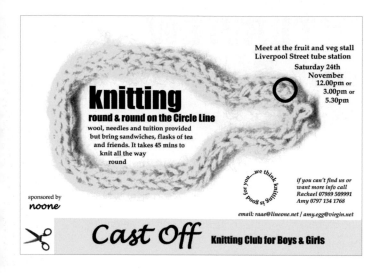

knitting
round & round on the Circle Line

wool, needles and tuition provided
but bring sandwiches, flasks of tea
and friends. It takes 45 mins to
knit all the way
round

Meet at the fruit and veg stall
Liverpool Street tube station

Saturday 24th
November
12.00pm or
3.00pm or
5.30pm

...we think knitting is good for you...

if you can't find us or
want more info call
Rachael 07989 509991
Amy 0797 134 1768

email: raae@lineone.net / amy.egg@virgin.net

sponsored by
noone

Cast Off Knitting Club for Boys & Girls

read books about "relational aesthetics." Stephen Fowler and Zeel designed the new Murri Folk Club, where we danced with Tatty Devine and made badges. Mei Hui Lui staged underground fashion parties where I DJ'd and knitted at the same time. We were suddenly out there, man … We had a platform; we stood on it and did it.

Q: What was the Cast Off Knitting Club?

A: The Cast Off Knitting Club grew like knitting, mostly out of drunken chats with Amy Plant.

We were "cast off" from the world and invited women and men to join us in knitting in public. We reclaimed public space and promoted craft. People were shocked to see us, and we were shocked at their shock, and at the end of the evenings, they had joined us. It was a marvelous situation.

Group emails were a new thing in those days. We chose knitting as a medium because it was easy to transport, but we did other crafts too. We generated stories to attract the press—simply because it needed to be talked about. They all called it a revival, but true craftsmen knew they had just been shy for a while.

Q: The Cast Off grenade pattern has been mentioned in conjunction with craftivism. Was it supposed to be an activist pattern?

A: I made the *Knitted Hand Grenade Purse Pattern* to protest the Iraq War, touting it around shops and galleries wherever I went. In those days, my knitting was about "applied usage"; it was designed to be a catalyst for discussion. In our protests, we'd shouted "Drop Stitches Not Bombs," so that became the subtitle of the pattern. It was the best I could do under the circumstances, and the pattern was eventually printed in *The Guardian* newspaper.

Q: What was your most craftivist act with Cast Off?

A: Monitoring the effects of actions big or small is hard. Gestures move people in intriguing ways. It's tempting to mention press-grabbing stories, but you can read about those on the Internet. I can only suggest that the giving and receiving of my nervous energies is my greatest achievement.

Doing live TV, radio, broadsheet interviews, and curating events like *Craft Rocks* and the *Knitted Wedding* required me to let the world's thoughts and questions pass through me like I was an autonomous, broadcasting aerial, charged with the responsibility of delivering a craft manifesto for a new generation. Offering wit when ridiculed in public and patience when listening or being questioned are the biggest lessons I have learned. Bravery in activism is impossible without friendships for nourishment. Gathering like-minded people together is therefore the most craftivist action I ever make.

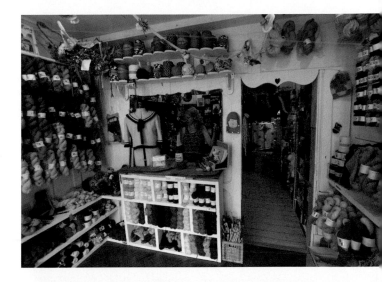

Q: Why did you decide to open Prick Your Finger?

A: The Cast Off Knitting Club helped inspire knitting groups around the world, so its work was done. The market for handmade textiles, however, was, and still is, wobbly. I had met many textile artists who needed a public space to show work.

The yarn I was buying in those days had little resemblance to the stuff I had worked with as a child. The wool smelled wrong, and you could no longer select among varieties made from the many breeds of sheep that had been bred for varying textures over hundreds of years in Britain. I wished there was a shop that sold yarn by sheep breed. Britain's sheep had suffered a devastating outbreak of foot-and-mouth disease, resulting in mass culling; simultaneously, the price of fleece was at an all-time low. My friends in the Lake District started

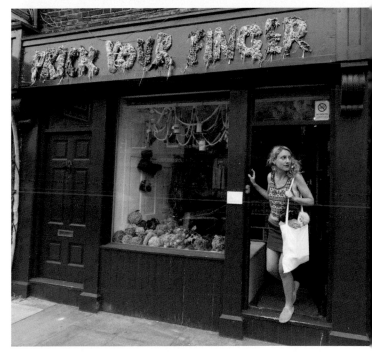

a wool cooperative called Woolclip, which I found very inspiring. They taught me the importance of hand spinning, which helps me earn money when I am too tired to do anything else.

My income was mostly through teaching textiles, and I wanted to teach in a deeper way. Shop rents in London were high, but I acquired a strange boarded-up call center with twenty-four telephone lines, which was asking to be converted into an alternative wool shop. Running a shop like this requires new skills. In addition to learning accounting and stock systems, I have learned to become an improvisational carpenter, writer, teacher, curator, and salesperson. It's not easy, but I am blessed with an evolving team of helpers and advisors, and the customers continually astonish us all.

Q: Is it hard to be an activist while running a shop?

A: Running this shop *is* activism. Exhibition programs provide catalysts for conversation. The library is an important resource. The yarns we sell support small businesses in rural areas and provide customers with materials connected to the landscape of our country. Classes for all abilities and documentation of customer achievements hopefully give a sense that craft belongs to everyone and can help change our world. In Lisa Anne Auerbach's show in August 2013, she made a sweater that reads "Occupy Yourself First"—I couldn't agree more. The effect of our customer's activism through knitting is incalculable. I always want more time to make statements, but they are here, right now, as I'm looking all around me in the shop.

Q: Are there times when your interests in activism conflict with running a commercial shop?

A: I saw our country's craft heritage dwindle, with the subsequent destruction of craft communities. The high suicide rate of sheep farmers and closing of local wool mills must never be repeated. We undercut our craft industry to the point where it almost died. This devaluation is still widely accepted, and is evident in this question. Making money through honest craft never conflicts with activism. It is wrong to think that it could, because the money you make can support other people or improve your own practice.

I often meet activists who are embarrassed about making money, and there are organizations that expect activists to work for free. Activists are brave, and like all artists, need to be looked after and fed. We live in an age in which showing a desire to make money is mistaken for a desire to make unjust profit. Healthy business models are rarely taught in art schools, and yet valuing something made with your head, heart, and hands is the most emotionally loaded valuation you might ever have to make. You must never apologize for being an artist. Our job is to educate, and that includes teaching people the value of creative actions and things.

The language of commercialism is not fashionable. I like to call Prick Your Finger a "going concern." I have chosen a life with long working hours, forfeiting a normal salary, but I constantly see the growth of good ideas, which cannot be valued in monetary terms.

Q: What are the benefits to being an activist with a shop?

A: I love being able to talk about the values of what we sell and make. I am proud to be able to host initiatives funded by the shop, rather than relying on grants. It means we are a self-sufficient movement, ripe for experimentation, when projects are in their infancy. I have watched artists grow through their associations with Prick Your Finger.

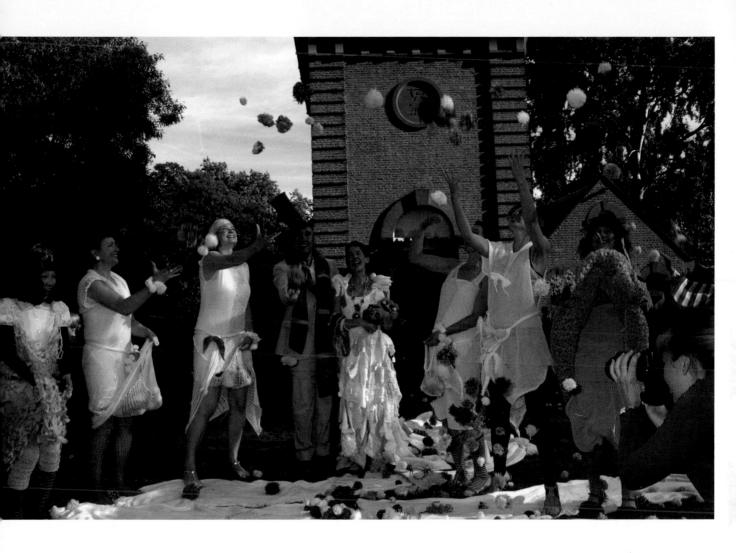

Q: *Has Prick Your Finger become its own brand?*

A: Prick Your Finger is a shop and gallery run by Rachael Matthews and it is also a project by Rachael Matthews. If I make a relevant project for Prick Your Finger, then it tends to be by Prick Your Finger, but if I make something personal, then I'll sign it with my name. I'm not entirely interested in making a name; I just want to make the work.

Q: *You have small shows at the front of Prick Your Finger. What is their aim?*

A: I show textile artists who push the boundaries of what textile art can be. The work must inspire us and be something we have not seen before. The aim is to develop the culture of textile art and raise the value of what we do.

Q: *Do you see Prick Your Finger as a place to disseminate and spread ideas through workshops or shows?*

A: People meet at workshops, but the shows are most beneficial. I can introduce people to each other at the parties and then collaborations happen. Artists showing work can use the space as a platform and excuse to experiment. In turn, these new energies help me and the business.

Q: *Among other things, you've constructed the "world's first bicycle-powered wool mill" with a charkha (spinning wheel). Do you think using these alternative methods of production is a type of activism?*

A: The *Louder Than Bombs Show* at Stanley Picker Gallery was the "world's first bicycle-powered wool mill." We didn't produce that much, but we studied production energy and spiritual fulfillment in the workplace for when the national [energy] grid runs out. Gandhi's philosophy of the spinning wheel and the ideas of Situationist International were the philosophies we chalked on the wall after the disco tea breaks and psycho-geographical moves between machines.

Q: *Do you have an affinity for another Lake District resident, Beatrix Potter? Do you think she was an activist in her own right?*

A: Beatrix Potter studied her craft from an early age, publishing books in a time when women were supposed to simply marry and keep house. After moving from London, she bought her first farm with her own fortune and lived off the land while writing more books. As her fortunes grew, she bought more farms, saving the land from developers, who planned to ruin the landscape. She famously farmed the Herdwick sheep, wearing their itchy, gray, weatherproof wool, thus appearing both local and worldly. She created a place where she was free to observe nature and use her imagination for the pleasure of others, in an independent and profitable way. Her brave decisions, independence, and sensitivity to the world around her are inspirational.

Q: *What would your dream craftivist workshop include?*

A: A gathering of beautiful, creative people, relaxing in a sublime atmosphere, with healthy dinners, a wide range of materials, and no pressure to produce anything at all. That is the best way to make things happen.

Q: *What are your future plans for Prick Your Finger?*

A: To create a scene not unlike the answer to the last question.

~~~~~~~~~~~~~~~~~~~~~~~~~~~~~~~~~~~~

**RACHAEL MATTHEWS** *is a practicing textile artist living in London, UK. She co-founded the Cast Off Knitting Club, which was at the forefront of the British Knitting in Public movement in 2000. She has written two books,* Knitorama *and* Hookorama, *and numerous articles about social interactions through textiles. Rachael now runs Prick Your Finger, an ethical yarn store and gallery in Bethnal Green, UK, which produces artisan yarns, teaches workshops in textile crafts, and shows the works of international textile artists.*

~~~~~~~~~~~~~~~~~~~~~~~~~~~~~~~~~~~~

PHOTOS:

Page 164: *Louder Than Bombs* installation, 2010. Photo: Rachael Matthews

Page 166: Amy Plant, *Circle Line* poster, 2,000. Photo: Amy Plant

Page 167 (top): The inside of Prick Your Finger, Bethnal Green, 2013. Photo: Antranig Basman

Page 167 (bottom): The outside of Prick Your Finger, Bethnal Green, 2013. Photo: Antranig Basman

Page 169: Throwing pompoms at the Knitted Wedding (of Freddie Robins and Ben Coode-Adams) at the Pump House Gallery, 2005. Photo: Angus Leadley Brown

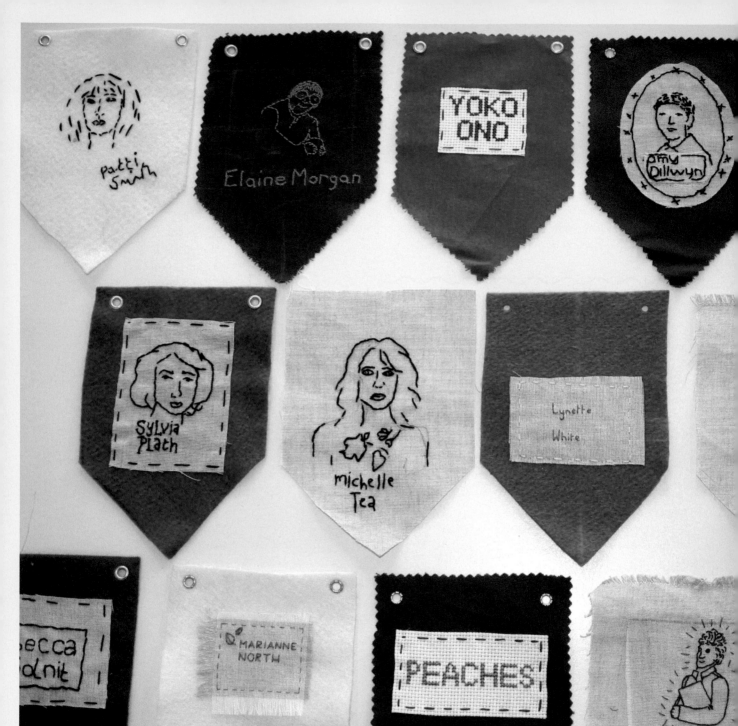

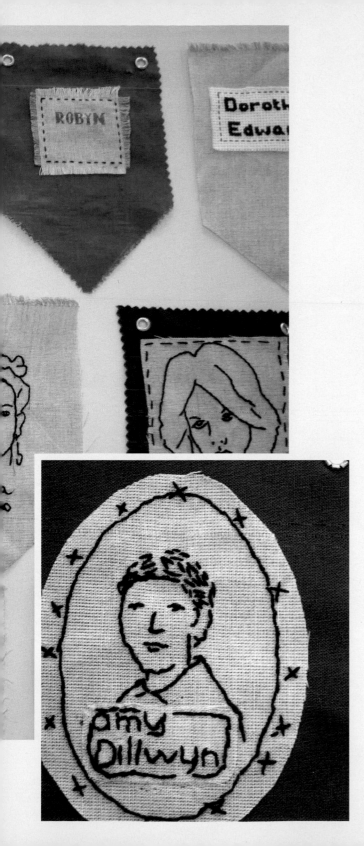

Suffragette Banners
Sian Lile-Pastore and Sara Huws

This project came about as our contribution to International Women's Day (March 8), 2013, and as a tribute to those women whose triumphs and achievements are often unacknowledged. The project is intended as a reminder of the continuing and evolving battle for equal recognition for women in all fields, whether it be art, politics, or everyday life.

We were inspired by early twentieth-century suffragette banners, some of which had the names of famous women embroidered or painted on them, and we decided to stitch our own versions about women who are important to us. In keeping with the craftivist ideology, the act of stitching itself becomes intrinsic to the project, allowing for the time to meditate on the women we love and why. The process of creating these banners connects us in spirit with the women who originally campaigned for women's suffrage.

We will continue to stitch portraits and names and then exhibit them and invite others to add to the collection. Often people are unfamiliar with some of the names that we have stitched onto our banners, but after seeing them, they are compelled to find out more. Ultimately, our project celebrates women's achievements and their lives. We hope to make sure that they are recognized for all that they do.

PHOTO:
Sian Lile-Pastore and Sara Huws, Contemporary suffragette banners, 2013. Photos: Sian Lile-Pastore and Sara Huws

CREATING TOBUCIL & KLABS: THE MAKING OF BANDUNG, INDONESIA'S FIRST INFO SPACE

Tarlen Handayani

I founded Tobucil & Klabs, a small bookshop, info shop, and community space, in 2001, only three years after the New Order regime of General Suharto collapsed after thirty-two years. At that time, there was no place like Tobucil & Klabs in my hometown—Bandung in West Java, Indonesia. It was a pioneer operation, an alternative place to meet people from many different backgrounds and communities and then share knowledge and ideas with freedom of expression. Its mission is to support the local literacy movement with the aim of capacity building and to support the craft movement.

At the start, it was not as simple as I thought it would be to run a place like Tobucil & Klabs, which is independent, that is, not dependent on funding organizations or sponsors. The biggest challenges have been finding sustainable ways to run this place and finance all the programs without deviating from our spirit of independence. Keeping our independence is a form of activism; it ensures that we are free to speak and create with our own minds, not those of the big sponsors.

In 2007, after Tobucil & Klabs moved to its third location, we found new approaches to survive and grow, built around the idea of fitting the literacy movement into our daily programming. We developed separate programs with two different approaches, clubs and classes. Every club, like the philosophy club and the reading club, is free. For classes such as basic photography, knitting, bookbinding, public speaking, essay writing, and fiction writing, people have to pay a very reasonable tuition fee. We have realized that when people pay for a class, they

feel more responsibility toward the program and achieve more program goals. Proceeds from tuition fees are shared, with eighty percent going to the instructor and twenty percent to Tobucil & Klabs. Anyone can be an instructor there, as long as they understand our mission and DIY spirit. Some of the instructors are highly qualified in their individual fields; the classes they teach have become a way to show their sense of social responsibility to their community.

Tobucil & Klabs belongs to the public; their contributions assure its survival. We also fund the programs through our shop, where people who create something in the classes can sell their products. Those involved in working here become members of the cooperative microfinance organization that is owned and jointly run by its members, who also share in the profits and benefits. This cooperative helps to support us financially, and its existence creates a mutually beneficial relationship for all who are involved.

Since we started Tobucil & Klabs, supporting the literacy movement has been our main goal. Literacy is not only about the skills of reading and writing, but about understanding everyday life and how individuals can improve themselves. We have become a hub for people in the community to exchange ideas and spirit on the same DIY frequency. We realized that craft offered a friendly, fun way to spread our literacy message and to achieve our goals. Through the craft program, we have taught skills and spread the DIY spirit by reinventing craft tools; we have taught knitting, crocheting, printing by hand, bookbinding, photography, sewing, embroidery, stop-motion animation, scrapbooking, and drawing.

In 2007, the "independent" craft scene in Indonesia was not as well known as it is today. Independent crafters had just emerged in cosmopolitan cities like Jakarta (capital of Indonesia), Bandung, and Yogyakarta, but

they were just individuals practicing activities by themselves; there was no communal crafting. Through the Internet, many of these crafters were inspired by *Etsy* and blogs such as *Design*Sponge*. These inspirations gave us new approaches with which to reinvent craft as part of our everyday lives and allowed us the possibility of being part of the global craft movement.

As a country with rich traditions, Indonesia's modern crafts have become part of the economic commodification of tradition. We clearly see this in the tourism sector. Our cultural traditions, including craft, have economic value and attract tourists from around the world. These crafts are not produced for everyday functions anymore, but are made mostly as souvenirs for tourists or for export. In many areas, brokers—the agents between producers and buyers—put traditional communities in the position of laborers who produce crafts driven by the market instead of paying attention to their cultural and community value. Every country that has longstanding traditions struggles to find ways to transform crafts and reinvent its true spirit in a current context. On a small scale, Tobucil & Klabs decided to become part of this transformation.

Along the way, we have learned that the tension between tradition and modernity in my generation can serve as a vast resource of ideas. We can absorb ideas from the West (like the blogs mentioned above), but also adapt them in the context of our own Indonesian experience. We are cognizant of current trends while also exploring the traditions of the older generation. Such contrasts allow us to come together to try new things, despite our different backgrounds and traditions.

We also have spread the idea that knitting, which is seen as something done primarily by women, can also be done by men. For example, the group called The Man Who Knit learned how to knit in a class at Tobucil

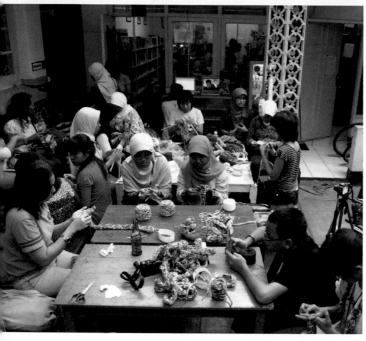

& Klabs. Afterward, they created a campaign to spread the message that men can knit. These men became the most popular teachers of knitting workshops held outside Tobucil & Klabs, especially when other men took part, as the participants felt comfortable learning the craft from other men. For those of us who live in patriarchal societies, this breakdown of boundaries between men and women in craft is important, because crafting is not just about learning a skill, it also is about embracing the DIY spirit. By taking cues from DIY that anyone can do anything, craft becomes genderless rather than stuck in traditional gender roles. For example, we had a program called Knitting for Humanity in 2010, in which men and women of all ages knitted together for the victims of the Mount Merapi volcanic eruption [in Indonesia] who needed warm clothes, shawls, blankets, and skullcaps. We asked for simple things from beginner knitters, like knitted squares or long ropes made with finger knitting; their friends from class helped make these items into blankets and shawls. In every item we produced, we added a tag that read, "Knitted with love by friends at Tobucil & Klabs."

Since 2007, we have held an annual program called Crafty Days to show off our local movement. Crafty Days has a different spirit than other craft fairs in Indonesia. It is not only about building a market for modern crafts for the sake of their economic value, but also developing a better appreciation and understanding of their various processes. Crafty Days is for emerging crafters and those in other fields related to art, craft, and design. The craft fair bridges the knowledge gap between crafters and the public through workshops. Its Craftypreneur forum has become a place to share knowledge, enjoy the spirit of fair trade, swap experiences, and trade tips about running a business. Crafty Days encourages emerging crafters to try different approaches, techniques, and

materials, and to create something different. The seventh annual Crafty Days in 2013 united crafters, designers, architects, artists, and puppeteers, giving them a space to share their artistic knowledge and experience with a wide audience.

Through Tobucil & Klabs and Crafty Days, we have realized that, even if it's simple, we can make something creative with our hands. Through the DIY spirit and the strength of our community, we can help each other, whether by working around literacy, craft, or both. This is fundamental for people who live in Indonesia, one of the biggest global producers of traditional crafts. Even though we are still struggling with independence and the confidence to define who we are as a people, crafting gives us a sense of empowerment, a sense that we can do something that contributes to society. Through Tobucil & Klabs, I feel proud to be a part of all of this and look forward to further contributions in the future.

〜〜〜〜〜〜〜〜〜〜〜〜〜〜〜

TARLEN HANDAYANI *is a bookbinder, community organizer, freelance writer, and researcher in Bandung, West Java, Indonesia. She is the founder of Tobucil & Klabs community space, which supports the local literacy movement (tobucil. net). Her writing has been published in local and national media. She produces handmade notebooks under the label Vitarlenology. Her artwork has been exhibited in art spaces and exhibitions in Bandung and Yogyakarta, Indonesia. vitarlenology.net.*

〜〜〜〜〜〜〜〜〜〜〜〜〜〜〜

PHOTOS:

Page 174: Bookbinding class at Tobucil & Klabs. Photo: Tobucil & Klabs

Page 176: Participants in the Papermoon puppet lantern workshop. Photo: Tobucil & Klabs

Page 177: Workshop on puppet lanterns hosted by Papermoon Puppet Theatre at Crafty Days #6, 2012. Photo: Tobucil & Klabs

Page 178 (top): The Man Who Knit: finger-knitting workshop in the Communities Festival, Jakarta, Indonesia 2010. Photo: Tobucil & Klabs

Page 178 (bottom): Knitting for humanity: Let's knit together for Mount Merapi eruption victims. Photo: Tobucil & Klabs

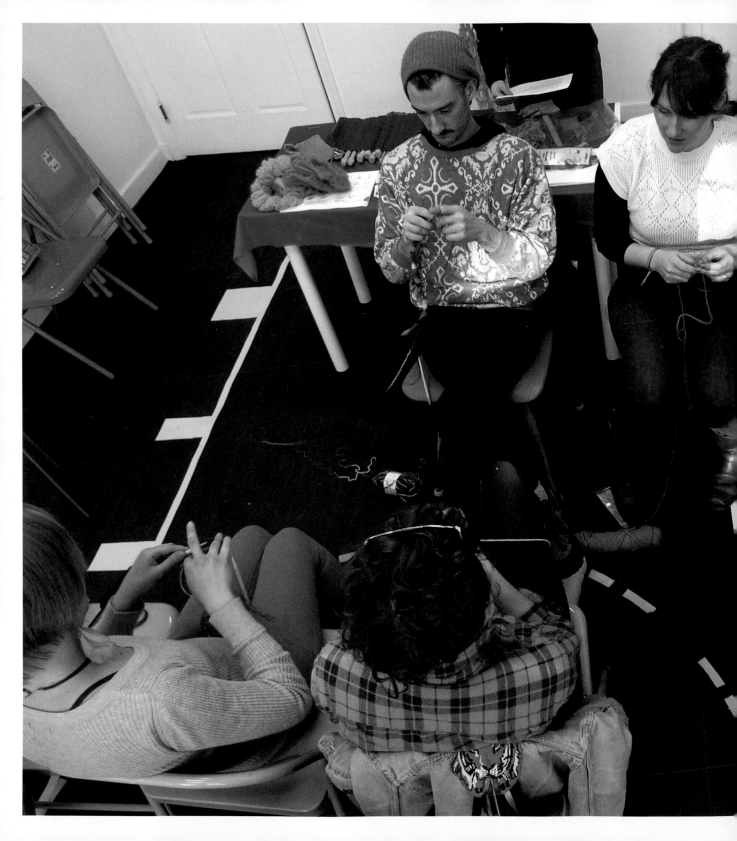

INTERVIEW with Maria Molteni of NCAA Net Works

Q: What is your definition of craftivism?

A: Craftivism is a powerful movement, influenced by DIY and feminist activity, where the form and function of "street" and "domestic" tactical aesthetics collide in the handmade to express dissidence or exhibit new approaches to public art. Craftivism, flirting slyly with its seemingly non-threatening connotations, is particularly powerful because it's often accessible and collaborative as well as positive and inclusive.

Q: How did you get started with both craft and activism?

A: I studied traditional oil painting in college and had a pretty rigorous practice. But I knew I was being materially, conceptually, and socially limited in this particular environment. It seemed my studio practice was just as important out in "the world" as it was in the solitude of a traditional space.

I started to teach myself to work with new materials and was particularly interested in objects you could touch as well as see. I wanted to continue making large work, but was sick of juggling giant paintings and also liked the idea of being able to fold the work into something portable or compact. I always wanted to work with yarn and fabric; color was my favorite part of painting, and I loved the saturated natural and synthetic colors

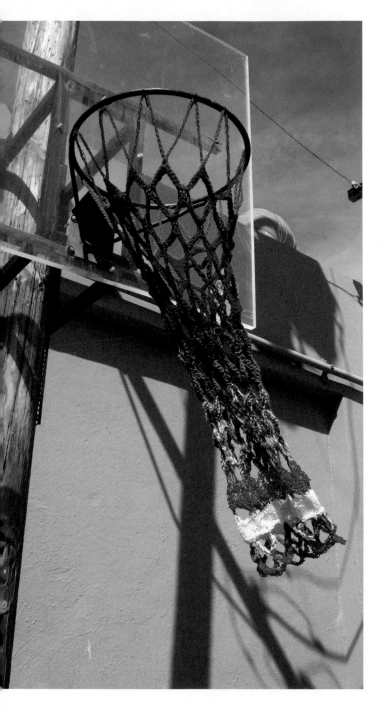

found in fibers, especially in any material that might play with the light, change colors, move, or sway.

Activism came to me later as I began to value working collaboratively and with my community. I began identifying as an activist more consciously when I became involved in Occupy Boston, though the Net Works project had already been around for a couple years. My friend Mallory Biggins, a New Craft Artists in Action (NCAA) player and excellent fiber artist, and I met at Occupy and started the Creative Actions and Subversive Arts working group with another friend, Forest Purnell. He was involved with the Institute for Infinitely Small Things, a collective I later traveled with to the Philippines, hosting an arts and activism workshop for college students in Zamboanga City.

Q: When did you realize there was a connection between craft and activism?

A: Craft and activism come in many shapes and forms. They often evolve and exist differently in different communities. I think the combination of the two allows people to look at one or the other practice with fresh eyes.

Activism finds a clear connection to craft in that one can easily be an activist—and a crafter—in his or her daily life. It's also important in both to negotiate one's relationship to production and consumption through small habits and gestures that add up to something larger and to think about the repercussions of these practices and the materials involved. Craft points to something you do on a regular basis to keep clothed, motivated, or entertained. Because there is a rich history and revival of collaborative work in the world of craft, many of these endeavors point toward an emphasis on small pieces that contribute to the larger picture. If you look at a swatch of knitting, you see that the stitches are

connected. If you pull a loose thread, the entire structure can fall apart. Communities share this design.

I think that craftivism shows people that there's an alternative approach to the spectacle and exhibitionism often associated with and necessary to activism. The world is beginning to see that craft is not simply a low-energy activity for women in the home. It's a bold, dedicated, and very physical form of expression that is difficult to ignore, dislike, or contest without looking foolish. It takes time and thought to complete such calculated constructions. Even the time spent on meditation and conversation during production brings a lot to the table since much activism is often viewed as reactive.

Q: What is NCAA Net Works?

A: The New Craft Artists in Action began in Boston, longitudinally central between Springfield's Naismith Memorial Basketball Hall of Fame and Lowell's American Textile History Museum. Brought to participants via traveling workshops, pick-up games, and Internet cataloguing, it's a craftivist project that addresses public space, diversity, collaboration, feminism, and interdisciplinary learning. Assembling handmade (usually knit and crocheted) basketball nets for abandoned hoops, we aim to build proactive relationships between artists, athletes, and neighbors for creative problem-solving in under-maintained urban spaces. We are inspired by a mapping process and a DIY form of slow production that makes use of neglected recreational space and the Internet as public venues. We also like to draw attention to the expressive potential of these spaces while critiquing commercially focused professional athletic institutions. We suggest that makers and players put their heads together to design Net Works in their own cities, meeting the needs and fancies of their own cultural surroundings.

Our nets have since spread across the US and as far away as South Africa, Hungary, and the Philippines. We've gained increasing interest via social media and exhibitions, including the upcoming Boston edition of Creative Time's *Living as Form*, curated by Claire Grace for Harvard University's Carpenter Center for the Visual Arts. The NCAA, with graphic design duo Golden Arrows, are writing, designing, and publishing a knit and crochet instruction book that includes patterns from artists across the country.

Q: How did you get the idea for NCAA Net Works?

A: For starters, I grew up in Nashville, Tennessee, where sports are huge, and basketball is particularly popular in the Catholic community of which I was a part. I'm also a beekeeper, and I'm about as obsessed with bees as I am with basketball. I had an art show coming up and decided to make a sculpture sort of like a honeycomb hanging from an empty hoop. (Bees will draw comb off of anything; they just need a top armature.) I crocheted a hexagonal basketball net (instead of the conventional diamond design) and my friends responded very well to the piece. Then I went to practice free-throws down the street from my apartment and noticed the hoop didn't have a net, so I put that one up.

Q: How did you assemble your team?

A: The NCAA has a core group that meets regularly at what we call YarnOverTime meetings to work on various aspects of the project. The first gals to join the team were badass artists Taylor McVay and Andrea Evans. I loved both of their work. Their personal practices and stories are also rich and eclectic. I often call Taylor a "Domestic MacGyver" because she can make anything and pursues an original and self-sufficient art-as-life

practice with her husband Jordan in Jamaica Plain [a neighborhood in Boston]. Andrea, who lives just down the street from me, makes very strong work as well—beautiful, sensitive drawings of garments she's made that she and her husband Kirk are tangled in together. She makes pieces that use craft in participatory and performative contexts, such as *Double Balaclava*, and a pair of socks that are joined at the toe.

Originally, I called on them because I desperately needed their help. I was getting great response to the project, but I still had this funky way of knitting and crocheting that I was afraid people wouldn't grasp. MOLTENi Net Works, as it was called at the time, had an upcoming show at an excellent artist-run space called MEME, and we wanted to host workshops so that people would learn to make their own nets. We didn't want the project to stay within our small circle; we wanted people to make nets that express their own interests and community. So Andrea and Taylor came to help me teach people. Taylor gave an amazing lecture about filet crochet, comparing it to computer code and contemporary architecture. Andrea taught knitting lace in the round. Alasdair Post-Quinn, who literally wrote the book on double knitting, showed up to a workshop and whipped out a net. We had so much fun!

We started getting emails from people who wanted to make nets, and I had a difficult time explaining how to make them in writing, so we decided to produce a publication. We put out a nationwide call for submissions asking for original knit or crochet basketball net patterns. Responders included amazing Boston artists Lizzie Curran, Cara Kuball (anarcho-feminist and founder of the International Pancake Film Festival), Samantha Fields (an incredibly dedicated artist of many crafts and also the professor who'd encouraged my wonky crochet style when I took her class), and Mallory

Biggins. We paired up with my dear friends and driven social-justice-centered graphic designers Golden Arrows to compile the book, slated for publication in 2014. Andrea and Taylor wrote and illustrated very thorough original knit and crochet instructions that I'm still in awe of. I'm honored to have craftivists that I admire, such as Pamela Wynn and Cat Mazza, involved in the book, and we've even included instructions for how to play classic basketball games illustrated by Boston artist Pat Falco. The content is extensive and very rich.

Q: What setbacks, if any, have you run into along the way?

A: The general public understands and appreciates the project immediately, but some crafters have been a little stubborn and narrow-minded. Some don't understand why we're making nets, while many are very positive but less familiar with the hoop structure and function. I have to remember that I'm fusing seemingly separate worlds together, and sometimes it takes coaxing and patience to get people to meet in the middle. I'm growing a lot from trying to orchestrate and organize many people. I have become quite the facilitator and administrator, but I still make time to make nets!

Q: What has your greatest success story been?

A: Every time we hang a net, my heart swells. Every single time I have a magical interaction with a stranger that I could have never predicted—whether it's a bunch of little girls that ran up cheering, an electrical engineer that offered me some warm gloves and zip ties, or the three queer students in my Filipino class who pumped their fists under a hot pink net shouting "Trans Power!"—it's a success story. When I was working with a group of at-risk young adult boys from the Cushing

House in South Boston, their leader, a Boston cop, said he'd never dreamed we'd have the boys knitting and laughing and looking forward to each class. He told me that they would "take care of" me if I ever needed help, that they "had my back." Every context is so different, from Detroit to Los Angeles, from Pittsburgh to San Antonio; the tiniest gesture motivates people beyond what you could imagine.

Q: *How do you find communities that need nets?*

A: All you have to do is keep your eyes peeled. Empty Net Syndrome is everywhere! My NCAA collaborators, such as Kevin Clancy and Zsuzsanna Szegedi, and I have discovered, as we traveled around the world installing nets in places like Zamboanga City in the Philippines, Johannesburg in South Africa, and Budapest, Hungary, that basketball is really popular everywhere. In the Philippines, politicians will have huge, sleek courts installed in tiny mountain towns and have their names written on the backboards to get votes. In Budapest, it is customary to carry your own net around, install it, and take it down when you're finished playing. The boys who installed with Zsuzsi in Hungary knew just what to do! Many people see the sport as particularly important to their culture, and it's amazing to see the various manifestations of facilities and athletic communities.

Q: *Do you ask local people in the community for permission to hang nets?*

A: We haven't tended to. Often, there's not really a point-person to ask. We have a very strict rule, which is that we never take down a net that is intact. It's important that we are filling a void. Net Works is an intervention, but it's not about destruction or entitlement.

Anyone could take the net down after we leave, but we hope they won't want to. We are making something intricate and special but then setting it free and accepting whatever may happen.

Q: *What type of yarn/craft is needed to make the nets?*

A: You can use anything. We generally use wool or acrylic yarn or "yarn" we make from plastic bags, or—probably the most successful material—mason's twine. It comes in such amazing neon colors and holds up extremely well. Andrea's *Diamond in the Rough* is still holding on after a year, even through the Boston winter! It's faded and fringed at the bottom now but has this gorgeous decayed aesthetic and is still entirely functional.

Q: *Can anyone donate a net to NCAA Net Works?*

A: Of course! They need not donate to us, though! We want people to put nets up everywhere, snap a photo, and share the story with us so we can include their work on our blog and map.

Blog: *molteninetworks.tumblr.com*
Twitter: *@YarnOverTime #NCAANetWorks*
Email: molteninetworks@gmail.com

MARIA MOLTENI *grew up in Nashville, Tennessee, as a parochial-school misfit in the Bible belt, where Protestants and Catholics settle their differences on the field or court. Aware of her mother's childhood dismissal from tryouts because she was "too skinny," Maria felt fortunate to spend ten years swallowed by team jerseys bearing Air Jordan's lucky number twenty-three. When asked about her future plans, she swore to become an "Art and Basketball Star." Her neighbors, who knew of her love for the game, expressed their support, offering one of their own* MOLTEN—*the official Olympic-brand basketball—with a bold black "i" painted on the end. After she received a BFA in painting from Boston University, her formative experiences became a source of new inspiration. This anecdote about an altered* MOLTEN *ball illustrates the processes and concepts embedded in what has become an art-informed-by-athletic practice. Maria is interested in Art as an act of gift-giving, a reassessment of authorship via appropriation, social spectacle, and expression of support/protest by way of DIY, graffiti, and/or handmade techniques.*

PHOTOS:

Page 180: Andrea Evans hosting a Knitting Lace in the Round workshop at MEME Gallery in Boston, Massachusetts, 2011. Photo: Maria Molteni

Page 182: MOLTENİ Net Work installed outside UCLA's graduate art studios; a little collaboration with Chris Burden, who built the backboard in his school days, 2012. Photo: Maria Molteni

Page 183: Maria, the Institute for Infinitely Small Things, and amazing arts and activism students from Western Mindanao State University pose under the campus's new Net Work, in Zamboanga City, Philippines, 2012. Photo: Forest Purnell

Page 184: Finger Knit Net Work installed on the neighborhood court of the D Street Housing Projects, South Boston, Massachusetts, 2013. Photo: Maria Molteni

Page 187: MOLTENİ Net Work Pittsburgh, installed with artists Kevin Clancy and Tara Kirmse on an abandoned court near Allegheny Commons in the North Side of Pittsburgh, Pennsylvania, 2012. Photo: Maria Molteni

Below: Extra-long Ombre net made by Maria for the abandoned Bartlett Bus Yard Muralfest near Boston's Dudley Square, 2013. Photo: Pat Falco

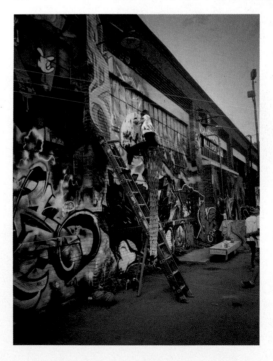

Craft in Mind

Deirdre Buckley

By using guerrilla craft and craftivism activities, people are more able to explore difficult issues and ideas. Craft in Mind was a creative project that brought together young people aged fourteen to twenty-two from Birmingham, UK, some of whom had experienced poor mental health. The project was intended to develop their understanding of mental health issues through guerrilla craft and craftivist activities.

The group worked with artists such as London-based renegade potter Carrie Reichardt (see also p. 143), Irish comic illustrator Maeve Clancy, and Birmingham-based filmmaker Nicola Paton to explore some of the complex issues and misconceptions that surround mental health. The young people did this through an active and creative approach, which included visits to exhibitions and events, the study of craftivists such as Sarah Corbett of the Craftivist Collective (see also p. 203), making and drawing sessions, and guerrilla craft missions that culminated in interventions at a café and a solicitor's office for Mental Health Awareness Week 2013. Participants went on to use their experiences to create a mental health awareness workshop that was piloted in an intercity school.

Craft in Mind was developed by Craftspace, funded by Birmingham City Council, and supported by Youthspace and Irwin Mitchell Solicitors.

PHOTO:
Sarah Fowler, Craft in Mind mini-protest banner, Birmingham, UK, 2013. Photo: Carrie Reichardt

GIVING VOICE THROUGH CRAFTIVISM

Catherine West

Even when it's been through odd gestures (such as stitching a wish for my community on a fabric water droplet to add to a fabric bucket in the community's wishing well), I have learned that, through craftivism, communities can help make things the way they should be. The creations, and the conversations they provoke, enable, or elevate, have an effect on the world around us.

Significant Seams undertakes craftivist acts on issues important to our own community in East London, UK. We live and work in a very artsy neighborhood with a heritage of creative industries, including the textile industry, which dates back to William Morris. It is also a multicultural neighborhood, as it reaches around the world through local families who own fashion businesses in other countries from India to Italy. A culturally rich area, our neighborhood has its downsides. We participated in the Craftivist Collective's campaign with Oxfam in 2012 regarding food poverty, and particularly focused on the fact that, in our ward, over a third of the children live below the poverty line, and yet a mere twenty-five percent receive free school meals.

Following the London riots in the summer of 2011, our neighborhood was identified as high-risk, geographically and socially. Its "health indicators" are well below average, and "social cohesion" is deemed quite low. The area has now become the focus of rather substantial regeneration investments. Funding cuts have begun to be felt in services, and yet the shops are getting new licks of paint, we have new, wider sidewalks, and some extra community days have been scheduled.

In response, we began a project called the *Softer Side of Regeneration*. We began to ask area residents, social groups, and community organizations to make cushion covers with an assigned letter on them. We also asked participants to complete a patch for the back of the cushion that identified something they received from their community and something they were willing to offer back.

We wanted to make the point that just because some statistics indicate that there are problems in the community, good, neighborly people live here, and we collectively share responsibility for it. The cushions tie together to spell messages: "Be the Change" at the cashpoint [ATM]; "Learn to Play" on the school fence; "What Do You Wish for Our Community?" outside our commuter train station. We also ran workshops in association with an exhibition about protest, *Regime Change Begins at Home*, by artist David Mabb that was held at the 2013 Museum of the Year, the William Morris Gallery. This project both inspires and demands accountability from local government and neighbors.

Working in this hyperlocal way, we have found that there is a great appetite for involvement in positive projects and ways to meet other people. Huge numbers of people struggle with isolation, loneliness, illness, uncertainty, and the responsibility of caring for others, especially where there is illness. The space to talk with others about the challenges they face and to offer support in return, while also sharing the insights they have gained from their struggles, helps people value their experiences. That and humming the *Mission: Impossible* theme tune en route to a pillow installation! Laughter too is a powerful medicine.

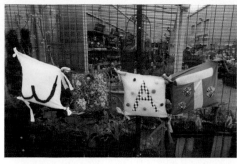
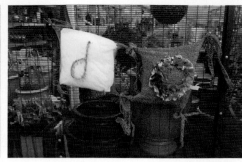
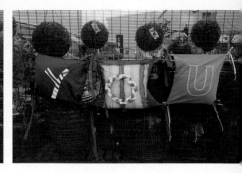
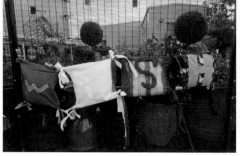
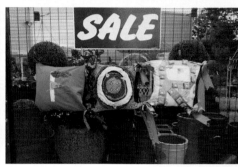
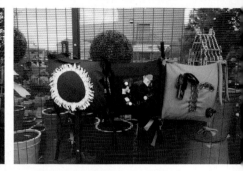
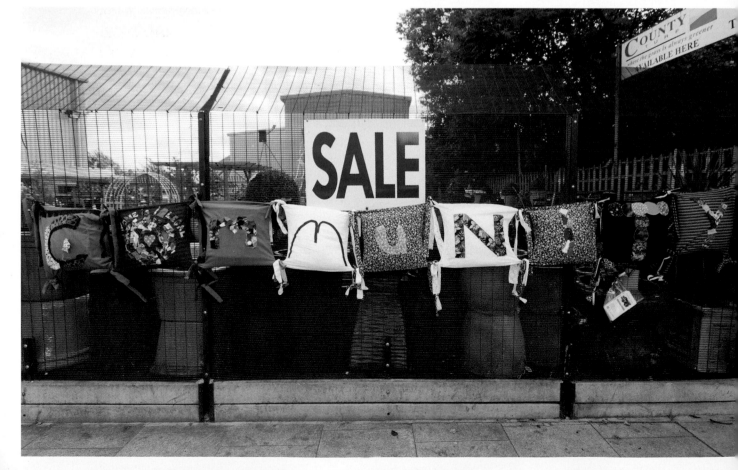

Craftivism is most powerful when it directly affects a community. A virtuous circle is created. We pay forward the good feeling, the care, the survival skills, the things we've learned, and we create new relationships along the way. Masses of research document the negative effects of isolation for the elderly, the infirm, or those struggling with poverty or illness. However, many programs tend to focus on a specific population's challenges rather than valuing what they already know about surviving that challenge and allowing them to offer these insights to their community. It can be amazingly empowering to "make" with a friend, share ideas about a planned project, develop those ideas, and think about why it is meaningful. Anthropologists put huge stock in the power of ritual for reproducing values and further suggest that "converts" adhere to their adopted morals more vigorously than those who "inherit" beliefs. Craftivism—by encouraging people to reflect on some of the most complicated issues of our times and model simple actions, helps people find their voices and share with others, breaking through isolation along the way.

When I founded Significant Seams, I knew many people with fabulous ideas on ways to improve our community but who seemed to be waiting for permission to implement them. I also had ideas of my own, which I wanted to try out, so I used my locally focused version of craftivism to discover untapped insights and connect with the community of people who might work with me. The first official Significant Seams project was the *E17 Neighbourhood Quilt*, which has come to be known locally as the "map quilt." I transferred an artist's rendering (with permission) of our area of London to fabric and recreated every road in the urban neighborhood in teeny, tiny patchwork pieces. (Each piece is about ½ x 1 in [1 x 2 cm].) I intentionally used raw-edged appliqué, as the neighborhood is known for a bit of scruffiness.

When I finished, I took this quilt and a bottle of gold fabric paint to public spaces and events around our area, and asked people to fingerprint where they lived. (The gold is intentionally symbolic, too.)

Raw-edge appliqué patchwork pieces form the roads of the area. The patchwork pieces are colorful and vibrant like the community they represent. The raw-edge technique creates not only a slight scruffiness, but also a surprising softness. Many people would have discarded the tiny scraps I used, but true to the thriftiness and environmental consciousness of E17 residents, I "upcycled" them into this map. The background and backing fabric come from the famous Walthamstow market. The quilt has a shimmer and sparkle from the gold-painted fingerprints. The *E17 Neighbourhood Quilt* was made possible by the sponsorship support of a number of local organizations, including the E17 Art House, Churchill Real Estate, ETW printers, Penny Fielding's Beautiful Interiors, the Mill Community Centre, and Woodside School and Children's Centre. Their locations are marked on the map with their logos.

While making the quilt, I witnessed neighbors meet for the first time. I heard elderly residents explain to younger generations why there are gaps in the terraced houses (bombs were dropped on the area during World War II, and some of the elders were witnesses to this). There were conversations about landmarks, maps, and how people orient themselves to their neighborhood: adults by transport links, children by their best friend's house and/or their school. Several people told me they wanted to participate if there was a future "neighborly" quilt project. With a growing cohort of volunteers and collaborators, I asked people, "What does it mean to be a good neighbor? What do you love about your neighborhood?" More than 100 area residents participated, and sixty-four let us keep their patches to stitch into *The*

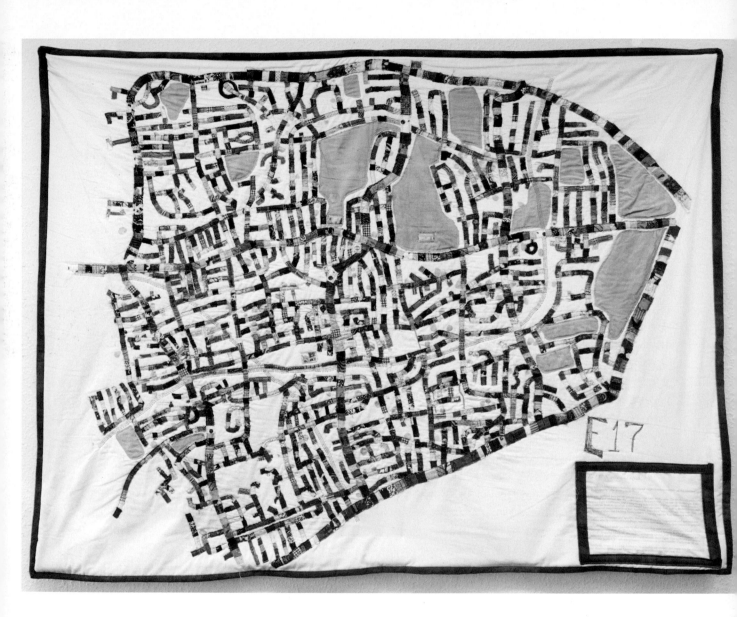

Neighbourly Quilt, which, like its predecessor, did a community-exhibition tour.

In addition to these community projects, I devised a "gently therapeutic" teaching program, designed to bring people together in moments of vulnerability and to help support them through craft. Initially, it featured programs called "Waiting for Baby" held in conjunction with professional support services, "Neighbourly Knit & Stitch" (with mental health services), and an earth-friendly upcycling program. One participant in the upcycling program made a patch for the *Neighbourly Quilt* from the remnants of a garment she had unpicked. She told me that unpicking her garment in that course had felt "unbelievably radical" and was "liberating" for her, changing her perspective on other challenges she was facing. When we started the *Neighbourly Quilt* project, she found a quote about William Morris learning to sew from unpicking and decided to do her first-ever embroidery. She said the class was the most "neighbourly" experience she'd had in a long time.

We now run a creative community space, complete with community-made patchwork couches, an intimate and supportive teaching space, the membership-based stitch and craft library, and a showroom for our retail offerings ("sewing supplies for social good"). Significant Seams has been made viable by the commitment and investments—of time, money, and more good ideas—of a huge number of people. Roughly eighty percent of our course participants have remained involved in the organization as volunteers. The loyal custom and generous donations of many more also keep us going. Many tell us that we are acknowledging, preserving, or valuing practical skills they once took for granted or memories they have imbued in the (literal!) fabrics of their lives. Most of the fabric and haberdashery donations we receive come with stories, and these stories are an incredibly valuable and affirming gift.

In addition to our original programs, we have a craft-based English as a Second Language Program, "Sew 'n' Tell ESL," a program that supports toddlers and their caregivers, and a wide variety of other workshops. We are always supporting at least one community project inspired by craftivism.

The connectedness of craft can extend across generations, space, and even language in a way few other things can. I love the power of textiles to evoke and represent feelings, memories, hopes, and ideas. I'm absolutely convinced that sewing can mitigate awkwardness and self-consciousness, especially in first encounters. By its nature relaxing, it promotes self-expression and an alternate means of encouraging reflection.

Many people find it difficult to articulate what they want and what they believe about how the world should be. It's a complex place, and most people recognize this. Sifting through possibilities and "embracing" one right, and possibly many wrongs, is hard, especially if it entails negative repercussions or conflicting views. Using the process of "making" to reflect on an idea, to sort through the complexities, is an important part of craftivism.

For vulnerable people, especially those struggling with depression or anxiety, the tangibility of making, of literally creating something, is very empowering amidst feelings of helplessness. The act of expressing through making can be cathartic. There is evidence that repetitive motions trigger "the relaxation response"—a change in breathing patterns and mental focus that releases calming hormones while also stimulating the problem-solving part of the brain.

At its best, I think craftivism is meaningful, active community development, even more than craft-based activism. Beyond being a method of campaigning, it transforms people, places, and ways of co-existing. In practice, craftivism can combat isolation, promote reflection, and enable new conversations.

The artful beauty of craftivism is also found in the silent conversation, the shared ideas between a maker or a collective of makers and a recipient or viewer. In our busy, instantly "connected" world, the reflection and communication inspired by craftivism may create more connection and real change than thousands of names on a petition. By approaching craftivism as community development on a local level, Significant Seams has connected the volunteering, community work, and generosity of a group of people who might not otherwise be activists to the international community of craftivists.

~~~~~~~~~~~

**CATHERINE WEST** *founded Significant Seams CIC and Seams Significant in 2010/11 after more than fifteen years in marketing and fundraising in arts and education. She is a former Development Director of LIFT, The London International Festival of Theatre. She helped established a distinctive creative-industries space called P3 at the University of Westminster after working at the International Festival of Arts and Ideas in New Haven, Connecticut. West learned to quilt while a student at Sweet Briar College, a woman's college in Virginia. She learned her patchwork from friends, how to be a leader from school, and her feminism from the combination.*

*Now based in London, UK, West likes to think of everything as a patchwork, and patchwork as a metaphor for everything. She loves the patchwork tradition that a quilt without a mistake is bad luck—and suggests that the more mistakes we make, the luckier we are. She is passionate about the power of craft and a little bit clever at linking causes, projects, and partners into, you know, a patchwork. significantseams.org.uk and seamssignificant.co.uk.*

~~~~~~~~~~~

PHOTOS:

Page 192: This patch of the *Neighbourly Quilt* was made by a participant in our upcycling program. Photo: Catherine West

Page 194: *The Neighbourly Quilt*, 2012, was made by more than 100 local residents over the course of six months and more than fifteen workshops inspired by the question, "What does it mean to be a good neighbour?" Photo: Mark Burton

Page 196: This quilt (2011) celebrates the creativity and mutual supportiveness abundant in the community of Walthamstow, northeast London, UK, whose postal code is E17. Photo: Mark Burton

Page 197: The retail space we redeveloped into a creative community space has a Community Living Room, Showroom, Workshop, Stitch & Craft Library, and a donation-based tea and coffee point. Photo: Mark Burton

Page 198 (top): Sculpture artist Harriet Hammel helped us make our Wishing Well and its silver bucket. Our team and volunteers have started making a garden around it. The *Be a Drop in the Bucket* project (2013) asked people to stitch a wish for their community on a fabric water droplet, and to fill the well's bucket with our wishes. Photo: Mark Burton

Page 198 (bottom): Former intern and ongoing volunteer Kate Rolison, a.k.a. @poesiegrenadine, stitching a wish on a water droplet at Significant Seams, 2013. Photo: Catherine West

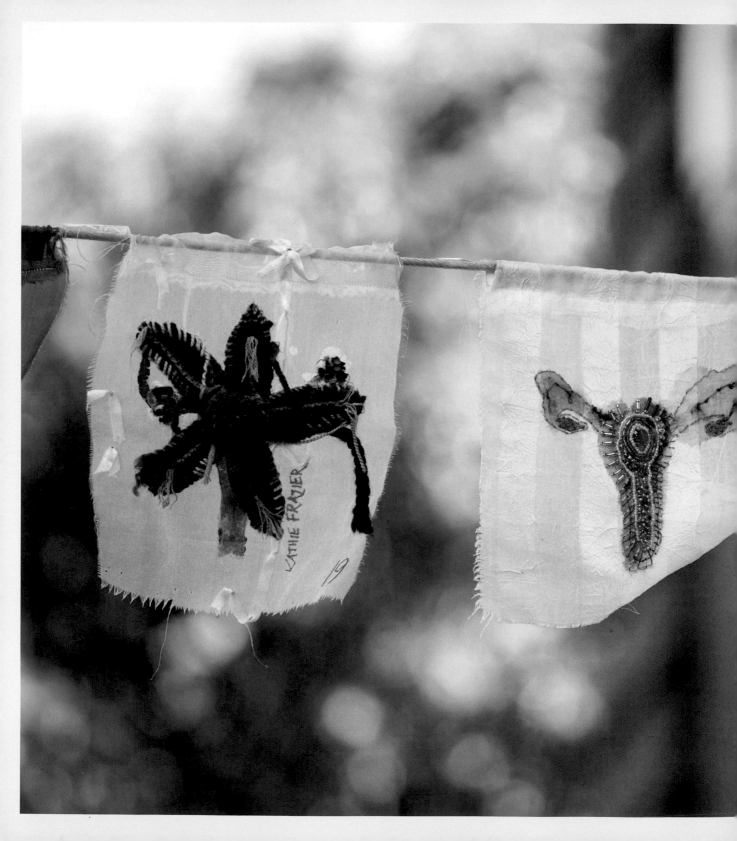

The Uterus Flag Project
Terrilynn

The Uterus Flag Project is a collaborative, social-practice art project involving participants who use fiber arts. They stitch a seven by nine-inch (17.78 x 22.86-cm) piece of fabric that's been pre-painted with an image of a uterus.

The project began in December 2010 in a sit-and-stitch group. It has evolved into an undertaking to create awareness around the importance of the uterus as an organ. The participants become the artists, and when the project is exhibited, it takes on a feeling of synergism focused on women's health.

Through this project, I have heard other women's personal stories and concerns about their health and their families. Everyone deserves access to valid information to help make better medical choices. My mission is to educate through the power of art that integrates the ideals of feminism, to change consciousness about women's health, and to include craftivism as an alternative way of giving voice to women.

Email: terrilynnquick@gmail.com
Blog: *uterusflagproject.blogspot.com/*
Facebook: *facebook.com/UterusFlagProject*
Youtube: *youtube.com/watch?v=sbOgn1XXA5A*

PHOTO:
Terrilynn, Uterus flags, Vermont College of Fine Arts, 2012. Photo: Neil Dixon

INTERVIEW with Sarah Corbett of the Craftivist Collective

Q: What was your first activist act?

A: I feel I've always been an activist. I grew up in a low-income area of Liverpool in the UK during the troubled 1980s. There's a photo of me aged three, standing alongside local campaigners who are trying to save thirty good houses that were slated to be demolished to make a park. The houses were saved, and that event has been a constant reminder to me that campaigning can work. Throughout my childhood, campaigning was a big part of my family's life. I've continued to be a campaigner in my adult life, and I've been fortunate to work as a campaigner for the last six years for large charities.

Q: You describe yourself as a "burnt-out activist." At what point did you know that activism was no longer personally working for you?

A: In 2008, I had moved to London and found myself feeling discouraged and exhausted. I had doubts about my effectiveness as an activist. Shouting and marching drained me; I didn't like demonizing people and telling them what to do. I didn't feel that I fitted into many activist groups, and being around so many people zapped me of energy.

I'm definitely more of an introvert. I prefer to concentrate on a single activity at a time and like to observe situations before I participate. I like spending time alone, wandering and thinking, crafting and creating. I tend to get easily overwhelmed by too much stimulation from social gatherings.

So although I've always had a burning passion to fight for justice, I've also always found it hard to fit into traditional forms of activism. I am hesitant to just sign petitions, because I first want to have a thoughtful discussion.

Q: How did activism lead you to craftivism? Were you already crafty?

A: Around the same time as I started to feel burnt out as an activist, I started to cross-stitch and found that I could cross-stitch anywhere (on the bus, train, sofa). It was creative but also slowed me down, helped me feel less stressed, gave me time to reflect on my job, my activism, and my life. I wondered how I could join my love of craft to the fire I still had in me to make the world a fairer place. I Googled "Craft & Activism," and this word "craftivism" popped up. So I contacted Betsy [Greer] to see if there were any projects I could do or groups I could join. Since there weren't, with her blessing I started to create my own projects and document them on my blog, "A Lonely Craftivist" (so emo, I know!).

Q: What is it about craftivism that engaged you?

A: As an activist, I was going to lots of meetings and demonstrations—there was lots of *doing*. I couldn't find time to reflect on the issues. Craft helped me to stop and think. If you are crafting on your own, you are exercising your inner monologue, which we seldom make time for. It helped me to try to put myself in the shoes of the

victims and the perpetrators, to think about how we can be part of a solution as voters, consumers, friends, campaigners, etc. You are not going to take the time to stitch a text that you don't believe in, and by stitching it you really take ownership of the words you are creating in fabric. Craft connects your hands, heart, and head, and when you connect that to justice issues, it can be world-changing both personally and politically.

I also struggled with the fact that many campaigns were negative and antagonized the very people they were trying to persuade. For example, I had been sending petitions to my MP. She told me to stop contacting her because it was a waste of my time and hers. So I decided to embroider a positive message on a handkerchief to give to her, asking her not to "blow it," but to use her power and influence for good. I hand-delivered the hanky, and it engaged her interest in a new way. I now have many good discussions with my MP. Craft is non-threatening, and people value handmade items because it takes time to make them. I believe that to make long-lasting change, we all need to be loving, critical friends rather than aggressive enemies. I saw craftivism as a great tool to help with that shift.

I believed that I had to fit into a particular activist mold, but I'm not an extrovert. I love fashion; I can craft happily for hours. As activists, we need to reach out to people where they are, not make them come to us. Craftivism engages the craft community where they are and reaches out to others.

Q: *How did you come to engage in public acts of craftivism?*

A: I always think about how to engage people in injustice issues but in a thoughtful, respectful, and personally transformative way. My hope when I started making the mini-protest banners was that people would find them, be provoked by the slogans, facts, or questions stitched on them, maybe Google "A Lonely Craftivist" or take a photo of the piece to share on Facebook, Twitter, Instagram, or with friends in a pub. I hoped this would create a natural conversation about the issue. We all know that if a friend (rather than a faceless person or organization) shares something they've seen, the listener is more likely to engage with it. A lot of that happened; people did blog about the issue. One person asked for a print for a banker friend, who then emailed her saying it caused a great conversation between him and his wife on New Year's Day.

Q: *How do you set the limits or boundaries of your craftivism work?*

A: Craft is the Craftivist Collective's method of campaigning, but the most important part for us is the political and social change. We enjoy craft and creating, but we're passionate about working toward a fairer society for all and using craft as a tool to help us on that journey.

Within six months of launching my blog, I got lots of emails and comments from people who said they felt they also didn't fit into the usual activist mold but who wanted to join [a group]. I founded the Craftivist Collective in 2009 due to this demand, and now we have thousands of supporters all over the world. In our first meeting together, London craftivists and I created our manifesto to help us feel we had a clear identity of what we should focus on rather than slip into trying to campaign on everything: "To expose the scandal of global poverty and human rights injustices though the power of craft and public art. This will be done through provocative, non-violent creative actions."

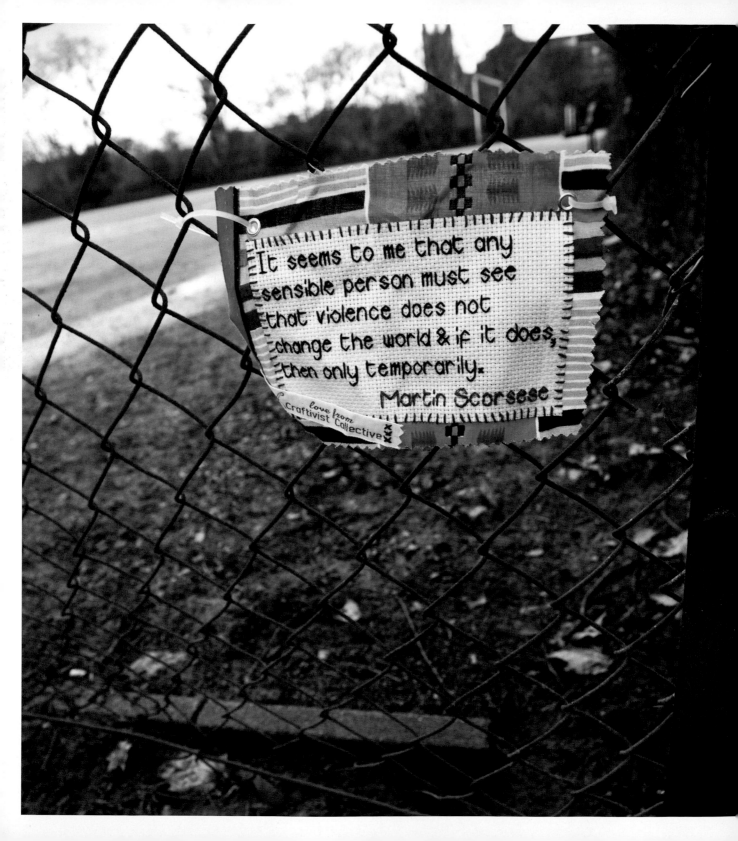

Q: You've also described yourself as an introvert. How does that mesh with giving talks and holding meetings?

A: Some people think that being an introvert conflicts with giving talks and holding meetings. But my passion around issues of injustice challenges me to go outside of my comfort zone and sometimes into the spotlight, which is scary but seems to be helpful for people. Susan Cain, who wrote *Quiet: The Power of Introverts in a World That Can't Stop Talking,* pointed out that Eleanor Roosevelt, Rosa Parks, and Gandhi all described themselves as shy, and yet they all took the spotlight even though every bone in their bodies was telling them not to. This is a lovely reminder that you don't have to fit a certain stereotype to help make the world be a better place.

Q: How did the national #imapiece campaign with the Save the Children foundation come about?

A: Save the Children contacted us to ask if the Craftivist Collective could support them by engaging the craft community in their Race Against Hunger campaign in the lead up to the G8 summit of 2013 hosted by British Prime Minister David Cameron. Save the Children was agreeable to our ways of working with the craft community, our communication style, and they gave us the support and time to make this the largest project we have delivered so far. More than 700 UK crafters stitched messages on textile jigsaw pieces about how we all need to be part of the solution and not the problem of world hunger. More than 120 blog posts were written by crafters about their experiences, and over 3,000 tweets using our *#imapiece* hashtag (with a potential reach of at least nine million readers) were pinged out onto Twitter. We received a lot of media coverage within the craft world and further afield, with a potential reach of

more than seventy-eight million readers. I'm most proud of the fact that upwards of 100 constituents agreed to meet their MPs for the first time to give them their craftivism jigsaw piece and have a conversation with them. I hope these participants will continue to see themselves as vital jigsaw pieces in the solution to world hunger.

Q: What are the main tips you give to people when they ask how they can start their own craftivist group?

A: First, agree on a manifesto so that everyone is in agreement on your mission and model of working. If each person's motivations and expectations are different, this can create cracks in the group, sooner or later. It's also important to have guidelines on how to work together to make sure people feel they have a voice and are respected in the group. I always remind people that it's just as important for them to do craftivism on their own and exercise their inner monologue as to craft with a group and discuss the issues. Therefore, it's not always essential to create a group. It might be best to do ad hoc events when appropriate. I try to encourage people to have their group meetings (we call them stitch-ins) in public so that passersby can ask what they are doing. This engages them in the issues. The location should be accessible for people and not intimidating, but in a safe, friendly place for honest discussions. Sometimes, when tackling an issue or project for the first time or planning a stitch-in, having a quiet, private venue with minimal distractions is best. In terms of recruitment for your group, it's also good to build relationships with like-minded people and organizations in your area and support each other where possible, so that they never feel they are competing with you for participants or event dates.

Q: In your workshops, you focus on the reflective aspect of craftivism. Can you tell us more about that?

A: Reflection has always been important in my craftivism. I truly believe that reflection is vital to create the strong, sturdy roots for our subsequent actions. Without understanding and knowledge and deep engagement with an issue, it is difficult to sustain our involvement— and it's also difficult to engage others. We live in such a busy world. We need time to reflect on our own and in groups when we try to grapple with issues such as how to eradicate poverty and other injustices.

Q: Where do you hope to take the Craftivist Collective in the future?

A: I hope to continue to assess how we can be most useful to people. I hope to continue to do more workshops, talks, events, written pieces, and joint projects with organizations. I am doing more guest lectures at universities now to help students think about how they can use their gifts to make a positive mark on the world. I am passionate about getting activism and global issues into arenas of the world where you might not normally see them addressed, such as having our products in arts, crafts, and fashion shops. It would be brilliant to continue to work with organizations who don't normally work with campaigners, such as cult jewelers Tatty Devine or experiential cinema producers Secret Cinema, and art institutions like the Victoria and Albert Museum in London. I hope the Craftivist Collective can be sustainable as it grows, and that it inspires more people to do craftivism and see that it is a valuable part of the activism toolkit as well as a useful personal activity that can help us strive to be our best selves.

~~~~~~~~~~~~~~~~

**SARAH CORBETT** *has been a professional campaigner for the last six years for Christian Aid, DFID (Department for International Development, [UK]), and Oxfam. She started doing craftivism in 2008 as a reaction to traditional forms of activism and set up the global Craftivist Collective in 2009. Sarah works in collaboration with large charities and art institutions as well as organizations such as Tatty Devine and Secret Cinema. She also sells products, delivers workshops and talks, exhibits her own work, and writes a column on craftivism for* Crafty Magazine. A Little Book of Craftivism *was released in the UK, America, and Canada through Thames & Hudson and D.A.P./Distributed Art Publishers in October 2013.*

~~~~~~~~~~~~~~~~

PHOTOS:

Page 202: Craftivist Collective "Stitch-in" event at Hayward Gallery as part of the *Tracey Emin* retrospective exhibition, 2011. Photo: Craftivist Collective / Robin Prime

Page 204: Craftivist footprint to keep at home as a reminder of our impact on the world and our journey, 2013. Photo: Craftivist Collective / Robin Prime

Page 206: Sarah Corbett, *Scorcese Mini-Protest Banner*, 2011. Photo: Craftivist Collective / Robin Prime

Page 207: Sarah Corbett, *Handkerchief for My Local Politician*, 2010. Photo: Craftivist Collective / Robin Prime

Page 210–11 Inspiring bunting, Southwark, London, 2011. Photo: Craftivist Collective / Robin Prime

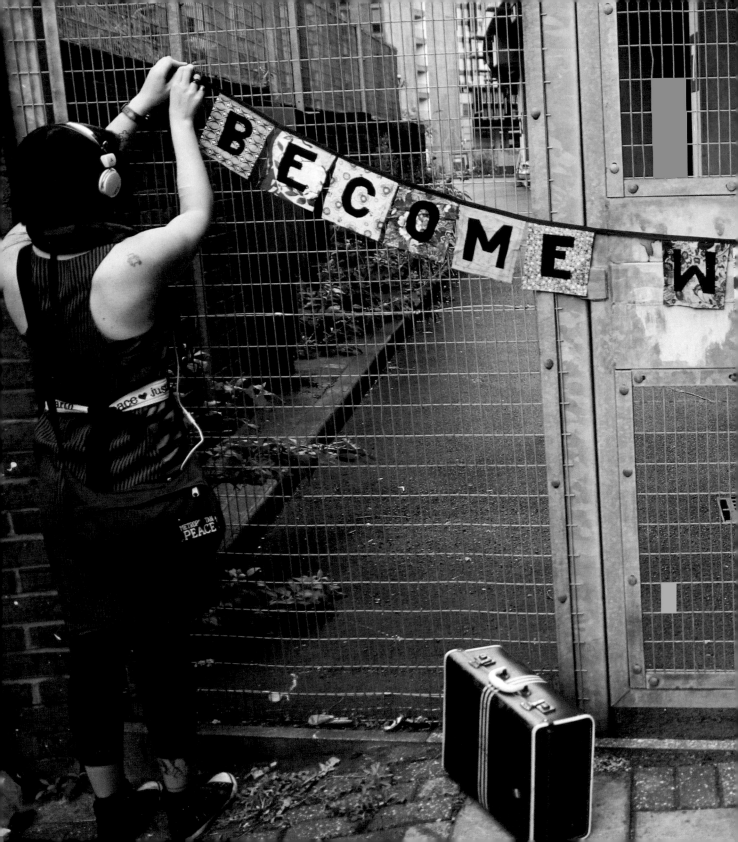

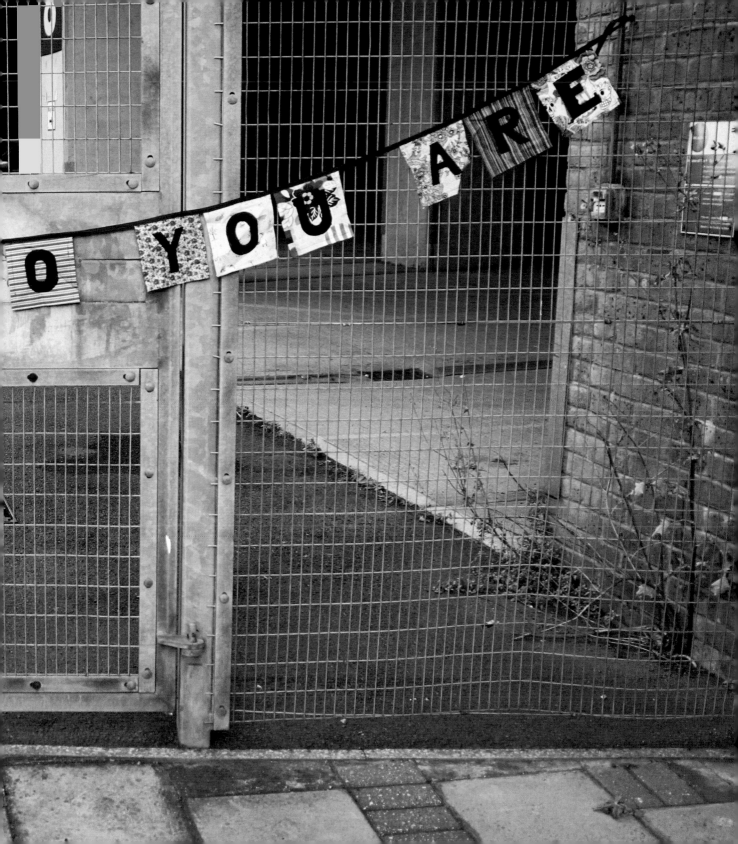

Acknowledgments

First, I'd like to thank everyone who has ever uttered the word "craftivism" over the past decade and those who will mention it in the years to come. Thanks for believing in a made-up word and seeing how it can help us get more deeply in touch with both our creativity and ourselves. While the concept of craftivism isn't a new one, your use of the term has brought life to a movement that has sparked people's hearts and hands. From the bottom of my heart, thank you.

Second, I'd like to thank all of the amazing contributors to this book. They say that it takes a village to raise a child, but it also takes a village to write a book; thank you all for believing in this project and for putting up with my frequent emails and questions! Thanks to everyone at Arsenal Pulp, especially my editor, Susan Safyan, whose belief in and enthusiasm for this project has helped turn a rough idea into the beautiful volume that you hold in your hands right now.

Third, but definitely not last in my gratitude, I'd like to thank my friends and family for cheering me on through this project for the past year. Your invites helped me get out of book-writing hermit mode; your calls and texts kept me going when I needed a laugh; and your ever-present love and support allowed me to delve fully into putting together this volume.

Additionally, thanks to you, dear readers, for picking up this book to learn about craftivism and how it can both fortify and enliven your life and work.

Index

BETSY GREER is a writer, a maker, and a researcher, and the author of *Knitting for Good!: A Guide to Creating Personal, Social, and Political Change Stitch by Stitch*. She runs the blog *www.craftivism.com* and believes that creativity and positive activism can save not only the soul, but also the world. Betsy lives in Arlington, Virginia, and can be found on Twitter at @craftivista.